THE ULTIMATE TROPHY

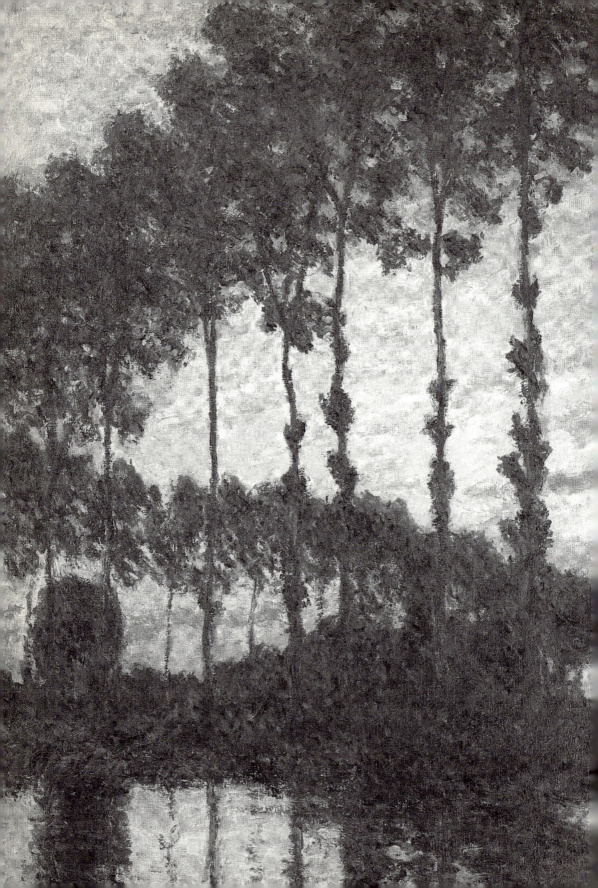

Philip Hook

THE ULTIMATE TROPHY

How the Impressionist Painting Conquered the World

PRESTEL

Munich Berlin London New York

CONTENTS

6 **Introduction**

CHAPTER ONE
8 **Up Close It's A Mess**
The Shocking Novelty of Impressionism

CHAPTER TWO
32 **The Cat on the Keyboard**
The French Reception of Impressionism

CHAPTER THREE
58 **A New Art for a New World**
America and Impressionism

CHAPTER FOUR
92 **A Cultural Deed**
The German Reception of Impressionism

CHAPTER FIVE
120 **Mormons in St Paul's**
The British Response to Impressionism

CHAPTER SIX
148 **Chatwin's Hair**
The Impressionist Painting, 1945–70

CHAPTER SEVEN
182 **Beyond Price**
The Impressionist Painting, 1970–90

CHAPTER EIGHT
202 **Optical Collusion**
The Impressionist Painting after 1990

218 Selected Bibliography
220 Index
224 Acknowledgements and Picture Credits

INTRODUCTION

This is a book about paintings and how people perceive them; not just as images, but as symbols of status, as cultural and social trophies. Specifically it is about the changing perception of Impressionism over the past century and a quarter.

Impressionism began in France in the second half of the nineteenth century as a revolutionary movement producing pictures that people found difficult to understand. It was the first modern art, provoking for the first time the reactions of public bewilderment and outrage that have since become so familiar, repeated by each succeeding generation as it confronts the 'excesses' of its own contemporary avant-garde. But over the past hundred or so years, an extraordinary change has taken place in the way people see Impressionism. These once controversial paintings have been transformed into the most popular and accessible art in the world. They have also become icons of extreme wealth, so much so that a Monet or a Renoir or a van Gogh now has a connotation that is as much financial as artistic: besides conjuring a vivid and familiar pictorial world, the names of these artists are like a unit of currency in their own right.

How has this happened? Why were some countries quicker to appreciate the Impressionists than others? Is there some quality unique to the Impressionists that makes them particularly attractive to the rich? These are some of the questions which I have set out to answer. In the process I have found myself drawing on the experience of my own career at both Sotheby's and Christie's and as an art dealer. So this book is partly a personal memoir, too: of paintings, of the people who buy and sell them, of the motives that drive those buyers and sellers. The paintings and the motives I have tried to identify correctly. The people I have sometimes disguised.

UP CLOSE IT'S A MESS

The Shocking Novelty of Impressionism

————

I once tried to sell a Monet to an Eastern potentate. He sat opposite me in the marbled splendour of his palace wearing an expression of intelligent perplexity. Outside, the palm trees barely moved in the oppressive afternoon heat, and the sea beyond was a still, deep blue. Through the window I could see the golden dome of a vast, recently constructed mosque, and a skyscraper decorated with the insignia of an international bank and a neon advertisement for Coca-Cola. Here in this cavernous reception room where the air-conditioning spun its chill cocoon, I noticed that even the carpets were sprinkled with gold dust. The lift in which a flunkey had accompanied me up to these private quarters was walled in mink. What was I doing here, I asked myself? Through a geological freak – huge resources of oil being mineable beneath the barren surface of his country – this man was rich to a degree that set him apart from the rest of humanity. He had a fine face and impeccable manners. He treated me with enormous politeness.

'So', he said, peering at the painting I had brought with me, 'this will cost 7 million dollars at auction?' He gave a quick, uncertain smile, as if he suspected he might be the victim of a practical joke but was determined to remain a good sport about it.

I told him it would, possibly even more.

'But how can that be?'

'Because it's by Claude Monet, one of the most famous of the Impressionist painters. It's a very beautiful one.'

'Please, explain to me something I do not understand.' He rose from his chair and walked over to a painting that he already had hanging on his wall. 'For this work by Jean-Léon Gérôme I paid only 900,000 dollars.'

It showed a street market in Cairo. Each figure was minutely, photographically painted, with all the finish that distinguished the masters of French academic art in the second half of the nineteenth century. 'Surely', insisted the owner, 'this Gérôme is superior to the Monet. It is a masterpiece. It is real. It is how things look'.

How things look. His Royal Highness had touched upon the essence of what Impressionism was about. Nonetheless, I decided not to risk a theoretical debate and stuck to the financial certainties. 'The Gérôme is a very good one, of course', I reassured him. 'But the Monet is more highly prized on the market.'

'But this man Monet does not know how to paint, not as well as Gérôme. The colour is jarring. The figures are awkward. The strokes of the brush are too broad, they are not precise. There is no detail.'

I thought about quoting at him how Mallarmé explained Impressionism in 1876: 'As to the detail of the picture, nothing should be absolutely fixed. The represented subject, being composed of a harmony of reflected and ever-changing lights, cannot be supposed always to look the same but palpitates with movement, light, and life....' But I wasn't confident it would do any good. My client came from a culture unfamiliar with the way western painting had

developed over the past century and a quarter. He was groping towards an understanding of it. By instinct, however, he preferred the certainties of Gérôme to the suggestive imprecisions of the Impressionists. And it came to me then that this was how people – not just the philistines, but intelligent people, too – must have reacted when the Impressionists first exhibited in Paris in the early 1870s.

In the early part of the twenty-first century, we are used to the shock of newness in art. It is barely a shock any more. But the Impressionists were the first painters to confront the public with a dramatic revolution in the way paintings looked. It simply hadn't happened before. As a result there was no set language with which to express reaction to what you saw, far less to assimilate it. Zola in his novel *The Masterpiece* of 1886 describes the public's inarticulate horror at the new sort of pictures they found in these first avant-garde exhibitions: 'That novel rendering of light seemed an insult to them. Some old gentlemen shook their sticks. Was art to be outraged like this? One grave individual went away very wrath, saying to his wife that he did not like practical jokes'.

That novel rendering of light. It is easy to forget how garish Impressionist colour must have seemed to the Parisian public of the early 1870s. They were used to the conservative colour keys of the typical Salon exhibitor like Gérôme, laboriously recording what he knew about an object rather than the effects of light he saw reflected off it. When it came to landscape there was already a group of painters – the Barbizon School – whose pictures were advanced enough to be painted '*en plein air*' in direct confrontation with nature. But what made the Barbizon School less problematic, less challenging, was that they – as did Gérôme – still tended to paint local colour rather than overall optical effect. Essentially the way they painted their fields and foliage was no different from the Dutch masters of the seventeenth century. Their paintings still looked reassuringly like seaweed. It took a big jump to come to terms with the Impressionist

1 The old way of seeing: detail and finish. Gérôme,
 The Baths at Bursa, 1885. (See pl. 1.)
2 The new painting: light and atmosphere. Monet,
 The Grand Canal, Venice, 1908. (See pl. 2.)

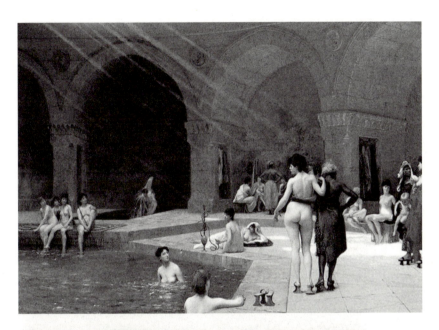

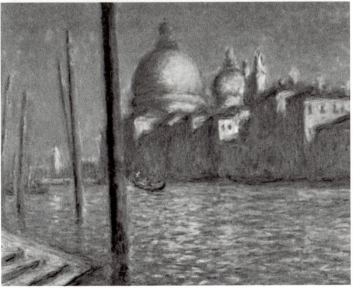

3 The Barbizon School, a reassurring link with the
past. Rousseau, *The Edge of the Forest*, 1866.

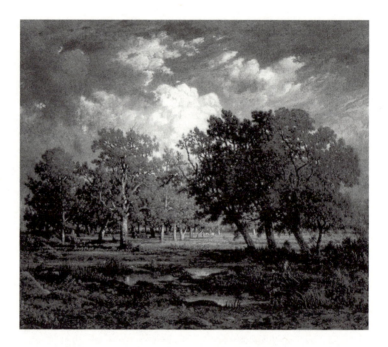

technique. This involved brushstrokes which did not of themselves
define form, but instead created a vibrating tissue of optical sensa-
tions. The new way of seeing meant that Impressionist pictures were
not only rougher in finish, but also much brighter than any others
around, because of their new understanding of light and colour.

Gérôme, the arch-conservative spokesman for the Academic
tradition, never forgave the Impressionists their impudence. Twen-
ty years on, in the 1890s, he was still ranting against them. The mod-
ernist painter Gustave Caillebotte had had the temerity to bequeath
his personal Impressionist collection to the nation. 'For the govern-
ment to accept such filth', declared Gérôme, 'there would have to be
great moral slackening'. A century later that moral slackening was
still being wondered at, here in this marbled palace beside an East-
ern sea.

How did Impressionism happen? It wasn't an isolated event: looked at in the European context, it was simply the most significant and sustained of the rebellions that took place against the Academy in nineteenth-century painting. Across the continent official, academic art had grown stale and moribund. By the middle of the century, for instance, the Paris Salon – the exhibition organised by the numbingly conservative committee of the École des Beaux-Arts as the showcase of contemporary French painting – was a depressing stew of sentimental genre scenes and tired melodramas drawn from history and antiquity. The rebellion took different forms in different countries, but what it had in common everywhere was the younger generation's desire to cleanse artistic vision, to invigorate it by a more direct pictorial representation of reality. The result became known as Realism (with its implicit grittiness), or Naturalism (literally, the remorseless transcription of Nature).

In France the leader of this tendency in painting was initially perceived to be Édouard Manet. Then, as the decade of the 1860s progressed, a band of young supporters emerged: Monet, Renoir, Pissarro, Sisley, and – in his own way – Degas. Out with the old, meaningless tradition of classicism, they declared. Out with history painting. Out with the tyranny of the subject. Out with Gérôme. In with the new way of seeing. In with the direct recording of an effect, an impression of nature. And in with the realism that demanded 'il faut être de son temps' in Baudelaire's words, that you should only paint what you had direct visual experience of, that is to say the world about you, regardless of whether it was conventionally beautiful or ugly.

The year 1863 was significant in the early development of Impressionism. That summer the rebels against the Salon were acknowledged for the first time. Those whose works had been rejected by the conservative jury (and thus excluded from access to the vast majority of the buying public) were allowed their own separate

exhibition called the Salon des Refusés. The critic Théophile Thoré went to the rebels' show and observed astutely:

> French art, such as one sees it in these proscribed works, seems to be making a new start ... The subjects are no longer the same as those in the official galleries: little mythology or history; present-day life, above all in its popular types; little effort and no taste at all: everything is revealed just as it is, beautiful or ugly, distinguished or vulgar. And [there is] a method of working altogether different from the working methods consecrated by the long domination of Italian Art. Instead of searching for the contours, what the Academy calls drawing, instead of insisting upon the detail, what lovers of the classical call finish, they aspire to render the effect in its striking unity, without worrying about the correctness of the lines or the minutiae of the accessories.

Five years later the young American painter Mary Cassatt, not long arrived in Paris from Philadelphia, was writing home in her charmingly breathless, if not always grammatical manner: 'The French School is going through a phase. They are leaving the Academy style and each one seeking a new way consequently just now everything is Chaos'.

The new way. You went for the overall effect, rather than the detail. You studied the light and its reflections with intense devotion. You painted with broader brushstrokes and with brighter, simpler colours. And you painted only what you saw about you, in its immediacy and directness. You didn't make things up out of your imagination. You didn't draw your subjects from the past. You didn't use black, because you'd discovered that shadow was actually composed of other colours, predominantly purples and blues. You didn't paint local colour at all, which meant you didn't paint the colour you knew something to be, but the variable colour you saw it to be, determined

by the condition of the light. Actually, the new way wasn't totally new. The British water-colourist Alexander Cozens had anticipated some of this in the late eighteenth century when he observed: 'In nature, forms are not distinguished by lines but by shade and colour'. But in French hands, at this later juncture of history, the formula proved explosive. In the Goncourts' 1866 novel *Manette Salomon*, a young artist declares: 'You've got to apply colour without mixing it, find the way to model without mixing your pigments, use the full range of the palette.... The palette is the reduction of sunlight to its component parts, and art is its reconstruction'. Eight years later the critic Jules Antoine Castagnary, reviewing the first Impressionist exhibition in 1874 (the one at which the term 'Impressionist' was first coined), summed it all up perceptively: 'They are Impressionists in the sense that they render not a landscape but the sensation produced by a landscape.'

There was an immediacy to the Impressionist technique, a spontaneity that the Goncourts' character hints at. You put the colour straight on, unmixed. In the face of the changing effects of nature, you didn't have much time to capture your impression. It had to come right with the first touch. 'Manet and his school use simple colour, fresh, or lightly laid on, and their results appear to have been attained at the first stroke, so that the ever-present light blends with and vivifies all things', wrote Mallarmé in 1876. This is an idea bubbling through from Romanticism. 'Posez, laissez', Baron Gros advised his pupils. Make the brushstroke and leave it. The first touch is the right one, because it's the spontaneous, sincere one. 'I am like the tyger', maintained Byron of his poetry. 'If I miss my first spring, I go growling back to my jungle. There is no second. I can't correct; I can't, and I won't'.

In the film *Clueless* the heroine, Cher, a worldly-wise 17-year-old from Los Angeles, and her friend Tai are watching another girl on the dance floor:

4 'Up close it's a mess': Impressionist brushwork.

TAI: Do you think she's pretty?
CHER: No, she's a full-on Monet.
TAI: What's a Monet?
CHER: It's like the painting, see: from far away it's OK,
but up close it's a big old mess.

Up close it's a mess. Cher was only echoing the view of my polite but mystified Eastern client. Actually, the fact that many Impressionist paintings only work at a certain distance was recognised early on. Lucien Pissarro reported to his father of the cramped conditions at a London exhibition in 1883: 'I must tell you that one is obliged to view the paintings from too close by, and you can imagine the fright which your execution causes'. Significantly it was an American critic, Theodore Child (Cher's spiritual great-grandfather), who wrote about the Impressionists in January 1887: 'Their pictures must

always be looked at from the requisite distance, and as wholes which cannot be decomposed, for their practice is to neglect particular tones in order to attain a luminous unity, just as a musical composer will arrive at harmony by an agglomeration of dissonances'.

In two different ways an Impressionist painting has the appeal of a pun. If you get too close to it, you are reminded that it is no more than an agglomeration of coloured brush strokes on a canvas surface; but step back a pace or two and suddenly the same brush strokes become a startlingly convincing illusion of light-flooded reality. Then there is the tendency of some Impressionist painters – Monet in particular – to paint the same scene over and over again under varying lights and in changing seasons (haystacks, water-lily ponds, cathedrals, in summer, winter, spring, at dawn, midday and dusk). The variety of effects which results is also a pun – dramatically different looking paintings simultaneously all of the same subject. There's a piquancy to the spectator, pleasing in the way that a pun is pleasing.

And perhaps there was one further element to the early appeal of an Impressionist painting: there may have been an attraction to its rougher texture and broader brush stroke. This was a generation still coming to terms with photography. It found the proximity of painting to this new science disquieting. Therefore a way of painting – Impressionism – which delivered an illusion of reality on a par with a photograph, but because of its conspicuous brush stroke could never be confused with a photograph, was a reassurance. Look, the spectator could tell himself: this is a painting because you can see paint on it. The brush strokes were the evidence of the artistry; proof that the work of art was created not by a machine, but by a human hand expressing a human temperament. In the late nineteenth century there was a vogue for painters like Velázquez and Hals, the bravura of whose handling of paint emphasised their individuality and distanced them from photography. The fullest exploitation of this

taste emerged in Sargent's hugely popular portrait style, a marriage of Impressionist brush stroke with the 'swagger' portrait tradition of the eighteenth century.

'The naturalist school', wrote Castagnary in 1863, 'declares that art is the expression of life under all phases and on all levels, and that its sole aim is to reproduce nature by carrying it to its maximum power and intensity: it is truth balanced with science'. The result is a scientific, unemotional, almost clinical cast to the Impressionist vision. You see it in the titles of the paintings: *Route de village; Effet de neige; Petite Danseuse de quatorze ans. Quatorze ans:* it has the precision of the labelling of a specimen in a museum exhibition. The same thing was happening in literature. Writers were becoming 'anatomists and physiologists' according to Sainte-Beuve. 'In order to find the beauty of today', said the Goncourts, 'there is perhaps need of analysis, a magnifying glass, near-sighted vision, new psychological processes.... This is the great century of scientific restlessness and anxiety for the truth'. And Flaubert – of whom Sainte-Beuve had written that he 'handled the pen as others do the scalpel' – declared: 'Human beings must be treated like mastodons and crocodiles; why get excited about the horn of the former or the jaw of the latter? Display them, stuff them, bottle them, that's all – but appraise or evaluate them: no!'

There were radical implications to this new way of seeing: all individuals were equal under the democratic eye of the scientific painter of modern life. Truth to nature – sincerity to what you registered optically, in contrast to the tired artifices of the Academy – carried with it a political stance: 'It is sincerity which endows works of art with a character which resembles a protest', wrote Zacharie Astruc in 1867. That element of protest was further defined by the Neo-Impressionist Paul Signac a generation later: 'The anarchist painter is not he who does anarchist paintings but he who without

caring for money, without desire for recompense, struggles with all his individuality against bourgeois and official conventions'. Here, glimpsed for the first time, are two of the great myths of modern art: art as protest, and the artist as heroic revolutionary, sticking to his innovative principles in the face of ignorant reactionary opposition. These ideas, so familiar to us today, were invented with the Impressionists. But it's important to draw a distinction between the original intention of the first Impressionist artists, and the effect that their art had. Unlike later generations of modernists, they didn't set out to attack the bourgeoisie. Nothing would have pleased them more than if their paintings had immediately appealed to the moneyed class of conventional picture buyers. It was only when their cleansing vision provoked such hostile reaction in those quarters that they became willy-nilly cast in the role of anti-bourgeois revolutionaries. Such is the common fate, we now know, of modernist art movements. But the Impressionists were the first to find it out.

An early American critic was in no doubt of the revolutionary agenda of the movement, describing the Impressionists – not without a note of awe – as 'communism incarnate, with the Red Flag and Phrygian cap of lawless violence boldly displayed'. He was wrong, in that individual Impressionists like Renoir, Monet or Degas were certainly not communists. But in a broader sense Impressionism as a style was a metaphor for change and flux. Its dissolution of form into colour and atmosphere was an alarming development for the conservative bourgeoisie. It could be interpreted as yet another assertion of the ambiguity and instability not only of the physical environment but also of social and political conditions.

The factor which ultimately facilitated the rise of Impressionism was a change in the way paintings were marketed. In an increasingly entrepreneurial age, it was perhaps inevitable that art and commerce would be drawn closer together. This produced a new phenomenon, the powerful dealer, who interpreted and marketed

the new art to the public, and simultaneously employed the artists
he was promoting by guaranteeing to buy their work. The impor-
tance of Paul Durand-Ruel to the Impressionists was incalculable, as
we shall see in later chapters. Indeed as a template for the future de-
velopment of the art market, the emergence of the entrepreneurial
dealer was an element of crucial significance. The active branding
of artists as commodities, paying stipends to them, nursing them
through various price-levels by a carefully judged series of com-
mercial gallery exhibitions, all are features of the sophisticated
contemporary art market of the twenty-first century. But all have

5 and 6 The young revolutionaries: Pierre-Auguste
Renoir and Claude Monet.

7 Anxiety therapy by dappled light. Monet,
Parc Monceau, 1878.

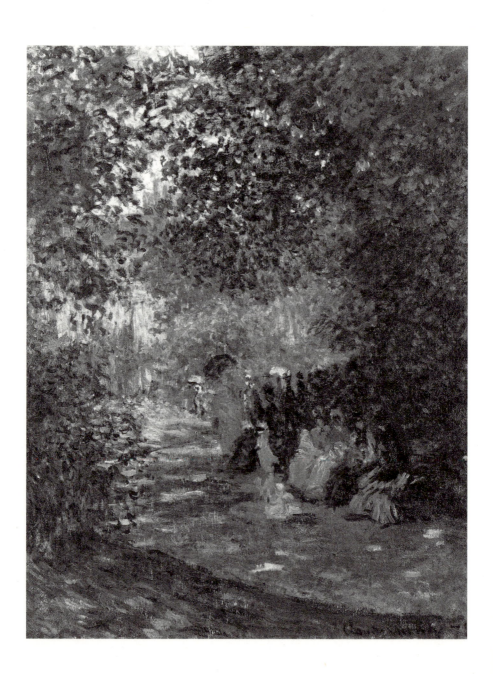

their origins in the way Impressionism was marketed by Paul Durand-Ruel in the last quarter of the nineteenth century. I certainly would not have had the sort of career I have enjoyed as an art dealer and auctioneer a hundred years later without Durand-Ruel.

The enduring appeal of Impressionist painting has proved to be its capacity to uplift the spirits of the spectator, its mood-enhancing effect. Doctors and dentists around the world decorate their waiting rooms with reproductions of sunlit Monets and Renoirs. It is anxiety-therapy by dappled light. Even amid the initial hostility, this anti-depressant quality was identified surprisingly early on. The critic Armand Silvestre wrote in 1873: 'What apparently should hasten the success of these newcomers is that their pictures are painted according to a singularly cheerful scale. A "blond" light floods them and everything in them is gaiety, clarity, spring festival...'. What the Impressionists chose to paint appears to the cynical eye of hindsight a deliberate exercise in customer manipulation, blatant exploitation of the feel-good factor. A list of what is characteristic Impressionist subject matter and what isn't would run as follows:

Impressionist	Anti-Impressionist
Conviviality	Anguish
Beaches	Battle scenes
Recreation, holidays	History, morality
Picnics, gardens	Death, disaster
Streets, restaurants, cafés	Anecdote
Race meetings	Emotional profundity
Theatres, concert halls	Intellectual complexity
Sea views	Shipwrecks
Undulating countryside	Precipitous landscape
Sunshine	Night scenes
Cornfields, sunlit snow scenes	Bad weather: storms, floods

Of course it would be an exaggeration to claim that the Impressionists never painted bad weather or its effects; but the reality of the present-day market is that subjects like floods are difficult to sell, precisely because they upset people's expectations of what Impressionist painting should be all about.

Another important factor in the rise of Impressionism was the railway. Railways were emblematic of modern life, and thus ideal subject matter for artists who strove to be contemporary. Monet, Manet and Pissarro all featured trains, stations and railway lines in their work. Indeed Monet's series of views of the Gare Saint-Lazare is one of the icons of Impressionism, the artist's technique finding its perfect expression in the rendering of the evanescence of the steam billowing up from the engines. The invention of the railway was important to landscape painters of this generation in another way, too: it opened up the countryside to city-based artists in search of accessible rural subject matter. A day-return to Argenteuil could produce five or six paintings (one of the advantages of their method was that Monet and his school worked quickly). Then there was the enormous wealth that the late nineteenth-century railway expansion produced, a significant element in France's economic boom of the early 1880s, which brought more money into the art market and in turn boosted demand for the Impressionists. Railway fortunes were even huger in the United States, and this new wealth also benefited the Impressionists: for instance Mary Cassatt's brother Alexander, president of the Pennsylvania Railroad Company, was an early collector. The age of mass travel had begun; and as coal yielded to oil as the fuel of preference, so yet more staggering wealth was created for oil producers. Hence, a hundred years on, my feeble attempts to sell this Monet in the shadow of the mosque.

'It **was as** if he had been struck with a subtle blindness that permitted images to give their colour to the eye but communicated noth-

ing to the brain', writes Edith Wharton describing a moment of crisis for Ralph Marvell in *The Custom of the Country*. Her imagery is taken from the theory of Impressionism. I tried it myself once: I let my gaze linger on one of Monet's series paintings of poplars on the River Epte, in an attempt to achieve Ralph Marvell's state of mind. I registered the pure visual sensation of the sinuous S-shape formed against the sky by the trees receding round the bends in the river, broken by the strong vertical lines of their trunks in the foreground. I congratulated myself. This was good, this was what Impressionism was all about: pure visual sensation, nature absorbed optically in a system of shapes of colour. Hadn't Monet wished he could have been born blind, then suddenly regain his sight, so that he could begin to paint without knowing what the objects were that he saw before him? In the same way that Ralph Waldo Emerson pursued the idea of the 'transparent eyeball' that would exclude all personal interpretation from the direct experience of nature, so Monet sought what he called 'the innocent eye'.

But here is the fallacy of Impressionism. Here are the seeds of its demise. There is no such thing as pure visual sensation. Because we have not been born blind, sensation and perception are inseparable. An artist cannot render objective truth. A painting reproducing nature will always be refracted through the personality of the artist, as Zola recognised: 'Art is a bit of creation seen through a powerful temperament', he wrote in 1867. Indeed that is what gives it its piquancy, what distinguishes it as a work of art. And as spectators, too, we know too much. We are interpretative beings. We will never be like Ralph Marvell seeing things simply as abstract patches of colour. The patches are inevitably significant, associative. So the S-shape means something. It is the foliage on a line of trees growing on the banks of a river curving into the distance. But because we know too much we can also interpret shapes in variant ways, not as the artist intended. As I stood in front of the painting, Monet's

poplars suddenly reformed themselves in front of my eyes as something quite different: the shimmering but unmistakable impression of a dollar sign.

By the end of the 1870s, artists in the Impressionist circle were beginning to recognise that it was time to move on. They had reached a kind of cul-de-sac. Just to register your impressions in front of nature, which the Impressionists were doing supremely well, had become limiting. Degas spoke of 'the tyranny of nature', declaring painters had made themselves 'the slaves of chance circumstances of nature and light'. Renoir wrote in 1880: 'While painting directly from nature, the artist reaches the point where he looks only for the effects of light, where he no longer composes, and he quickly descends to monotony'. The symbolist Odilon Redon took the argument a step further. 'Man is a thinking being', he wrote the same year. 'Man will always be there. Whatever the role played by light, it won't be able to turn him aside. On the contrary, the future belongs to a subjective world.' Art was more than simply registering your optical impressions in front of nature. Art meant the interpretation of the objective world by the subjective experience. In 1893, Pissarro too was admitting in a letter to his son: 'Everything (in nature) is beautiful, the whole secret lies in knowing how to interpret'. In Zola's equation, a balance between nature (the thing depicted) and temperament (the artistic prism through which it is depicted), the scales now tipped in favour of the latter. The way was open for van Gogh and Gauguin, and the generation of the Post-Impressionists, to brandish their temperaments to such extraordinary effect.

The lack of intellectual and emotional content in Impressionism has worried people ever since. Impressionist art is the art of surfaces: its subsequent historians are sometimes guilty of 'going very deeply into the surface of things', and in their anxiety investing paintings with an emotional profundity which simply isn't there.

8 A receding line of trees, or a dollar sign?
Monet, *Poplars on the River Epte*, 1891. (See pl. 3.)

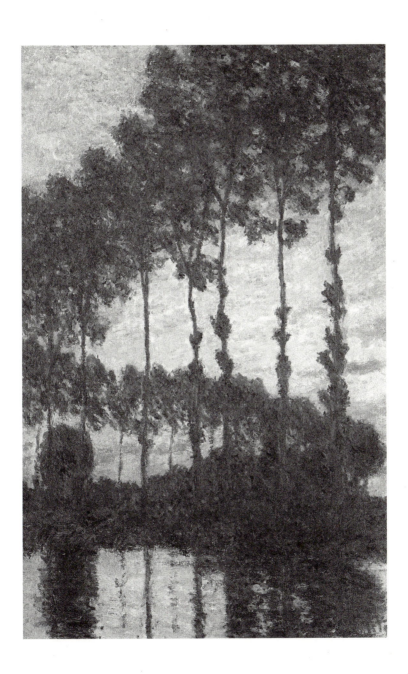

Here is a modern writer, Paul Hayes Tucker, struggling with Monet's winter scenes of the early 1880s:

> With its surface cluttered with huge slabs of ice from the once-frozen river, the views of the Seine in these paintings, indeed the scenes as a whole, are both sonorous and silent, energised and elegiac. The canvases appear to be filled with cries of pain and moments of wonderment, sighs of resignation and odes of hope. They suggest notions of the past cracking and splintering and concerns about whether the present was liberating or unnerving.

You can't help suspecting that the pain, wonderment, resignation and hope exist more meaningfully in the mind of Professor Tucker than that of Claude Monet.

A debate was instigated in a Parisian literary journal in 1890 as to whether naturalism was now dead. The writer Paul Alexis was so exercised by the question that he telegraphed to the editor: 'Naturalisme pas mort. Lettre suit'. But whatever the letter said, the tide had turned in both literature and art. The Impressionists were 'taking orders from outside', whereas Gauguin wanted to obey what came from within. 'Don't copy too much from nature'. he said to his disciple Schuffenecker. 'Art is an abstraction. Derive it from nature by indulging in dreams in the presence of nature, and think more of creation than of the result.' Van Gogh echoed him: 'Instead of trying to reproduce exactly what I have before my eyes, I use colour more arbitrarily so as to express myself forcibly'. This was the beginning of modern art and the unshackling of the artist from the obligation to reproduce natural appearances. But it couldn't have happened without the Impressionist revolution. The emancipation of light and colour achieved by the Impressionists destabilised people's expectations as to how a picture should look and opened the way to

9 'Cries of pain and moments of wonderment'.
Monet, *Winter on the Seine, Lavacourt*, 1880.

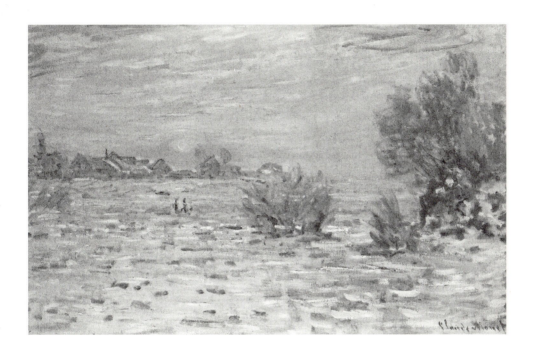

modernism. It was a catalyst to the development of Expressionism and non-representational art.

So the original Impressionist movement began to break up. Renoir's reawakened interest in the tradition of figure painting took him in a new direction. Seurat's Pointillism – an attempt to ground Impressionism in science by analysing what the eye saw into dots of pure colour on the canvas – for a while seduced Pissarro. Even Monet, throughout his long life the most faithful to the Impressionist vision, grew sick of not selling his pictures and went back briefly to exhibiting at the hated Salon, where the money was. Renoir followed him, declaring: 'There are in Paris scarcely 15 art lovers capable of liking a painting without Salon approval. There are 80,000 who won't buy an inch of canvas if the painting is not in the Salon'. Sisley worked on in penury. Cézanne decided that he wanted to make out of Impressionism something solid and durable, like the art of the museums, and began his investigations into form that became one of the main strands of modernism. As for Degas, he had never had much time for pure Impressionism anyway. His brilliant draughtsmanship inclined him to a preference for the human figure. 'Ah! Those who work from nature!' exclaimed Degas to Gide in 1909. 'What impudent humbugs! The landscapists! When I meet one of them in the countryside I want to fire away at him. Bang! Bang! There ought to be a police force for that purpose.'

Had there been such a police force, it would have had a field day patrolling the meadows round the Normandy village of Giverny. Here Monet set up residence in a farmhouse and worked on deep into the twentieth century painting the effects of light, in the surrounding countryside, in his garden, and on his lily pond. Today Giverny has become one of the holy shrines of Impressionism, visited by awe-struck pilgrims from all over the world. By the time Monet bought the house in 1893 his fortunes had already turned and he was making money. His popularity in America was growing rapidly. He

was free to continue his experiments, achieving in the last phase of his life canvases that pulsate with light and colour and in their freedom and spontaneity provide one of the stepping-stones to modernism. Kandinsky records what a revelation his first sight of one of Monet's haystacks (in an exhibition in Moscow in 1895) was in his own journey to pure abstraction. But that also is another story.

I wish I were a natural salesman. At heart I find selling people things embarrassing. It's too personal, this insinuating imposition of your own will upon another human being. You are trying to persuade them into something they don't necessarily want to do, to buy something they don't actually need. Exactly, says my friend Jasper, it's a bit like a seduction. Jasper is an art dealer with a brilliant eye, a persuasive tongue, and a very thick skin. As a result he is enviably successful at selling people pictures, and probably as a Casanova too.

What was I doing, I asked myself in the opulence of my Eastern client's private drawing room, trying to get this man to buy a Monet? I realised I was only doing it because he was very rich. Because the Impressionist picture has become the conventional accoutrement of the rich, the symbol of his status: the poplar that turned into the dollar. In fact this is a book about selling things. Initially, difficult things that buyers had to be persuaded they wanted; then, in the twentieth century, priceless things that the very rich had been persuaded they wanted very much indeed. Literally priceless, because they are of no definable intrinsic value. When did this change come about, I wondered? And why? And how was it that – despite my shortcomings as a salesman – my Eastern client ended up buying the Monet that at first so bemused him, for rather more than the $7 million it had been estimated to fetch at auction? The rest of this book is an attempt to provide answers to these questions.

THE CAT ON THE KEYBOARD

The French Reception of Impressionism

———

'The impression which the Impressionists achieve', declared Albert Wolff in *Le Figaro* in 1875, 'is that of a cat walking on the keyboard of a piano or of a monkey who might have got hold of a box of paints'. He spoke for the French public: when people first became aware of it from a series of independent exhibitions in Paris in the 1870s, Impressionism provoked widespread incomprehension, expressed on a scale varying from amusement to outrage. The painters themselves were castigated as variously lunatics, incompetents, or political anarchists. In March 1875, as a follow-up to their first group show the previous year, Monet, Sisley, Renoir and Berthe Morisot decided to hold an auction of their own pictures at auctioneers Drouot. The result was chaos: hecklers howled at each bid in an effort to obstruct sales. Police had to be called to restore order. Prices realised were dispiritingly low.

But nonetheless there were one or two people prepared to buy. The first collectors tended to be friends, or at least acquaintances, of

10 The revolution announces itself: the catalogue of the
First Impressionist Exhibition, 1874.

11 Might the excesses of Impressionism induce
premature childbirth? A contemporary cartoon,
Paris 1876.

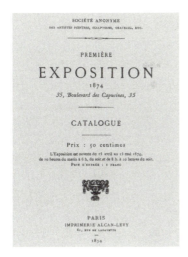

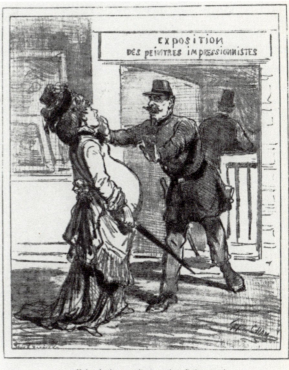

— Madame! cela ne serait pas prudent. Retirez-vous!

the young Impressionists. These were not collectors with particu-
larly well-lined pockets, nor the newly rich industrialists or finan-
ciers who came later. But they saw something in these new painters,
something refreshing and worth encouraging. There was also an ele-
ment of financial speculation, as there must be with the purchase
of any work of new art, although given the initial response it would
have taken a profound optimist to foresee the rise in prices that came
two decades later. The first buyers came from an intriguing range of
backgrounds: Théodore Duret was a connoisseur and critic; Ernest
Hoschedé ran a wholesale fabric firm; Georges de Bellio and Paul

12 Dr Gachet: pioneer Impressionist collector and
homeopathic doctor.

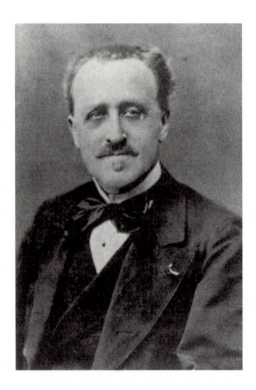

Gachet were both doctors with an interest in homeopathy; Eugène
Murer was a pastry-cook; Victor Chocquet was a civil servant on a
miserly salary; and Jean-Baptiste Faure, as a successful opera singer,
was the first to consummate the happy and long-lasting marriage
between Impressionism and show-business.

Albert Wolff was no more sympathetic to the exhibitors in his
review of the Second Impressionist show in 1876:

> At Durand-Ruel's gallery a new exhibition has opened of what are
> claimed to be paintings.... Five or six lunatics, one of whom is a
> woman – a group of miserable individuals gripped by crazy ambi-
> tion – have combined here to exhibit their work. Some people guffaw

13 Jean-Baptiste Faure: the first show-business collector
of Impressionism.

when they set eyes on these things; personally, I feel deep anguish.
These so-called artists call themselves 'intransigents' and 'impres-
sionists'; they take canvases, colours and brushes, lay on a few indis-
criminate tones and then risk all with them. What they do resembles
what the distraught inmates of La Ville-Evrard do, when they gath-
er pebbles on the roadside and fondly imagine they are diamonds.
It is shocking to witness human vanity pushed to such extremes of
madness.

Had the twenty-first-century tabloid press been around at the time,
there would have been derisive features juxtaposing images of an
Impressionist picture and the scribble of a child of five under the

headline 'Can *You* Tell Which is Which?' As it was, Parisian jour-
nals ran cartoons of pregnant ladies being barred from entry into
Impressionist exhibitions for fear that the shock of what they would
see might precipitate childbirth. These Impressionist shows of the
1870s provided the newspapers with their first opportunity to laugh
at modern art, a never-failing recourse for the popular press ever
since.

The woman identified by Wolff as one of the five or six lunatics
exhibiting with the Impressionists in 1876 was Berthe Morisot. Her
husband had to be restrained from challenging the critic to a duel.
Her well-heeled bourgeois background and instincts meant that she
was an unlikely revolutionary, but she noted ruefully the political
alignment that her painting forced her into when she wrote to an
aunt: 'If you read any Paris newspaper, among others, which is pop-
ular with the respectable public, you must know that I am one of a
group of artists who are holding a show of their own, and you must
also have seen how little favour this exhibition enjoys in the eyes of
the gentlemen of this press. On the other hand we have been praised
in the radical papers, but these you do not read'.

The political and social context in which Impressionism first
appeared is important to an understanding of how it was received.
France was recovering from the humiliating experience of invasion
and defeat in the war with Prussia, and the horrific episode of anar-
chy and bloodshed which followed in the Commune. Germans had
killed Frenchmen, then – even worse – Frenchmen had killed French-
men in large numbers. There was widespread political uncertainty.
Under the circumstances it was inevitable that conservative reac-
tion – craving lost stability – would be fiercely against any new di-
rection in art. But for a smaller group of proponents of change, re-
cent experience only increased their urge for something new, their
sense of what might now be possible. The fact that the few voices
of early support for the Impressionists were raised in the columns

of the radical press is no coincidence. There was an equation in the public mind of artistic revolution with political revolution. An early name given to the Impressionists was 'Intransigeants', which had a definite political resonance as it was what the anarchist wing of the Spanish federalist party were then calling themselves. Parallels were drawn between the separation of Academy and State sought by the Impressionists and the separation of Church and State sought by political radicals. Similarly the subject matter of the Impressionists, their preference for everyday life, was interpreted by some as a deliberately and dangerously democratic vision.

In fact the issue was not as clear cut, and it is of course a mistake to assume that every early supporter of Impressionism was a political revolutionary. In the view of Frédéric Chevalier, writing in 1877, the new art was not so much a manifestation of a left-wing point of view as an expression of 'the chaos of opposing forces that trouble our era'. He saw Impressionism as a 'disconcerting mixture of contradictory qualities and defects', citing 'the brutal handling of paint, the down-to-earth subjects, the appearance of spontaneity that they seek above all else, the deliberate incoherence, the bold colouring, the contempt for form, the childish naivety that they mix heedlessly with exquisite refinements'. Castagnary draws a further important distinction: 'Does it constitute a revolution?' he asks of Impressionism. 'No...it is a manner. And manners in art remain the property of the man who invented them.' He was right to emphasise this element of individualism which characterised the artists of Impressionism. A similar independence of spirit is necessary in the collector, too, of ground-breaking contemporary art. One advantage, as far as the Impressionists were concerned, of the troubled climate of the 1870s in France was that it encouraged such individualism not just in painters but in a few brave patrons as well.

The original Impressionist collectors also relished what one might call the personal pleasure of collecting. A cult of the private

art collector grew up in France in the nineteenth century. Edmond de Goncourt declared his wish that

> *my drawings, my prints, my curios, my books, the things that have been the happiness of my life not suffer the cold tomb of the museum and the stupid gaze of the indifferent passer-by: I ask that they all be dispersed under the auctioneer's hammer and the pleasure each one of them afforded me be given again to those who inherit my tastes.*

Apart from being a dream marketing testimonial for auctioneers (I wonder that Sotheby's and Christie's don't print it on the first page of every catalogue), this quote underlines how collecting art was simultaneously a refuge of private escapism and a declaration of independent sensibility. Unlike the plutocrats who came later, these first collectors were not making a statement about themselves to the world by buying Impressionist art. Any statement they were making about themselves was to themselves. These were the heirs of Cousin Pons, Balzac's art collector of limited means but limitless enthusiasm, who combined 'the legs of a deer, the leisure of a *flâneur*, and the patience of an Israelite'. Looking back from the vantage point of 1919 Jacques-Émile Blanche saluted the individualism of these early patrons of the new art, regretting the passing of 'that appealing figure, the modest picture collector, crushed by the stampede of irresponsible American millionaires or the new industrial aristocracy from Germany and Russia.'

Théodore Duret was one of the most influential early supporters of the Impressionists as both collector and critic. He was a passionate devotee of Japanese art, travelling extensively in the Far East: the novel style of Manet, Monet, Degas, Renoir and Pissarro exerted the same appeal to his visual imagination as did the colouring and composition of Japanese prints. He had one of those aesthetic intelligences that is stimulated by innovation and daring. In 1873 he

wrote to Pissarro that he was 'looking more than ever for the impossible in painting'. On the track of the then almost unknown Cézanne, he wrote to Zola: 'I seem to remember that you talked to me about a totally eccentric artist from Aix...would you please give me his address and a word of introduction?' A pleasure in the eccentric and a desire for the impossible in painting is what motivates any number of collectors of contemporary art today. But in Duret's time it was exceptional, a taste that had barely existed before. The fact that it surfaced now in Duret and a few others was of crucial importance for the progress of the new art. He recognised the role he was playing, reassuring Pissarro in 1874: 'People who are good judges of painting and who face the mockery and scorn are few and rarely ever millionaires. Which doesn't mean that we must lose heart. Everything, even fame and fortune, will come in the end; and in the meantime the opinion of connoisseurs and friends compensates you for the oversight of fools'.

Another early collector who made up for his lack of funds with a passionate enthusiasm for the new art was Victor Chocquet. His days were spent following the dull rhythms of office routine as a civil servant in the French Customs. The economic details of his life are intriguing: his annual income in the 1870s never exceeded 6,000 francs, of which 960 francs went on the rent of his modest four-room residence in the Rue de Rivoli. And yet he succeeded in assembling a magnificent group of Impressionist works bought early on direct from the artists themselves, often for prices of less than 300 francs. Given his modest earnings, however, these sums still represented considerable outlays. Today, for instance, I have noticed that there is a limit to what people are prepared to spend on an individual work of art as a proportion of their wealth. Although this figure has never been explicitly formulated, it is unusual in my experience for someone to pay more than one per cent of their net worth for a painting. Thus someone buying something for $100,000 is likely

to have at least $10,000,000. And if they pay $10,000,000, then their personal assets probably exceed $1 billion. You have to be a very passionate collector to exceed these parameters, and that Chocquet indisputably was.

Renoir painted Chocquet's portrait around 1875. Impressionist portraiture is a contradiction in terms: the speed of execution implicit in seizing the visual moment is at odds with the slower process of achieving psychological insight. But Renoir's portrait is a masterpiece, partly because of the palpable sympathy that existed between artist and sitter. Chocquet has a high, intelligent forehead, and a gentle, sensitive mouth. Only the eyes betray a certain fanaticism. Georges Rivière gives a vivid account of the missionary fervour which gripped Chocquet at the 1877 Impressionist show:

> He challenged the mockers, made them ashamed of their jokes, lashed them with ironical remarks; in animated, daily repeated discussions, his adversaries never had the last word. Scarcely had he left one group than he would be discovered somewhere else, dragging a recalcitrant art lover almost by force before the canvases of Renoir, Monet or Cézanne and trying to make the other share his admiration for these disgraced painters. He found eloquent phrases and ingenious arguments to convince his listeners. With clarity he explained the reasons for his partiality. Persuasive, vehement, domineering in turn, he devoted himself tirelessly, without losing the urbanity which made him the most charming and formidable of opponents.

It is intriguing to speculate what Chocquet actually said to the mockers and doubters. Presumably that the new art was a fresh wind to blow away the moribund academicism of the Salon, that it was sincere in its truth to visual perception, that its apparent incoherence was evidence of its spontaneity; that the only legitimate subject matter of contemporary art in this last quarter of the nineteenth century

14 Limited means but unlimited enthusiasm: Renoir's
portrait of Victor Chocquet, c. 1875.

was contemporary life. When Chocquet finally came into money,
through his wife's inheritance in the 1880s, some of his enthusiasm
for buying modern art diminished. It seems that he was one of those
rare collectors largely driven by the excitement of being a pioneer, an
excitement intensified by the paucity of the resource at his disposal.
But despite Chocquet's best efforts, general acceptance of Impres-
sionism was still some years away.

The chief interpreter and promoter of the new art was, significant-
ly, a dealer. The story of the changing response to Impressionism in
France is very much the story of the entrepreneur who marketed it,
Paul Durand-Ruel, 'a small beardless man', as described by Zola, 'cold

15 The first champion of the avant-garde:
Paul Durand-Ruel, c. 1910.

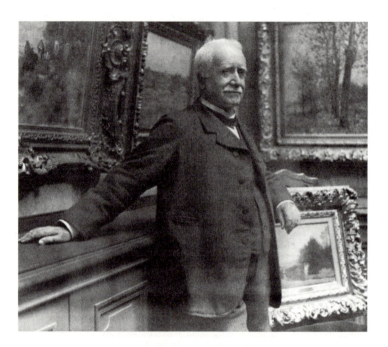

in temperament and sustained by clerics'. His portraits show a faint-
ly military-looking figure, with none of the flamboyance sometimes
associated with princes of the art market. Durand-Ruel is a paradox,
the perfect refutation of the belief that those who promoted the new
painting were a bunch of communists. This spearhead of innova-
tion and change in art was himself an ardent Catholic and die-hard
conservative, whose dearest wish was the restoration of the French
monarchy.

A study of the politics of those who deal in art today suggests
that most are to the right of centre, because dealing is a commer-
cial activity and profits tend to be better protected by right-of-cen-
tre governments. Even those who are at the cutting edge of contem-
porary art do not tend to be rabidly left wing. You don't see Larry
Gagosian or Jay Jopling (son of a Conservative peer) on the platform

of Socialist Worker meetings. But that's partly a reflection of the way the avant-garde has become the new orthodoxy. Art is now expected to be new and daring; in that respect there is no longer anything revolutionary about it. For Durand-Ruel, however, it was different. He was the first contemporary art dealer in the modern sense, and he was fighting a seemingly unwinnable battle against entrenched attitudes about what a painting should look like. He was the purveyor of something shocking. Perhaps Renoir was right when he said: 'We needed a dyed-in-the-wool reactionary to defend our work, which the *Salonards* were calling revolutionary. At least Durand-Ruel was someone they wouldn't shoot as a Communard'.

'Often, the night before I had to conduct an uncertain piece of business I would go into some church along the way to ask God for His help, and help He always did', recounted Durand-Ruel. Today Catholics are probably in a minority as art dealers. One pleasing example was Billy Keating, who bought Impressionist paintings for the Australian collector Alan Bond in the 1980s and later became a colourful and engaging convert to Rome. Legend has it that he once dropped in to the church of the Holy Redeemer in London's Chelsea to pray for the recovery of the art market, and when he came out found his Porsche had been stolen. There were plenty of dark days in the 1870s and 1880s when Durand-Ruel probably uttered similar prayers. But at least he didn't own a Porsche.

The phenomenon of Durand-Ruel is a product of the collision of art and commerce in an increasingly entrepreneurial age. As early as 1836, the French critic Alphonse Barbier was writing presciently:

> Here it is, art become bourgeois, and what is worse, commercial…it caters for the small investor, if pressed it can provide you with works at a fixed price, in good, saleable quality, and I am amazed that its products have not yet been quoted on the commodity market along with sugar and coffee.

By 1881 business moguls like Monsieur Walter in Maupassant's *Bel-Ami* are buying pictures. He confides to the hero the secrets of his art-investment strategy:

> '*I have other pictures in the adjoining rooms, but they are by less known and less distinguished artists.... At present I am buying the works of young men, quite young men, and I shall hold them up in the private rooms until the artists have become famous.*' Then he said in a low voice: '*Now's the time to buy pictures. The artists are starving, they haven't a sou, not a sou*'.

As with sugar or coffee, you aimed to buy low and sell high. Art investment had arrived. And new, young artists – perhaps even the outlandish Impressionists – offered the best potential for gain.

In the middle of the nineteenth century the role of the art dealer increased in importance, as the middleman between the artist and his newly expanded bourgeois clientele. Flaubert's roguish dealer Arnoux in *A Sentimental Education* is an extreme case: 'With his passion for pandering to the public, he led able artists astray, corrupted the strong, exhausted the weak, and bestowed fame on the second-rate'. But on the other hand there were also dealers like Durand-Ruel who were prepared to nail their colours to the mast of the avant-garde. His achievement was to see the potential of Impressionism and, dynamic and innovative salesman that he was, to stick diligently to the challenge of promoting it.

Paul Durand-Ruel was born in 1831, which made him a little older than the Impressionists. His father before him had been in the art trade, as a dealer in paintings and a supplier of artists' materials. This was important because it meant that the young Durand-Ruel's early experience of the business brought him into direct contact with artists. He was drawn to contemporary art, to the process of painters painting pictures. He dealt in the Barbizon School, and continued to

do so throughout his career, those sales sometimes even subsidising his interest in and support for the Impressionists. In 1870 Durand-Ruel took refuge from the Franco-Prussian War in London, where he set up a gallery at 168 New Bond Street. Ironically, it was in London that he met Monet and Pissarro who were fellow refugees, and for the first time bought work directly from them. Back in Paris after the war, Durand-Ruel was introduced by Monet and Pissarro to Renoir, Sisley and Degas, from whom he also bought. And in January 1872, he had one of those experiences which make one realise that, besides being a man of commercial acumen, he responded passionately to art and was capable of being strongly moved by it. He saw two works by Manet in the studio of another artist, Alfred Stevens. He bought them immediately, and the next day went to Manet's studio where he bought everything he found: 23 canvases for 35,000 francs. From then on, Durand-Ruel's career was linked closely to the progress of the Impressionists. He made mass acquisitions of their work, and when times were particularly difficult helped them out with monthly stipends. Like Monsieur Walter, he bought the pictures of the younger men and held them in anticipation of the artists becoming famous. But unlike Monsieur Walter, he himself was the agency for their acquiring fame and ultimate wealth. It was a slow and sometimes disheartening process, which didn't start paying dividends till the later 1880s.

Durand-Ruel's particular significance is that he was the first to grapple successfully with the challenge of marketing 'difficult' contemporary art. He realised that such paintings needed their expert interpreters in order to be understood and bought. He changed the conventional approach by shifting the attention of the public away from specific canvases and on to artists and the span of their work. He pioneered one-man shows – for Monet, Renoir, Pissarro and Sisley – in a strategy which has been described as 'the promotion of temperaments'. At the same time he published magazines and catalogues to

extol and explain what he was selling. The critic was important here, too. What people read in their journals and newspapers about the new art helped them to accept it. Monet acknowledged this: 'I myself think very little of the opinion of journals', he wrote to Durand-Ruel in 1881, 'but one must recognise that, in our period, one can do nothing without the press'. In fact in the 1880s Monet subscribed to two separate press-cutting services.

In art dealing, Durand-Ruel claimed, it was the art not the dealing that mattered. He invented the self-serving image of the dealer as idealistic pioneer, altruistic hero, almost as artist himself in the discovery, appreciation and promotion of new talent. Perhaps it's no coincidence that in the 1880s on the other side of the Channel Oscar Wilde was writing 'The Critic as Artist'. Durand-Ruel affected a distaste for business. He wrote in 1869: 'A genuine dealer must be at once an enlightened amateur, ready to sacrifice if necessary his apparent immediate interests to his artistic convictions, as well as capable of fighting against speculators rather than involving himself in their schemes'. Even in 1896, when Impressionism was selling well, he was still maintaining, 'I am rather particular as to what I buy, and if I were less rigorous in my choice, I would certainly have a much larger clientele than is the case at present'. Up to a point. The truth is that throughout his life Durand-Ruel remained a canny operator with an acute eye for a financial opportunity. A year later his son Joseph offered a more ruthless insight when he boasted in a letter to the American collector Harry Havemeyer: 'In some cases we may avail ourselves of a quick opportunity to buy a thing at a great deal less than the price named by the owner, taking the moment when he is depressed by some circumstances or...in immediate need of money'.

No one blames a dealer for making an honest profit. But Durand-Ruel rather cleverly muddied the waters by deploying his high-mindedness as a marketing tool. It's a tactic much used in the

trade since, and still current today: 'I'd rather sell this picture to you, who understands it, than to a speculator who doesn't. If I make less profit, then so be it'. Or, if you're really clever: 'I've shown you all my normal stock. But upstairs I have a couple of really special things, which I only show to really special clients, those who will truly appreciate them'. These are pretty irresistible selling lines, flattering to the buyer's self-esteem while at the same time ratcheting up the pressure on him to buy. Durand-Ruel's greatest achievement is that he established the template of the modern art dealer who educates his clientele, the high priest who interprets the mysteries of contemporary art for them. It is not Durand-Ruel's fault if this template has occasionally been abused to dress up banality as genius in the generations since.

The innovations of Durand-Ruel are part of a fascinating process that unfolds from 1850 to the present day: first the Salon, or official Academy, yields to the dealer as the most effective purveyor of art to the buying public. This is followed by the heyday of the dealer. And then in the final quarter of the twentieth century the dealer finds his own role increasingly usurped by the international auction house. The enduring importance of French Impressionism to these changes, and exactly how and why they occurred, will be examined in later chapters.

Between 1871 and 1885 French commerce was distorted by a sequence of the sort of boom and bust cycles that would bring tears to the eyes of a modern economist. First there was the desolation of the Franco-Prussian War; then, for two or three years after hostilities there was a recovery, and people made money. A slump followed in 1874, the year of the first Impressionist exhibition. Unwisely the Impressionists chose to offer their work at auction the following year, with the disastrous results described earlier. By 1880 things looked better again: there was an economic upturn led by a boom in railway building. But in 1882 there was another crash, the dire after-effects

of which persuaded Durand-Ruel – in debt for more than a million francs – to seek new markets for the Impressionists across the Atlantic. The sort of people in France who had been early buyers of Impressionist paintings, not being rich enough to ride out this market volatility, found they had to sell again. As a result prices were depressed. What you want to avoid, as owners of Impressionist paintings have been discovering ever since, is finding yourself obliged to sell when there's a market downturn. People who had to sell in the early 1990s, after the Japanese slump, got a poor return relative to what they would have received had they been able to hang on for five or ten years. But such times are good for buyers if they still have the resources – and courage – to bid. The sale of the Faure collection in 1878 was a case in point. The economy was still grim, and Impressionism appealed only to a very small circle. Chocquet was able to pick up two Monets for 153 francs. The beady-eyed Berthe Morisot was encouraging her sister to snap up investment opportunities in the Manet estate sale of 1884 because 'everything would sell at extremely high prices if we weren't in the middle of a depression'.

Even if prices were held down by economic conditions, it's interesting to observe a gradual shift in critical attitudes to the Impressionists. In 1879 Paul de Charry, writing in *Le Pays*, conceded of Degas that 'at first sight his work is disagreeable to the eye, but one grows accustomed to it'. The shock of the novelty of the Impressionists – the bright colours, the unusual vantage points, the rough execution – was apparently wearing off. By 1882 even Albert Wolff, writing of the 6th Impressionist show, was grudgingly admitting: 'Among Monet's forty paintings there are two or three pretty things'.

In the mid-1880s the commercial tide, too, began to turn for the Impressionists. The rise in their prices was led by Monet, whose growing success with Americans made him increasingly desirable to French collectors as well. 'Hold on to your Monets', wrote Mary

16 The Impressionist painting as luxury object:
the galleries of Georges Petit.

Cassatt to her brother. 'I am only sorry I did not urge you to buy more.' Other dealers handling Impressionist painting sprang up in Paris to challenge Durand-Ruel, the most significant of whom was Georges Petit. A watershed moment came in 1887 when the Boussod Valadon gallery gave up their contract with the arch-academician William Adolphe Bouguereau whose work they had handled since 1866, and, under the direction of Theo van Gogh, started trading in Monet and the other Impressionists. The following decade saw the establishment of dealers like Bernheim-Jeune and Vollard, with lasting significance for the progress of twentieth-century modernism.

By now Durand-Ruel had become such an institution that his gallery was included in the Baedeker guidebook to Paris. But at the same time there was a perception that he was losing ground to his

rival Georges Petit. Petit's premises were extremely grand, and he presented his pictures in highly elegant surroundings. He did particularly good business when the Americans arrived each year in May. Monet appreciated the glamorous element in the salesmanship of Petit and wrote to Durand-Ruel to suggest an alliance with him: 'One can't deny that the public is captivated and that they dare not make the smallest criticism because these paintings are mounted advantageously, because of the luxury of the room, which together is very beautiful and imposing on the crowd'. What we are witnessing here is the gradual reinvention of Impressionist paintings as luxury commodities.

Not that Durand-Ruel didn't live well himself on the proceeds of his gathering success. Goncourt reported on his home life in June 1892 as follows:

> A huge flat in the Rue de Rome, full of pictures by Renoir, Manet, Degas etc., with a bedroom with a crucifix at the head of the bed, and a dining room where a table is laid for eighteen people and where each guest has before him a Pandean pipe of six glasses. Geffroy tells me that the table of Impressionist art is laid like that every day.

This raises the interesting question of the relationship between a dealer and the people he is trying to sell pictures to. Is there a moment when a successful dealer's lavish lifestyle starts to undermine his rich clients' confidence in him? On balance, I don't think there is, because buyers of art tend to be aspirational and find such evidence of high achievement appealing, even reassuring. But there is certainly a point at which a dealer's ostentatious display of wealth undermines the confidence felt in him by the artists he represents, especially if they don't think their own sales are going very well. In November 1894 Pissarro – who never sold as successfully as Monet – met the American collector Quincy Adams Shaw, and they worked

each other up into a state of high moral indignation. Pissarro record-
ed approvingly of Shaw: 'He hates all dealers, especially Durand, and
complains, not without reason, that the dealers have assumed the
task of governing tastes and of showing only those paintings they
think are saleable'. Another question: is extreme physical ugliness
in a dealer a drawback, when he is purveying items of rarity and
beauty? It didn't seem to compromise the success with his clients
of Georges Petit, described by René Gimpel as having the face of 'a
rutting, obese, hydrocephalic tom'. An Italian collector to whom I
was once offering a picture told me apologetically he could not de-
cide whether to buy it until he had met my wife. I suppose there was
a certain logic in his position: an art dealer may have no control over
his own looks, but those of his wife are a sound indication of his feel-
ing for beauty. No doubt Madame Georges Petit was loveliness per-
sonified.

The appreciation of Impressionist painting was generally led
by dealers and private collectors, not by museums. The paucity of
major French Impressionist paintings in Spanish and Italian muse-
ums today bears witness to the lack of early collectors in those coun-
tries. Italians who bought contemporary art were generally focused
on their own revolutionary realist painters, the Macchiaioli and the
Divisionists, who operated independently of Paris. In the same way
the Spanish were more interested in what was going on in Madrid
and Barcelona than in Paris. The exception was Germany, where – as
we shall see – an unusually enlightened group of directors of public
collections who bought French modernism emerged either side of
1900. In France (and Britain) such enlightenment was lacking, and
a major confrontation between the French museum authorities and
the Impressionists took place in 1894, precipitated by the death of
Gustave Caillebotte. Caillebotte, a distinguished painter himself,
had inherited considerable private means which had enabled him to
put together a very fine collection of his Impressionist colleagues'

works. This he bequeathed to the French nation. The forces of reaction marshalled themselves for one final explosion of conservative outrage, led as we have already seen by Gérôme: 'I do not know these gentlemen', he declared stoutly, 'and of this bequest I know only the title…. Does it not contain paintings by M. Monet, by M. Pissarro and others? For the government to accept such filth, there would have to be great moral slackening'. A correspondent in *L'Artiste* of April 1894 described the Caillebotte donation as 'a heap of excrement whose exhibition in a national museum publicly dishonours French art'.

Caillebotte's will insisted that his collection should enter the Luxembourg Museum in its entirety. Over our dead bodies, said Gérôme and his friends. The authorities wrung their hands. Renoir, as executor of the will, was in a difficult position. In the end a compromise was hammered out whereby only about half of the pictures were accepted for display. Pissarro said it would serve France right if Caillebotte had put in his will that his bequest should go to another country unless accepted as prescribed. But meanwhile the Impressionist bandwagon gathered commercial momentum. Durand-Ruel reported to Havemeyer in December 1899: 'There is actually in Paris a kind of fever which has taken possession of all the amateurs and dealers in objects of art and consequently a high increase has taken place on the paintings and especially those of the new school'. A new generation of collectors of Impressionist art had emerged in France: Count Isaac de Camondo, the banker; Paul Gallimard, the publisher; Auguste Pellerin the industrialist. These were men whose pockets were considerably deeper than the original patrons. They had to be, in order to compete with American money.

From the beginning of the twentieth century, Impressionism was no longer at the cutting edge. The avant-garde had moved on elsewhere. This plateau of acceptance was achieved at different times in different countries: by the 1890s in France and America; by 1910 in

17 The scourge of Impressionism: Jean-Léon Gérôme.
18 The sort of late Monet that reminded Picasso of a
brothel: *Water-lilies*, 1908.

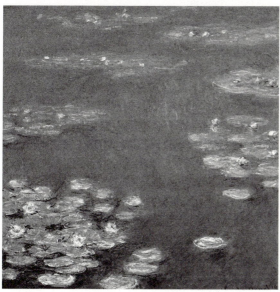

Germany and Switzerland; and by 1920 in Britain. From the vantage point of the new avant-garde, Impressionism started looking tame and unexciting. Picasso, for instance, was dismissive of Monet's late large-scale water-lilies series, the seemingly unending sequence of effects of light on the pond in his garden. He claimed they put him in mind of a contraption he had once seen in a brothel. An old woman was employed to wind a band of landscape on a roll past the window of the mocked-up interior of a wagon-lit, so as to create the illusion of travelling at speed for the copulating punter within. (There was apparently a demand for this sort of simulated railway experience.) In John Richardson's words, 'the thought that Nabism, Fauvism, Cubism, Futurism, Expressionism and Dada came and went against this constantly unfurling yet never changing backdrop of water-lilies struck Picasso as distinctly droll'.

The objections of those who originally opposed Impressionism were threefold: the colours used were strident and garish; there was a lack of finish; and the subject matter was banal. In time, these three negatives were turned to positives: the garish colour started looking rich and exciting; the lack of finish was increasingly perceived as an exhilarating freedom of brush stroke; and the banality of subject matter took on the reassurance of the everyday, a confirmation of the universality of bourgeois experience. And further down the line, as Impressionist pictures became records of a time and society now lost, they grew even more desirable, visual documents of a golden age.

By the end of World War I, Impressionist painting had become absorbed into the taste of the rich amateur in Paris. A photograph taken around 1918 of the study of the banker–collector Jules Strauss shows Monets, Manets and Renoirs, in elegant eighteenth-century frames, hanging on the wall beneath a seventeenth-century tapestry, while the room is furnished with fine Regency chairs. Prices for Impres-

19 The marriage of Impressionism to eighteenth-century taste: the apartment of Jules Strauss, Paris, c. 1918.

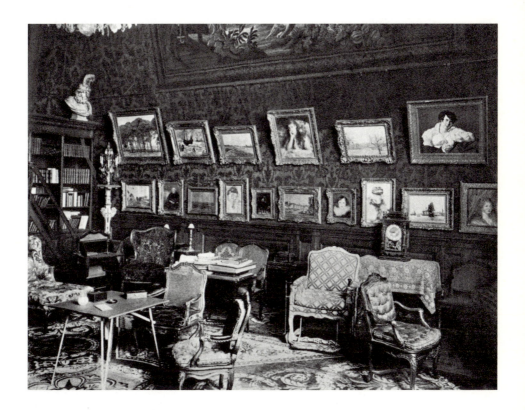

sionist art moved upwards steadily if unspectacularly in the years between the wars, punctuated in France as in the rest of the world by the Wall Street Crash and the Depression that followed. Paradoxically, demand for Impressionist paintings in Paris reached a peak during the years of the German occupation in World War II. A combination of factors meant that 1942 was the most successful year ever for auctions at the Hotel Drouot. Wars are often good for the art market, and the Parisian bourgeoisie, seeking a home for its spare cash and with diminished confidence in conventional financial institutions, turned to works of art, which are in the last resort portable assets. At the same time high-ranking Nazis (from Goering downwards) were

20 The dentist collector: Georges Viau (seated).

frequent visitors to Paris in search of art treasures, and their eager participation in sales forced prices ever higher. Impressionist paintings were particularly sought after, even by the Germans. A case in point was the sale at Drouot on 11–14 December 1942 of the Impressionist collection formed by the late dentist Georges Viau. It realised nearly 47 million francs for 120 lots, the highest total ever recorded at Drouot for a single session sale. A Cézanne landscape fetched 5 million, and a Degas, *Femme s'essuyant après le bain*, 2.2 million francs.

'The Parisian market needs neither Hebrews nor Yankees to have sensational prices reached', was the cynical verdict of *Le Nouveau Journal*. The same newspaper also commented on the sort of people attending the sale: the room was very 'vieille France', filled with 'monocles and white moustaches à la gauloise' and jackets adorned with the red rosette of the *légion d'honneur*. It was another measure

of how far Impressionism had become woven into the fabric of the French establishment. But prices would not have been so high had it not been for competitive bidding from occupying Germans, too.

The ambivalent attitude of the Nazis to French Impressionist painting is examined in more detail in Chapter Four. Although it was never declared degenerate, more extreme elements in the Third Reich tried to remove examples of Impressionism from German public collections in the later 1930s. Some Nazis, on the other hand, rather liked it and bought it surreptitiously when it became available in Paris during the Occupation. Whatever the Nazis felt about modern French painting, they recognised and exploited its international value as a trading currency. French Jews with good Impressionist collections thus soon found them summarily confiscated by the occupying German forces. Sometimes these works were then traded with dealers in Switzerland for Old Masters or the sort of German pictures that were more acceptable to the Nazis; as a consequence some Swiss collectors who weren't too particular about issues of provenance were able significantly to enhance their Impressionist holdings, and a number of major French Impressionist pictures were lost to France for ever.

Bizarrely, the exchange in French Impressionists was not all one way during the Occupation. In an effort to promote Franco-German cultural understanding, the museums of Berlin and Bremen even lent works by Monet (those which remained unpurged from their collections) for exhibition in a Rodin–Monet show held in the Orangerie in Paris in 1943. It was as if the German authorities recognised what Impressionism could do for public morale – the tranquillising effect of dappled light on an occupied nation. The cat that walked on the keyboard had mastered a seductive melody.

A NEW ART FOR A NEW WORLD

America and Impressionism

———

To understand the American response to Impressionist painting, you first have to understand the prevailing American attitude to France in the 50 years or so leading up to World War I. Americans were besotted with the place. They loved it with an undiscriminating passion, with all the sentimental ardour of an innocent young man in thrall to an experienced, stylish, and thrillingly amoral older woman. 'How much more amusing is France than any country of the earth whatsoever', exclaimed Henry James, 'and how dreary would that human family be if it were not for that distinguished – the only distinguished – member'. James, the outstanding contemporary chronicler of this American gallomania, was in no doubt about his judgement. For him, and for many of his characters, France was simply 'the most brilliant nation in the world'.

'I've come because – well, because we do come', says Sarah Pocock in *The Ambassadors* (1903) when asked why she is visiting Paris. It was an accepted fact of American life that once your family

had amassed enough money to make the trip in comfort, you set off to spend time in Europe, and particularly in France. The American discovery of Paris began in earnest after the Civil War. Restored stability in the United States generated an extraordinary release of entrepreneurial energy, which in turn created a degree of wealth unequalled anywhere else in the world. The last part of the nineteenth century was a time of momentous commercial expansion. Huge fortunes were made, in coal, in steel, in railroads, in construction. In the twenty years from 1880 to 1900, the population increased by 50 per cent, from 50 million to 75 million. And many Americans, newly empowered with money, came to France to further their education, and to leave behind them the naïve provincialism of their homeland. They knew they were provincial, because Henry James told them so. Here he is in 1870:

> We are condemned to be superficial. The soil of American perception is a poor little barren, artificial deposit. We are wedded to imperfection. An American, to excel, has just ten times as much to learn as a European. We lack the deeper sense. We have neither taste, nor tact, nor force. Our crude and garish climate, our silent past, our deafening present, the constant pressure about us of unlovely circumstance, are as void of all that nourishes and prompts and inspires the artist, as my sad voice is void of bitterness in saying so.

To France, therefore, to rectify the situation. A sizeable American colony was established in Paris, swollen further in the summer months. This process of 'Columbus in reverse' is symptomatic of a larger change in the way Americans viewed themselves. In 1890 the last armed conflict between Native American Indians and settlers took place at Wounded Knee Creek. The same year the Census Bureau announced that there was no longer a land frontier. 'Whether they will or no', declared Captain A. T. Mahan in Atlantic Monthly,

'Americans must now begin to look outward'. As a consequence of the pioneering dream being laid to rest in their own country, Americans looked back to Europe as their new frontier, as their new source of romance. And particularly they looked to France to find the 'deeper sense' that Henry James told them they were lacking.

They liked what they found. One strand of the appeal was that on the alternative map of Europe, the one that charted the continent's imagination, Paris was the indisputable capital of Bohemia. 'Bohemia only exists and can only exist in Paris', declared Henri Murger in 1851. It was where artists lived in garrets, struggled, starved, took mistresses, wrote poetry, painted pictures, composed music. Americans could play at doing this as well, and a significant number of art students took studios in the French capital until either their money or their talent ran out (more often the latter). France was also the place where people knew how to live with style. Miranda Hope in James's *A Bundle of Letters* (1878) finds Paris 'truly elegant' and 'very superior' to New York. (Intriguingly the admiration wasn't all one way. Degas repaid the compliment when he visited New York in 1872. He described it as 'immense city, immense activity. In physiognomy and general aspect much closer to us than the English'.)

The British were not immune to the guilty attractions of Paris, but they treated the city warily, as a dangerous latter-day Babylon to be visited on trips of clandestine self-indulgence. The Americans on the other hand embraced it uncritically and wholeheartedly, as the closest thing to Elysium they were likely to find on earth. 'The American goes to Paris as though returning to his inheritance and to his own people', wrote R. H. Davis in 1895. 'He approaches it with the friendly confidence of a child.' Oscar Wilde summed it all up in the classic exchange from *A Woman of No Importance* (1893):

> MRS ALLONBY: *They say, Lady Hunstanton, that when good Americans die they go to Paris.*

LADY HUNSTANTON: Indeed? And when bad Americans die,
where do they go to?
LORD ILLINGWORTH: Oh, they go to America.

What bound many Americans to France was the brotherhood of two late eighteenth-century revolutions: Davis describes how every year 'the American Colony (in Paris) arises in its strength, remembers Lafayette and decorates his grave'. But the *Ancien Régime* also exerted its fascination on the American imagination. The style of 'Louis Cans' or 'Louis Sez' took an early grip on rich Park Avenue taste.

Meanwhile, visiting Americans continued to be rendered weak at the knees by Paris. 'Paris is a wonder to behold', wrote Robert Cassatt to his son Alexander in 1878, describing it as 'the gayest city in the world'. 'Ah, dear old Paris! Wonderful bewildering Paris! Alluring, enchanting Paris!' rhapsodised W. C. Morrow in 1899. The city takes on a magical, transfixing quality. 'In the light of Paris one sees what things resemble', declares Miss Barrace in *The Ambassadors*. 'That's what the light of Paris always seems to show. It's the fault of the light of Paris – dear old light!' Or here is Undine Spragg in Edith Wharton's *The Custom of the Country* (1913):

> As she looked out at the thronged street, on which the summer light lay like a blush of pleasure, she felt herself naturally akin to all the bright and careless freedom of the scene.... Her senses luxuriated in all its material details...all the surface sparkle and variety of the inexhaustible streets of Paris.

When American novelists either side of 1900 set scenes in the French capital, they found it hard to deviate from an established vocabulary of praise. It wasn't just James and Wharton, but lesser writers like Dorothy Canfield Fisher and Booth Tarkington who sprayed the city with adjectives such as 'warm', 'rich', 'brilliant', 'garnished and

spangled', 'fragrant', 'dazzling', 'enchanting', 'sparkling' and 'glittering'. There was also an implicit belief among Americans that the French knew how to order things better, how to live life not just with more style, but with a profounder understanding of intellectual and spiritual matters. 'I really believe that a rational life is only to be lived on this side of the water', Mary Cassatt wrote home from Paris in 1892, reinforcing the American inferiority complex earlier articulated by Henry James. Spiritual life at home in the United States was constantly belittled as 'meagre and starved', in comparison with the 'abundance and elegance' of France. The American obsession with business and making money, the country's vulgar cult of success, was contrasted with French connoisseurship of pleasure and philosophical acceptance of failure. Even today that difference in mentality remains: to call someone a loser in the United States is to damn them beyond redemption; in Europe sympathy with the underdog and a taste for self-deprecation breeds a more tolerant attitude to defeat.

So materialist, Puritanic America paid wide-eyed homage to the elegant hedonism of France. This led to some extraordinarily naïve judgements about French morals. 'What would be vice among us', declared the American commentator W. C. Brownell in 1895, 'remains in France social irregularity induced by sentiment'. There was a lot of social irregularity induced by sentiment in Paris. Americans on sabbatical in France watched it, fascinated. If they did not themselves join in, it was because they were not qualified to do so: vice was still vice in the United States. It was left to the Hemingways and Henry Millers of the Lost Generation to redress the balance in the years between the wars.

It is clear that late nineteenth- century Americans were predisposed to France in a way that the British, for instance, were not. This admiration extended also to French art. It meant that something new

21 An American in Paris: the young Mary Cassatt.

and shocking like Impressionism was received more open-mindedly than by Europeans who were (a) more prejudiced against France and (b) more prejudiced against innovation. But it didn't mean that no sooner had Impressionism appeared on the scene than every Francophile American in Paris was queuing up to buy it. Initially it was appreciated by a small elite, an elite amongst whom the American artist Mary Cassatt was an extraordinarily influential figure.

Mary Cassatt arrived in Paris in 1865, a young but determined art student who was emphatically not one of those Americans with a single season's passport to Bohemia. She was serious; in it for the long run. She was immediately attracted to the new developments

in French painting, the way of seeing pioneered by Manet and enthusiastically taken up by Monet, Renoir and the others. She was closest to Degas, an irascible and difficult character, who seems in turn to have been genuinely attached to her (although being Degas he was still capable of appalling rudeness to her, which generally she took in her stride). Her paintings are clear-eyed, beautifully lit, and delicately coloured. She showed at four of the eight independent exhibitions mounted by the Impressionists between 1874 and 1886, and her work was handled by Durand-Ruel.

But her greatest significance in the promotion of Impressionism ultimately lay in her social background. She came from a well-connected Philadelphia family, and her brother Alexander was later president of the Pennsylvania Railroad Company. She moved naturally in moneyed circles. When she started advising her American friends, and friends' friends, to invest in the new art she was listened to. Something recommended by the Cassatts of Philadelphia – no matter how outlandish it looked at first sight – was given a reassuring imprimatur of respectability.

And it did look outlandish at first sight. Initial American reaction to Impressionism tended to be as shocked and uncomprehending as everyone else's. An American commentator reported in 1879: 'We cannot in fact understand the purpose of the new school. It is founded neither on the laws of Nature nor the dictates of Common Sense... Worth seeing for the same reason that one would go to see an exhibition of pictures painted by the lunatics of an insane asylum'. However, there were a few who saw past all this. When the sixteen-year-old Louisine Elder from New York arrived in Paris in 1876, she was taken on a tour of the art galleries by a family acquaintance, Miss Cassatt. She fell in love with a Degas pastel which – with Miss Cassatt's encouragement – she bought for $100 with her own pocket money. It was one of the first recorded instances of an American buying a French Impressionist. When the young

collector lent it, in February 1878, to the Annual Exhibition of the American Watercolor Society at the National Academy of New York, it became the first work of French modernism to be shown in America. Louisine Elder went on to marry H. O. Havemeyer, the sugar king, and together they established one of the greatest American art collections of all time, particularly strong in Impressionist painting. Their adviser throughout was Mary Cassatt.

As Théodore Duret noted later: 'America is free from the prejudices of the Old World; the atmosphere is favourable to novelties.... In taking root there, the new art has only to overcome an opposition due to the astonishment which is at first naturally evoked by the appearance of original forms and modes of art'. He was right: America was a new, young country feeling its way in the world of culture. It was more susceptible to a new, young art. It was no coincidence that Louisine Elder was only sixteen when she bought her first Degas. The Impressionists were lucky in their timing: their emergence coincided with this huge first wave of American wealth, wealth moreover in the hands of a generation of Americans prepared to look outwards from their own country for the first time.

Gradually the American attitude to the Impressionists softened: 'If they have neglected established rules', declared one commentator in New York, 'it is because they have outgrown them, and if they have ignored lesser truths, it has been in order to dwell more strongly on larger'. Hitherto a few enlightened Americans had come to discover Impressionism in France. The time had come for Impressionism to be brought to America.

In 1879 Manet sent his *Execution of Maximilian* for exhibition in New York and Boston. The public responded without great enthusiasm. But more American collectors were beginning to materialise: men such as Erwin Davis, for instance, an industrialist from Pennsylvania who was buying from the late 1870s onwards. In 1883 Durand-Ruel, ever on the look out for new markets, sent some

Impressionist pictures to Boston for a 'Foreign Exhibition'. He wrote to Pissarro in May that year: 'One must try to revolutionise the New World at the same time as the Old'. Durand-Ruel gradually realised that he was going to have to cross the Atlantic himself if his American enterprise was really going to get off the ground. What finally convinced him to do so was an exceptional sale in 1885.

It was a three-day auction at the American Art Association in New York from 31 March to 2 April to dispose of the Searcy Collection, largely composed of Barbizon School pictures. The painters of the Barbizon School were still great favourites with American buyers and the sale realised the extraordinary total of $406,910. The huge potential of the transatlantic market was suddenly apparent. One of the men who conducted the sale, James Sutton (a partner in the American Art Association), sensed the opportunity that existed for new merchandise, for a new area of art to promote. Later that year he approached Durand-Ruel in Paris to send over an exhibition of his stock, with particular emphasis on Impressionist pictures.

The exhibition that resulted in New York in 1886 is one of the landmarks in the history of Impressionism. Durand-Ruel sent about 300 works, including 23 by Degas, 48 Monets, 42 by Pissarro, 38 Renoirs, 15 Sisleys, 3 by Seurat, and – a clever touch – 50 works by respectable mainstream artists as a reassurance to the public. 'Do not think that Americans are savages', Durand-Ruel wrote to the artist Fantin-Latour. 'On the contrary, they are less ignorant, less closed-minded than our French collectors.' A contemporary New York critic wrote of Durand-Ruel's exhibition that it was 'one of the most important events that ever took place in this country. These pictures... are the result of an effort on the part of the painters to break with tradition and to see things freshly with their own eyes'. This was a public with a hunger for new sensation, particularly if it came out of Europe. Four years earlier it had thrilled to a lecture tour by Oscar Wilde.

22 How Degas framed his work.
23 The sort of gilded eighteenth-century-style frame
 that American taste demanded for Monet.

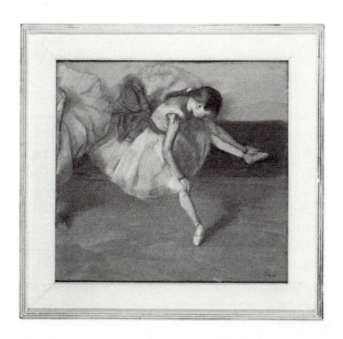

How successful was this first exhibition? About 20 per cent of it (by value) sold, for a total of $17,100. Durand-Ruel summed it up: 'I did not make a fortune, but it was a significant success which was encouraging for the future'. In the following two years he made six further trips across the Atlantic and in 1889 he felt confident enough about the American market to open his own gallery in New York. But these early inroads into American taste have to be set in context. The established vogue was still for conventional French painting: that same year a typically detailed and minutely worked historical costume piece by the arch-conservative Meissonier, measuring only 4 by 5 inches, fetched $7,100 in New York. This was a far higher price than any Impressionist could yet command, particularly if measured in dollars per square inch. But the tide was turning. Durand-Ruel wisely continued his policy of exhibiting Impressionist painters in the context of established masters. A nervous first-timer, seeing Monets and Renoirs alongside tried and tested artists such as Gérôme and Meissonier, like Millet and the Barbizon School, was reassured. The growing practice of presenting Impressionists in impressive eighteenth-century frames reinforced his confidence that he was buying something good enough to take its place in the grand tradition.

Soon other French dealers were establishing New York bases. Boussod Valadon, for instance, for whom Vincent's brother Theo van Gogh worked, set up there and held an important Impressionist exhibition in 1893. By now the popularity of Monet in particular was growing dramatically in the United States. There was a circle of especially fervent admirers in Boston. Pissarro commented to his son Lucien in 1891: 'For the moment people want nothing but Monets, apparently he can't paint enough pictures to meet the demand.... Always the same story, everything he does goes to America at prices of 4, 5, and 6,000 francs. All this comes, as Durand-Ruel remarked to me, from not shocking the collectors!' The understandable note

of envy is clear: at this stage in his career Pissarro himself was mired in Pointillism, a more difficult style which had much less commercial success than Monet's colourful, sun-drenched crowd-pleasers. Pissarro was still lucky to get 300 francs for one of his landscapes, and it hurt. But Monet went from strength to strength in America. In 1889 he became the first French modernist to be accepted by an American public collection when the Metropolitan Museum accepted two Monet landscapes as a donation from Erwin Davis. This was a significant landmark: no Impressionist had yet made it into a Parisian museum. As for a Monet being accepted into London's National Gallery at this point, the idea was unthinkable. American Monet-mania was a two-way process: in the late 1880s and 1890s a number of young artists from the United States, the most famous of whom was John Singer Sargent, made the trip across the Atlantic to study 'open-air painting' with the master at Giverny.

In France there were some misgivings about the American vogue for Monet, not least from the artist himself. 'I must say', he wrote, 'I should be sorry to see some of my paintings go to Yankeeland; and I should like to have certain canvases kept for Paris because Paris, above all, is the one and only place where there's still a little good taste'. This was Monet biting the hand that fed him; but he was facing uncomfortable criticism at home. Félix Fénéon, writing in the *Revue Indépendante* in 1888, found the artist's recent work on the Mediterranean coast 'shallow and vulgar' and 'geared to New York taste'.

In 1886 Mary Cassatt had a frustrating but illuminating experience with another early American collector of Impressionism who sought her advice in Paris. This was Frank Thomson, who had made money in steel. Cassatt introduced him to a small Parisian dealer called Portier, less well-known than Durand-Ruel. Cassatt takes up the story: 'Portier brought him two Monets or three, cheap, but he preferred buying one from Durand-Ruel at 3,000 francs.... I suppose he is the kind to prefer buying dear. I have little doubt Portier's were

the best pictures'. The kind to prefer buying dear: it's an early example of a phenomenon not uncommon since, the buyer who is reassured by a high price. To the novice in a challenging and unfamiliar arena like the art world, a high price can seem a guarantee of quality. When I first became a dealer, I couldn't understand why a particularly charming early nineteenth-century landscape I had on the gallery wall was attracting so little interest. My friend Jasper put me straight: 'You're underselling it,' he told me, 'it's too cheap. Double the price'. To my amazement, it found a buyer within a week.

Zola notes in the same year as Mary Cassatt's contretemps with Thomson: 'It flatters an American's vanity to be able to say that he bought the most expensive painting of the year'. There was certainly an element of commercial machismo about American art collecting. The other significant feature of Thomson's preference was his reassurance at buying from Durand-Ruel rather than Portier. Durand-Ruel was the better-known brand name. Thus collectors in the century since have been reassured to acquire a picture at Duveen, Wildenstein or Acquavella because, in a calculation which involves not just artistic merit but also fantasy, glamour and social status, the painting becomes worth more as a 'Wildenstein picture' or 'bought from Acquavella'.

The other artist who was particularly popular in America was Degas. Louisine Elder had been prescient in her purchase of his pastel: in 1893 Mary Cassatt was writing with her usual breathlessness to the collector John Howard Whittemore: 'I don't think my friend in New York would sell her pastel it would bring 20,000 francs in Paris. Not a bad investment'. Here is Cassatt, the beady-eyed investor of other people's money. The romantic, the consumer and the investor wage eternal war in the minds of American collectors of Impressionism. The Cleveland collector Theodore Pope is a good example. In 1889 he had bought three Monet landscapes from Boussod Valadon's New York branch, paying $3,240 for two of them. In 1892 he moved

on to Sisley, Pissarro and Degas. Degas particularly enthralled him, and in 1894 he made a trip to Paris to find more examples and make some quality comparisons. The letter he wrote home from France in August to his friend Whittemore gives some fascinating insights into his mentality as a collector. He says he has been shown a

> Degas horse picture, its fine best worked horse picture I have ever seen, its beyond criticism except being in pastel...I didn't 'rise to it', although I know its good...Count C. has many Degas, one Ballet Master & girls, interior green side walls, air every thing. It's the great Degas here...would be cheap at any price. I have just seen Manzies since & its 'out of sight' of his. I would not exchange mine for Faures or any of Manzies. Durand-Ruel has the Opera, its good, but I don't 'rise to it' as I am bound to do to any and every picture before I purchase it, unless of course I loose my head [sic].

No one could doubt that this is a man moved by the paintings he is seeing. It is a remarkable passage, because it illustrates so many of the different motives and emotions of a collector: the pride in the quality of his own pictures as against other people's; the excitement of seeing a really superb and covetable example belonging to someone else – 'would be cheap at any price'; the evolution of a personal vocabulary of aesthetic pleasure: 'rise to it'; 'out of sight'; and the wonderfully expressive economy with which he registers one of the defining qualities of Degas's new art: 'air everything'.

'Rising to it'. Pope's piscatorial imagery has a hint of sexuality in it, too, a stirring that is perhaps at the root of most art appreciation. Jasper puts it more bluntly: his sincerest accolade to a painting is when he tells you that, in front of it, 'my arse tightened.' Towards the end of his life Renoir, his hands crippled with arthritis, was interviewed by a journalist. 'With such hands, how do you paint?' asked the journalist earnestly.

24 Renoir in old age, painting – on this occasion –
with his hand.

'With my prick', replied Renoir.

'No one laughed at this quip', recounts his son Jean. 'For what
he said was a striking expression of the truth; one of those rare testi-
monies, so seldom expressed in the history of the world, to the mira-
cle of the transformation of matter into spirit.'

Henry James is a disappointment when it comes to Impressionism.
He was ideally positioned and equipped, as a writer who wrote ex-
tensively about art, to become the movement's interpreter to his fel-
low countrymen. But he rarely touched on the Impressionists. It's
odd, because as a novelist he was not immune to their influence.

How far one can identify literary Impressionism as a meaningful phenomenon is open to debate, but in *The Art of Fiction* (1884) he declared the novel to be 'a personal impression of life.... If experience consists of impressions, it may be said that impressions are experience, just as...they are the very air we breathe'. An indication of how prevalent the imagery of Impressionism gradually became is the entry in his notebooks of 1894 about his plans for a short story that he is beginning (*The Coxon Fund*):

> *The formula for the presentation of it in 20,000 words is to make it an Impression – as one of Sargent's pictures is an impression. That is, I must do it from my own point of view – that of an imagined observer, participator, chronicler. I must picture it, summarize it, impressionize it, in a word – compress and confine it by making it the picture of what I see.*

The influence of the new painting is also detectable in some of James's descriptions of his beloved Paris. In the following two passages from *The Ambassadors* the city is portrayed – consciously or unconsciously – in terms of an Impressionist picture:

> *It hung before him this morning, the vast, bright Babylon, like some huge iridescent object, a jewel brilliant and hard, in which parts were not to be discriminated nor differences comfortably marked. It twinkled and trembled and melted together, and what seemed all surface one moment seemed all depth the next.*
> *[...]*
> *The early summer brushed the picture over and blurred everything but the near; it made a vast warm fragrant medium in which the elements floated together on the best of terms, in which rewards were immediate and reckonings postponed.*

Even without Henry James to lead the way, by the early 1890s two formidable American ladies had become big players in the collecting of Impressionist art: Louisine Havemeyer (née Elder), and Berthe Honoré Potter Palmer. Add to them Mary Cassatt, plus another influential artist/adviser in Paris, Sara Hallowell, and it becomes clear what a significant role in the promotion of French modernism was played by American women. At the turn of the century some male commentators with a Symbolist agenda, intent on disparaging Impressionism for its lack of content, tried to dismiss it as an essentially feminine art. According to Téodor de Wyzewa, 'women should see the universe like a gracious and mobile surface, infinitely nuanced. Only a woman has the right to rigorously practice the Impressionist system, she alone can limit her effort to the translation of impressions'. But this is to miss the point about these enormously strong and determined women. In the American journey west, women had been the wagon-followers, subservient to their pioneer menfolk. Now that America was looking outwards and back east again, the roles were reversed and women became more significant than men. In the journey to Europe, the woman is now the pioneer, the guide, the motivator. She embodies the worldly and aesthetic aspirations of the new urban society. She is connoisseur and shopper, decorator and investor. Her husband tags along in her wake, meekly making the money to finance the whole operation.

And the husbands of these women did make money, in vast quantities. That is what they were good at. Mr Potter Palmer was the richest man in Chicago. He was a property developer who built hotels. The Palmer House Hotel was one of the most luxurious in America: rather churlishly Rudyard Kipling reported that it was 'crammed with people talking about money and spitting about everywhere'. At home in the Palmer residence there was a vast Louis XVI salon and all sorts of glamorous accoutrements. Mrs Potter Palmer was the unchallenged queen of Chicago social life. Advised by Mary Cassatt,

25 Mrs Potter Palmer, who took no prisoners on the
 wagon trail east.
26 Grandeur and luxury. The main reception room in
 the Potter Palmer residence, Chicago.

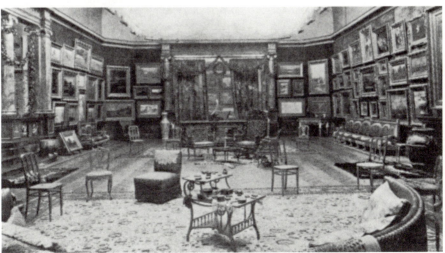

Mrs Potter Palmer went to visit Monet in Giverny in 1891 and bought a painting from him. Many more followed. Back in Chicago her pictures were hung in a three-tiered *mélange* on the marbled and brocaded walls of a room furnished with leopard skins and whatnots.

But she was more than a social mountaineer, pioneering art in order to enhance her status. She was a serious women's rights activist. As chairman of the Women's Committee planning the Chicago World's Fair in 1893, she organised a Women's Building decorated by women artists, including Mary Cassatt. Her energy was materially responsible for the huge success of the exhibition, which 27 million people visited that year. She didn't collect French modernism in order to show off, because she didn't need to. Rather her championing of the Impressionists, because of her impregnable social position, actually made the new art more acceptable in America. She may have been bossy and used to getting her own way. But there was something splendid about the way she took no prisoners on the wagon trail to Europe. When the Infanta of Spain came to Chicago, she turned down an invitation from Mrs Potter Palmer on the grounds that she preferred not to meet 'this innkeeper's daughter'. Mrs Potter Palmer apparently got her own back in Paris a few years later when she was able to refuse an invitation to a fête in the Infanta's honour saying, 'I cannot meet this bibulous representative of a degenerate monarchy'.

The Potter Palmer collection ended up in The Art Institute of Chicago and is the main reason why that museum is so rich in Impressionism. The Metropolitan Museum in New York was even more fortunate because of its bequest from Mr and Mrs H. O. Havemeyer. The former Louisine Elder was unquestionably the driving force of the collection, which extended into many different areas besides Impressionist painting. Her husband followed along gamely. They marauded Paris in their search for masterpieces. When Mrs Havemeyer set her heart on something, she had to have it. She became obsessed

with owning Degas's *Danseuses à la barre*. Finally it came up for auction in Paris in 1910 and she paid the extraordinary sum of $95,000 for it. That record stood for nearly fifty years as the highest price ever paid for the work of a living artist.

Manet and Degas were Mrs Havemeyer's particular favourites. By instinct she preferred figure painting to pure landscape, and never quite weaned herself off a lingering taste for anecdote. Here she is reminiscing in later life about the painting *Gare Saint-Lazare* by Manet that she and her husband bought from Durand-Ruel in 1898:

> *What made us want to possess it? What caused us to forgive Manet that we could never see the child's face? You ask us why we paid for iron rails and steam engines we barely see? You tell us that the child is not even pretty and the mother is positively ugly...that even the doggie is unattractive, and you long to know why we put so much money into such a picture when we might have had a gorgeous academic, an imposing English portrait, or some splendid Eastern scene, for the same price.*
>
> *I answer art, art, art. It is there appealing to you, as it appealed to us. You must hear the voice calling to you, you must respond to the vibrations Manet felt, which made his heart throb and filled his brain, which stirred his emotions and sharpened his vision as he put his brush upon the canvas. Art, art, art, I say.*

Art, art, art. A hundred years later, in my own life as an auction-house specialist, history was repeating itself. Dr Eric Spavin (not his real name) was the director of an exceptionally rich mid-western museum. Under an Armani jacket, he wore jeans and a white T-shirt. At the top of his forehead, where it met the fringe of his close-cropped hair, he balanced an expensive pair of sunglasses. His unusually tiny feet were shod in crocodile-skin loafers. He shimmered into the room with a sort of dainty authority, ushering in with him a couple

27 Manet, *Gare Saint-Lazare*, 1872–73. A painting that sang to Mrs Havemeyer. (See pl. 4.)

we shall call the Markoviches, a husband and wife in their early sixties whose bulk by comparison with Spavin's made them seem like a couple of elephants being corralled by a ballerina.

We all shook hands. I was apprehensive of Spavin. He spoke with the sort of simmering, faintly camp fastidiousness that could at any moment boil over into a tantrum. 'Mr and Mrs Markovich wish to preview the outstanding lots from your upcoming auction', he explained. I knew that the Markovich collection had been bequeathed to Spavin's museum; hence his presence now as quality-control on any new additions to it. We were taking the first, cautious steps in that old three-way dance routine, the dealer–collector–adviser triangle, the line-up that in its vintage days read Durand-Ruel–the Havemeyers–Miss Cassatt. Dealer proposes, collector vacillates, adviser decides.

'Would you like to see the Degas?' I asked Mrs Markovich. The generousness of her figure was emphasised by a pair of floral leggings.

She raised her hand. 'Mr Hook, first I would like to share with you our life-ethic.'

28 Prototypes of the great American Impressionist
 collector: Mr and Mrs H. O. Havemeyer.

I nodded encouragingly.

'You see, we don't do golf or sports.'

'No?'

'Don't get time to work out', added her husband. He was dressed in a blazer with very glittering buttons, immaculately pressed trousers, and a tie by the same designer as his wife's leggings.

'No.' Mrs Markovich was emphatic. 'We're trying to grow as human beings through our collection.'

'I just write the cheques', said Markovich morosely.

The Degas was brought in by a porter. We all peered at it in silence. 'Do you like it?' I said at last.

I watched both Markoviches glancing surreptitiously towards Spavin for guidance. He was making a cryptic little pursing movement with his lips.

Finally Mr Markovich said, 'Don't you have any Renoirs? I like Renoirs'. He spoke querulously, as if complaining about the omission of broccoli from an expensive restaurant menu.

We found him one. He shrugged non-committally. I decided not to tell him with what part of his anatomy Renoir claimed to have painted his late works. Spavin frowned. They said they'd go away and think about it. Dealer proposes, collector vacillates, adviser decides.

Not all Louisine Havemeyer's later imitators are like Mrs Markovich. There are serious collectors today who successfully emulate both the Havemeyer determination and the Havemeyer flair. The point about Mrs Havemeyer is that she set the template. You underestimated her at your peril: she was a determined woman who knew her own mind, and she was perfectly capable of over-ruling Miss Cassatt. Despite her occasional lapses into sentimentality, her aesthetic sensibility was highly developed and she understood perfectly well what Manet was trying to do, what made him exceptional. Elsewhere she wrote of him:

> *He concentrated all his art, all his ability, on that which he wished to paint and was still able – what a gift to a painter – to eliminate all unnecessary details. No wonder he was so little understood by his contemporaries.*

And of the *Gare Saint-Lazare* she went on to observe:

> *Where in art will you find a curve like the one which outlines the dress upon the child's shoulders, or see such light as that which creeps up to the yellow hair and models the lovely neck? Look at the*

*pose of the head, the movement of the arm, the way the flesh of the
little hand is pressed against the iron rail, see how atmosphere and
light envelope the two figures and give distance to the scene below.
Finally, notice the colour! Did you ever see anything more beautiful
and harmonious?*

Her earlier reference to the 'doggie' should be forgiven. Perhaps she
was even ahead of her time in drawing attention to the animal: it is
a measure of how widely modern scholarship has trowelled into the
surface of Impressionism that an academic has recently come out
with a book entitled *Cats and Dogs in Impressionist Art*. Where Mrs
Havemeyer made an indisputably significant contribution to later
generations' understanding of French modernism was her discovery
and championing of Degas's sculpture. She sought it out from his
studio after his death, disinterring the 72 wax models from which
bronze versions (so highly prized today) were ultimately cast.

'After all, give me France', declared Mary Cassatt in 1894,
'– women do not have to fight for recognition here, if they do serious
work. I suppose it is Mrs Palmer's French blood which gives her her
organising powers and her determination that women should be
someone and not *something*.' If Mrs Potter Palmer was an enthusias-
tic upholder of women's rights, then Mrs Havemeyer fought with
equal fervour for the cause. In 1915 she mounted a loan exhibition
of largely Impressionist art in aid of women's suffrage. Many works
by Degas were included, both from her own collection and borrowed
from others. One can only hope that the artist himself – holed up in
reactionary and misanthropic old age in his Paris apartment – nev-
er got to hear of it. Mrs Havemeyer, now widowed, soldiered on. At
the age of 64 she burned an effigy of President Woodrow Wilson on
the White House lawn and was jailed for three days; after that she
set off on the 'Prison Special', a train which toured the country for
a month to promote the cause of women's suffrage. As with most of

29 Mrs Louisine Havemeyer, pioneer of Impressionism
and of women's rights.

the projects in her life, she got what she wanted in the end and lived
long enough to see women achieve the vote.

By the beginning of the twentieth century, Impressionism was firm-
ly established in America. More and more paintings were crossing
the Atlantic into private collections. And these were major works:
when it came to the new school of art, the American eye was as con-
fident in its judgement as that of the Old World. Frank Rutter wrote
from London in 1905: 'In revenge for the imitation "old masters" and
museum curiosities of painting long foisted on her by cunning deal-
ers, America is now stripping Europe of her finest modern master-
pieces'.

Mary Cassatt remained at the centre of this process. She wrote in 1904: 'In these days of commercial supremacy artists need a "middle man", one who can explain the merits of a...work of art...to a possible buyer'. She was thinking of what dealers such as Durand-Ruel, Georges Petit and Vollard did, of course, but she also had in mind her own role as informed expert adviser. She added pointedly, 'I would turn my back on the society side, for in that set pictures are mostly bought for reasons of vanity'. She was too perceptive an observer not to realise that a strand of social ambition, of aspiration after cultural and financial status, was now woven into the psychology of the American pursuit of the Impressionist painting. But she also knew that this was not a motive for the Havemeyers who were serious collectors.

One thing that annoyed Renoir about American taste was its lingering penchant for anecdote and sentiment. Jean Renoir quotes his father as complaining:

> 'Those picture-dealing scoundrels know perfectly well that the public is sentimental. They stuck a blasted title on my poor girl, who can do no more about it than I can. They called her La Pensée.' He frowned at the recollection of it. Then his eyes sparkled with malice, as he looked at his listeners. 'MY models don't think at all.'

A similar thing happened to Renoir's *Portrait of Madame Clapisson*, commissioned in 1882 by her admiring husband, a French industrialist. When Monsieur Clapisson was disappointed by what Renoir produced, and refused to accept it, Durand-Ruel bought the painting and recycled it for the American market by re-titling it *Dans les roses*. As a sentimentalised scene of generic female beauty it had appreciably more appeal than as a specific portrait of someone else's wife, and it found an American buyer in 1886. (It sold again, at Sotheby's in 2003, for $23.5 million.)

There were further questions of conscience to grapple with. In September 1903 Mary Cassatt wrote to Theodate Pope, the collector's daughter, who had raised the uncomfortable issue of the morality of private ownership of great works of art:

> What you say about pictures being things alone, and standing for so much, and therefore the wickedness of private individuals owning them is I assure you a very false way of seeing things.... Surely there is nothing wrong with a hard-working lawyer or businessman putting some of his earnings into a work of art which appeals to him.

Miss Pope's scruples were to be relieved, for, as the twentieth century progressed, more and more American collections ended up in museums.

There is nothing like giving people a financial incentive towards philanthropy. It makes everyone feel good. What added momentum to this flow from private to public collections was a change in US tax legislation which allowed those who donated works of art to museums to deduct from their taxes 30 per cent of their declared value, while maintaining possession of the works of art for the rest of their lives. As the museum which was to benefit from the donation had the sole responsibility of making the valuation, there grew up a whole crop of 'mushroom museums', as Gerald Reitlinger puts it, 'the principal purpose of which was to act as favourable valuers for the most easily obtainable museum-quality works of art – Impressionist paintings'. The trick was to put the valuation for tax purposes far enough above the original purchase price for the benefactor in effect to make a profit. Thus it was possible for the rich actually to earn money by spending large sums on Impressionist paintings. The inflationary effect on the market was paralleled in the late 1980s when the Japanese found that other dodges involving Monets, Renoirs and van Goghs worked as a way round their country's tax system.

30 Renoir, *Portrait of Madame Clapisson*, 1882. Retitled
Dans les roses for the American market.

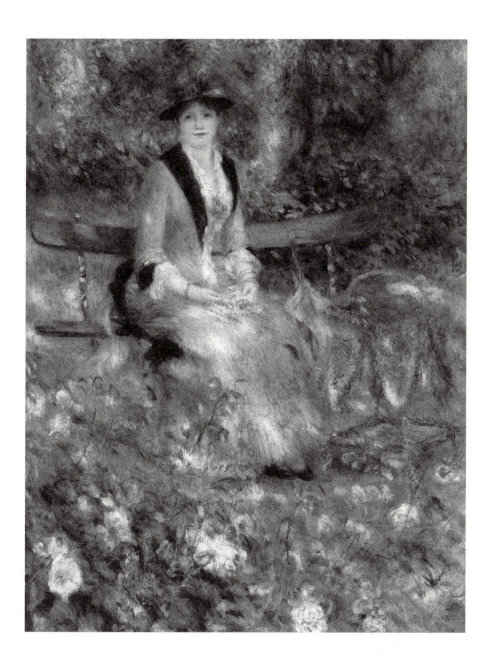

As more advanced modern art movements succeeded Impression-
ism, Mary Cassatt found the new developments increasingly diffi-
cult to stomach. She even criticised Monet's late work, the endless
views of his lily-pond at Giverny: 'I must say that his "Nemphas" [sic]
pictures look to me like glorified wallpaper', she wrote in 1918. The
same year René Gimpel expressed doubts as to whether the water-
lilies series would sell in America, but for different reasons: the
houses were too small, he thought, but the panels might go well in
swimming pools. In fact Durand-Ruel had already proved himself
the master at selling water-lilies in America. It was one more proof of
his marketing genius. In 1908 he came up with a novel way of coun-
tering the growing notion that Monet's production was excessive-
ly prolific, that his latest works lacked rarity value. He announced a
major exhibition of new paintings by Monet in his New York galler-
ies; then, a week before it was due to open, he cancelled it. The reason
for the cancellation made front-page news:

> Pictures with a market value of $100,000 and representing three
> years of constant labor were destroyed yesterday by Claude Monet
> because he had come to the conviction that they were unsatisfac-
> tory.... M. Durand-Ruel told the correspondent of The New York
> Times that while he was disappointed to be unable to hold the exhi-
> bition as advertised, M. Monet's actions showed him to be an artist,
> not a mere manufacturer.

It was an inspired move on Durand-Ruel's part. It simultaneously
reassured Americans that Monet was emphatically not a painting
factory, and meant that the next batch of Monets that Durand-Ruel
offered to the New York market would come with the added cachet of
having passed the master's rigorous quality control.

The perception of Impressionism had now changed: by the
second decade of the twentieth century people were reverting to the

Impressionists as a safe, colourful and pleasing refuge from the ex-
cesses of their successors, the much more challenging productions
of Matisse and Picasso. The Impressionists in general, and Monet in
particular, were valued as demonstrators of 'the joy of living', purve-
yors of 'a delightful sense of movement, vibration and life', accord-
ing to the American painter Theodore Robinson. The curious proc-
ess was set in motion whereby an Impressionist collection became
a pleasing emblem of old wealth in America. Later in the twentieth
century the President of the Chicago Art Institute was boasting: 'We
don't buy Renoirs. We inherit them from our grandmothers'. From
early on, Degas too became a potent status symbol for Americans.
What was particularly appealing to old money was his subject mat-
ter, the ballet and the race-course. If you bought the former, you
were making a statement of your interest in, and probable patron-
age of, the socially desirable art of dance; if you bought the latter,
you were declaring your familiarity with the upper-class cult of the
horse. Cecil Beaton was a more caustic observer of the snobbery im-
plicit in such collecting in the United States. He describes in his dia-
ry watching Brooke Astor at a Wildenstein Impressionist exhibition
in New York in 1965:

> She looks at the catalogue, and, pointing at the Gauguins, Cézannes,
> Monets and Bonnards, exclaims, 'There's the Morton Schwartz!
> There's the Freylinghausen, there's the Lilyanmilch, there's the
> Cutting Curtis. Do you prefer the Schiff Ogden or the Glubleselz?'
> How the rich are impressed with one another!

A new generation of collectors emerged in the early twentieth cen-
tury, men like Dr Barnes of Philadelphia and Duncan Phillips in
Washington, both of whom blended Impressionism with the more
controversial modernism that followed. Nonetheless the same adu-
lation of France persisted: Gimpel says of Phillips that 'he speaks of

France with the same fervour as we speak of Ancient Greece'. Barnes remained in no doubt about the seminal importance of what the Impressionists achieved. He wrote in 1915 of his admiration for 'the men that make up the greatest movement in the entire history of art – the Frenchmen of about 1860 and later – whose work is so highly expressive of life that means most to the normal man alive today'. But a subtle change in appreciation of the Impressionists evolves. When Duncan Phillips bought Renoir's *Le Déjeuner des Canotiers* from Durand-Ruel in Paris in 1923, he viewed the artist not so much as a rebel but as part of a great tradition. 'His light gaiety resembles that of the French decorators of the 18th century', Phillips wrote. 'The Italian Renaissance reaches a belated culmination in the ripe perfection and marvellous modelling of the *Déjeuner des Canotiers*.'

More details of the acquisition of the painting are provided by his wife:

> *We were invited to lunch at the home of the Joseph Durand-Ruels. Much to our delight we were seated opposite that fabulous, incredibly entrancing, utterly alive and beguiling Renoir masterpiece.*

What she is unwittingly revealing is a sublime piece of salesmanship on Joseph Durand-Ruel's part. Entertaining your best clients to an excellent lunch and sitting them – as if by chance – in front of the best painting in your stock is a strategy much deployed by art dealers. In this case it reaped glorious dividends. Phillips was persuaded to part with $125,000 for the picture.

The graph of Impressionist prices followed a steady if unspectacular incline upwards in the years between the wars, marked by occasional spikes when a spectacularly good example caught the eye of a spectacularly rich collector. Such a spike occurred when Duncan Phillips bought his Renoir, or when John Hay Whitney bought Renoir's *Au Moulin de la Galette* for $165,000 in 1929. A further

31 Mr and Mrs Duncan Phillips sitting in front of the
painting they acquired over lunch at Durand-Ruel.

supply-line into America of important Impressionist pictures was
activated in the 1930s as a succession of Jewish collectors crossed the
Atlantic to escape Nazi persecution in Europe. These collectors were
joined by a generation of distinguished art historians, fleeing Ger-
many for the same reasons. They were welcomed by an American so-
ciety eager for knowledge about art, precursors of the Markoviches in
their desire to grow as human beings through their collections. Pro-
fessor Erwin Panofsky recounts that he was in demand to deliver lec-
tures not merely in seats of learning, but in rich private houses too,

'the audience arriving in twelve-cylinder Cadillacs, seasoned Rolls-Royces, Pierce Arrows and Locomobiles'.

As early as 1901, a writer in *The New Republic* identified Monet's art as a feature of the new century of change in America, linking it to 'the railroad, the telephone, the telegraph, the linotype machine, the steamship, the phonograph, and "the movies", all of which contribute to the rush of changing impressions, to the bewildering multiplicity of effects'. Monet and the movies: perhaps it was inevitable that Hollywood should discover Impressionism. This meeting of two such hyped visual institutions, both of relatively recent invention, was a marriage made in heaven, and between the wars directors and film stars like Sam Spiegel, Billy Wilder, Greta Garbo, Alexander Korda and Edward G. Robinson became significant collectors. 'First off, I am not Bernard Berenson', announces Robinson in his autobiography, acting up to his hard-bitten screen image. But, Berenson or not, he had a good eye and bought excellent pictures. When filming in London in 1935, he called at the Lefevre Gallery to look at the stock. 'Because I was from Hollywood and they had seen me as a gangster, they did look a little bit alarmed when I walked in', he recounts. But they all sat down to a cup of tea, that never-failing balm to anxious British nerves.

The relationship between Hollywood and Impressionism was a mutually beneficial one. The glamour of Hollywood rubbed off on Impressionism. Hanging an Impressionist painting on your wall became even more desirable, because film stars did it. The plot-line of the struggling artist who later comes good, first enshrined in the story of the Impressionists, fed a variety of dramas, comedies and musicals. One of the most successful books of the decade of the 1930s was a historical novel, *Lust for Life* by Irving Stone (1934), which dramatised the turbulent career of van Gogh and was later filmed starring Kirk Douglas. The book itself boasts dialogue like the following:

THEO VAN GOGH: May I present my brother, Vincent van Gogh? Vincent, this is Paul Gauguin. Sit down, Paul, and have one of your inevitable absinthes.

Inevitable absinthes. The American dream of Paris continues to enchant – clean-living young America's star-struck tribute to naughty old France. It is a cultural admiration that gradually leads on to a cultural appropriation. The van Gogh brothers talk like Americans; even their surname is Americanised to rhyme with 'show'. Today as you come out of the Los Angeles County Museum you are confronted across the street by a restaurant which advertises itself with the huge legend 'Van Gogh Ate Here'. In smaller letters below comes the explanation, 'Well, he would have', but the message is clear: the Impressionists were really American.

A CULTURAL DEED

The German Reception of Impressionism

————

In the first 45 years of Impressionism's existence, France was twice invaded by Germany. It is a curious background for an artistic relationship. The hostility of the conservative German response to modernism in French painting was understandable; much more surprising is the level of enthusiasm for Impressionism that was simultaneously felt in more liberal circles. You don't fall in love with the avant-garde painting of your defeated enemy, do you? Or do you?

The first recorded German encounter with French Impressionism took place during the Franco-Prussian War of 1870–71. It was an unwitting one: the Prussian soldiers billeted in Pissarro's hastily vacated house in Louveciennes used the canvases they found lying about the place as a carpet to prevent their boots getting muddy in the garden. But if we jump forward less than fifty years to the next German occupation of France, in the Great War, we find a huge change has taken place. This is Helmut Zschuppe, a German soldier

in the trenches, writing in his diary on 5 September 1917 about the
French landscape:

> *I rejoice in the beauties of Nature; in this summer-like Renoir*
> *autumn of the canal and the Aisne; in the ever-shimmering, ever-*
> *rustling avenue of elms.*

That Zschuppe should express what he sees in the vocabulary of
French Impressionism is a measure of the insidious stranglehold
that French modernism now exerted over the German visual imagi-
nation, even though the two countries were at war.

It is a bizarre transformation. The defeat suffered by France in
1871 could not have been more ignominious. The military and politi-
cal ascendancy won by the Germans was total. And yet over the next
three or four decades this ascendancy was gradually eroded by an in-
creasing cultural subservience to the French avant-garde. A number
of influential collectors and museum directors fell under the sway of
French Impressionism. The conservatives were horrified, none more
so than the Kaiser himself who led a vigorous opposition to any art
that was not virile and German. Friedrich Nietzsche, on the other
hand, took a more resigned view in the wake of the Franco-Prussian
war: 'There cannot be any question of the victory of German culture',
he wrote, 'for the very simple reason that French culture continues
to exist and we depend upon it'.

The Kaiser would not countenance such defeatism. 'An art
which transgresses the laws and barriers outlined by me ceases to
be an art,' he thundered. He saw himself as the nation's ultimate cul-
tural arbiter, indeed as a practising painter and musician, too; but
given that his favourite music was military marches and the subject
matter of his pictures was battle scenes, he was not pre-disposed to
Impressionism. One of the things he most objected to about the Im-
pressionists was their predilection for realist subjects rather than

32 Kaiser Wilhelm II, striving to keep German art
untainted by French modernism, 1899.

elevated ones. 'The supreme task of our cultural effort', he declared
in 1901, 'is to foster our ideals. If we are and want to remain a model
for other nations, our entire people must share in this effort, and if
culture is to fulfil its task completely it must reach down to the low-
est levels of the population. That can only be done if Art holds out its
hand to raise people up, instead of descending into the gutter'.

But the truth to nature inherent in Impressionism touched a
chord in the literalist German spirit. Philip Ernst, father of Max, was
a keen amateur painter in turn-of-the-century Frankfurt. It is re-
corded that he once painted a picture of his garden, but – for compo-
sitional reasons – omitted a tree. When he had finished he was over-
come with remorse and went out and cut down the tree. Monet, too,
sometimes played God with nature in order to create the right sub-
ject matter. He bought a line of riverside poplars from the local tim-
ber merchant in order to preserve them for a summer's painting; he

redirected a local stream in order to create his famous lily-pond; he tried to delay the departure of the Rouen train from the Gare Saint-Lazare to prolong certain steam-effects. But Monet's forward planning in contrast to Ernst's after-the-event remorse tells you why Nietzsche was probably right about the artistic relationship between France and Germany.

The German discovery of Impressionism began in the early 1880s. The first conduit by which the new French art reached Berlin was Carl Bernstein, a professor of law, whose Parisian cousin Charles Ephrussi (a pioneer patron of Renoir) encouraged him to buy on visits to the French capital. By 1883 Bernstein had already acquired enough works by Manet, Pissarro and Monet for an exhibition to be mounted in the Gurlitt Gallery, Berlin. The introduction to the catalogue was written by the French poet Jules Laforgue, who was Ephrussi's private secretary. This is an early and significant example of the way an appreciation of Impressionism was fostered by the international contacts of cosmopolitan Jewry. Germany's taste for modernism, rather like America's, gathered momentum with the country's rapid economic development. Between 1870 and 1900, Berlin's population doubled, from 900,000 to 1,800,000. New money was being made; the private art market expanded; new artists emerged. People loosened up. In February 1892 the Berlin Secession was formed as a forum for modernism, in revolt against the conservative Salon. One of the leading lights was Max Liebermann, himself a considerable painter and, significantly, already an enthusiastic collector of French Impressionist works.

Why was there early enthusiasm for Impressionism in Berlin which was not matched in London? In the same year as the foundation of the Secession, Adolph von Menzel, the great chronicler of everyday bourgeois life in Germany, painted a picture which unwittingly offers some clues. A railway carriage has stopped at a point on

33 The feverishness of the late nineteenth-century
German spirit. Adolph von Menzel, *Auf der Fahrt
durch schöne Natur*, 1892.

the track from which there is apparently a magnificent view (prob-
ably alpine). Passengers scurry about their opulent, heavily uphol-
stered compartment in an ecstasy of excitement, grabbing guide-
books, training binoculars, urging each other to new heights of
appreciation. There is a feverishness to the scene that borders on the
unhealthy. That feverishness was a feature of the German psyche in
the twenty-five years leading up to World War I, often remarked upon
by historians as one of the contributing factors to the conflict. Ger-
many was a gleaming new nation, excellent at producing soldiers,
industry and money. By 1913 the national income was $12 billion,
double that of France. But beneath the surface there was a cultural
insecurity, amounting almost to an inferiority complex. Newness as
a nation cut both ways. Who are we, some Germans wondered? What
are we? We have all this material success, but what about our Soul?
Do we find it in nature, in magnificent views from railway carriages?
Do we find it in new forms of art like French Impressionism? Ger-

many was a country in need of counselling. As Degas said, there is a certain sort of success that is indistinguishable from panic.

There was thus a sense of mission amongst the first German discoverers of Impressionism. Enlightened Germans were grievously aware of the inadequacy of their knowledge of contemporary avant-garde art. Looking back, the critic Julius Meier-Graefe (unable to resist a military metaphor) said that in 1890 'the inside of our heads looked like an emergency railway station in war time. It is impossible to conceive how riddled with holes our mental communication system was'. Hugo von Tschudi, director of the National Gallery in Berlin, declared in 1899: 'The German public is helpless before modern art; it must be given the opportunity to educate itself in museums and exhibitions'. And Paul Cassirer, the dealer, remembering his early years in Berlin, asked: 'Why did I have to speculate with French paintings? Because I regard bringing French art to Germany as a cultural deed'.

The critic, the museum director, and the art dealer all speaking with one voice. By the turn of the century, that voice was being heard louder and clearer in Berlin. When in 1896 Tschudi took up his appointment as director of the National Gallery, the research on which his reputation rested was into the fifteenth-century Master of Flémalle. But the same year Tschudi travelled to Paris with Max Liebermann and visited the Durand-Ruel gallery. His encounter with the French Impressionists was a revelation, and he came home convinced that he must buy their works for the National Gallery. It was difficult to use government funds for such acquisitions, but he encouraged sympathetic private collectors to donate. By 1900 the Gallery owned works by Manet, Monet and Pissarro (who noted Tschudi's purchase in a letter to his son: 'Surprise! Thus my pictures sell'.)

Other museums in Germany followed. In the first years of the twentieth century, Bremen bought Degas, Manet and van Gogh, while

34 Paul Cassirer, planning his 'cultural deed'.
35 An enlightened German museum director of the early twentieth century, Georg Swarzenski of Frankfurt.

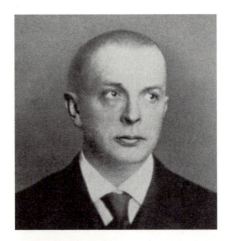

36 One of the first instances of the well-worn pun on
'Monet' and 'money': a German cartoon of 1899.

Die Berliner Kunst-Salons.

Salon Schulte.
Sollte eigentlich Salon Cassirer heissen,
denn der Cassirer hat dort eine grosse Rolle.

Salon Cassirer.
Devise: Durch Manet und
Monet zu money.

Frankfurt, under the guidance of its director Georg Swarzenski, bought a Sisley in 1899 and a van Gogh in 1908. 'There is no doubt about the French painting of the 19th century', declared Swarzenski. 'The painters created masterpieces of the highest order, in which the world and its appearance are recreated in a new and perfect way.'

Simultaneously commercial art galleries specialising in avant-garde contemporary painting began to spring up. In 1895 Berlin had only two, but by 1900 there were eight. The most significant was Cassirer's, which opened in 1898. Paul Cassirer worked on many fronts: he was a member of the Secession; he formed close links with the important Parisian dealers like Durand-Ruel, Bernheim and Vollard and bought new art from them; he published journals to explain the new art, and – most crucially – to sell it. Meier-Graefe, for instance, writing in 1904, provided an aesthetic justification for modernism. Embracing Heinrich Wölfflin's thesis that the history of art should be seen as a progression from the linear to the painterly, he proclaimed French Impressionism as the highest peak to date. As in France, fostering the popularity of the Impressionists was the work of dealers in collaboration with sympathetic critics, and Cassirer

presided over a hugely successful marketing operation. He dressed up salesmanship in the guise of altruistic missionary work, bringing the good news of French art to Germany was, after all, 'a cultural deed'. Who were the first collectors of French Impressionism in Germany? One of the earliest was Liebermann, of course; another was Harry Graf Kessler, who was already buying in Paris in the 1890s. His diaries record the enchantment of his discoveries at Durand-Ruel. In the summer of 1895, for instance, he is bowled over by Monet's Rouen Cathedral series: 'Every image has its own unique colour effects…the richness and magic of the colours is like a serpentine dance'. The following year he concludes that 'Monet's treatment of light is in fact a completely new conquest for painting' (26 May 1896); and four days later he is at Durand-Ruel again to look at Renoirs, 'true miracles in the light of living colour'.

Oscar Schmitz, Karl Osthaus, Carl Sternheim and Paul Mendelsohn-Bartholdy were others who bought significantly in the first years of the twentieth century. Generally these early collectors were liberal, cosmopolitan intellectuals. Many were children of newly rich German manufacturers. Vollard had an interesting take on the way Germans responded more positively than the French to the innovation of Impressionism: 'The Frenchman, who is argumentative by temperament, becomes a conservative when confronted by any new trend in art, so great is his need of certainty, and so afraid is he of being taken in. The German, by contrast, while bowing instinctively to anything in the way of collective discipline, yet gives enthusiastic support to every anticipation of the future'.

There was a rigour, almost an asceticism, about Impressionist collectors in Germany which contrasted with those French and American patrons who were drawn to the opulent grandeur of Paris galleries like Durand-Ruel and Georges Petit, where French Impressionist paintings were increasingly packaged as luxury items. Cassirer's Berlin gallery was something quite different, appealing

to the intellect rather than the senses. Its rooms were spare and austerely elegant, with their walls painted a neutral grey. Kessler, for instance, hung his paintings by Renoir and Cézanne in simple frames of painted wood. Not for him the illogical insistence on presenting Impressionist paintings in ornate Louis XV frames, as if they had been miraculously reinvented as eighteenth-century decorations.

But if the settings were austere, passion simmered not far beneath the surface. The feverishness could not always be suppressed. Here is Max Liebermann raising his own temperature as he elaborates on Manet's spontaneity:

> The artist celebrates his wedding night with his work; with his first passion and the concentration of all his powers he pours into the sketch what has been in his mind, and in the intoxication of his enthusiasm he generates what no effort or labour could replace.

Liebermann's wedding night takes its place alongside Renoir's prick and the stirring of Theodore Pope in the lexicon of sexual imagery stimulated by Impressionist painting.

To the conservatives the taste for Impressionism had a politically subversive subtext. It betokened a dangerous internationalism, and a threat to the existing order of things. When Meier-Graefe observed that there were soldiers, industry and money in abundance in Germany, but a lack of harmony and culture, it made the old guard nervous. As Kessler later pointed out, the fragility of the Imperial Monarchy was sensed and attacked much earlier in art and literature than in politics. It is not surprising, therefore, that a final backlash against modernism in general, and Impressionism in particular, was felt in the years leading up to World War I.

In 1907 the Emperor paid an official visit to the National Gallery. Here was the hour of reckoning for Tschudi, the moment when

the Kaiser would confront the French modernist paintings which the Director had so lovingly infiltrated into the collection. At the last minute Tschudi felt misgivings about the Cézanne, and removed it from the walls. He was probably right: it would have been a step too far for the Imperial sensibilities. In the event, the Emperor pronounced sourly that the French Impressionists that he encountered – works by Manet, Monet, Pissarro and Renoir – 'lacked interest'. He ordered that they be relegated to a less prominent position on the second floor. Two years later Tschudi was removed from his post as gallery director. Harry Kessler had also fallen victim to the conservatives, having lost his job as director of the Weimar Museum in 1906.

It is significant that a high proportion of the first collectors of French Impressionism in Germany were Jewish. German Jews only received the franchise in 1871; this coincided with the start of a period of huge economic growth in the country, resulting in large personal fortunes being made. An inherent cosmopolitanism, reinforced by international banking connections, opened Jewish minds to what was going on in Paris. As Grodzinski notes, the new art appealed more readily to these newly rich German Jewish patrons, 'unencumbered by traditional German values such as *völkisch* historicism, images of German aristocracy or Christian religious iconography'. James Stourton suggests that increasing Jewish secularisation in the nineteenth century led to a significant transfer of energy and scholarship from the study of the Torah and Talmud towards art collecting. 'The basic spiritual aims are there as well as the desire for self-improvement', he says. 'Art collecting becomes a metaphor for spiritual improvement.' When it came to Impressionism, the essentially optimistic subject matter, projecting serenity and underlining the universality of a growing bourgeoisie, also struck chords in a Jewish patronage aspiring to freedom, liberty and assimilation. And on top of that, many of the art dealers purveying modernism, in both Paris and Berlin, were themselves Jewish.

Under these circumstances, it is no surprise to find that op-
position to Impressionism in Germany was laced with an unhealthy
mixture of nationalism and anti-semitism. Good, honest German art
was being throttled by these over-rated Frenchmen. And it was all a
Jewish conspiracy. A certain Dr Volker, writing in 1903, defined Im-
pressionism as 'a sensual force rather than an intellectual and emo-
tional assimilation', and thus 'an un-German way of seeing nature'.
He went on to identify the culprits: 'It is characteristic and signifi-
cant that the transmitters of this type of art and its first critical her-
alds are – I don't want to say Jews, but rather, and this is the essential
point – representatives of the specific Jewish spirit residing in the
West End of Berlin'.

Two years later the conservative art historian Henry Thode
went on the offensive against Meier-Graefe. Meier-Graefe's views
were the result, he said, 'of a concept of art advocated by the fanatic
admirers and lovers of French Impressionism, who have gone so far
as to call Manet a genius'. Thode expanded his attack to include the
art dealers too: 'Artists are more intimately connected with the art
dealer than ever was the case in the great ages of art...art dealers have
made a place for themselves as agents of the new'. Impressionism,
which these art dealers were peddling so vigorously, was all wrong
anyway. 'How does it relate to the German character? Does it suit us
Germans? No! Never!' On the one side, according to the conserva-
tives, stood the German conventional artists, diligent men of tradi-
tional values whose works were uplifting to the nation. On the other
side were the Jewish conspirators, peddling new-fangled French val-
ues, making themselves rich by undermining what was good about
German art. According to a contemporary satirical song:

Impressionists / Have no taste. / We Christians love / Shiny varnish /
And gleaming Germanness / And teach the citizen / Respect and
Patriotic Enthusiasm.

Opponents of Impressionism would have found a sympathetic ally in the German physician Max Nordau, who wrote an acclaimed book on degeneracy in 1895: 'Degenerates are not always criminals, prostitutes, anarchists, and pronounced lunatics; they are often authors and artists...the degenerate artist who suffers from nystagmus, or trembling of the eyeball, will in fact perceive the phenomena of nature trembling, restless, devoid of firm outline'. Impressionism as a degenerative physiological condition was an appealing argument. Nordau was formulating medically the answer to a question already posed by an American sceptic, Montague Marks, writing in September 1893: 'It would be very interesting if we could have a report from some oculist of repute as to the actual condition of the eyesight of Monet, Pissarro, Renoir, and others of the 'Impressionist' school. The measure of its departure from normal might account for much...'.

But there remained the nagging unease about French art, that it was possessed of something delicate which eluded plodding Germany. 'We Germans are probably somewhat ponderous in our views, somewhat stolid, not nervous enough', Paula Modersohn-Becker wrote home from Paris in 1900. Of the French she observed, 'the only thing about these people that really speaks is their nerves'. It was a view confirmed earlier by van Gogh: 'All the Impressionists are more or less neurotic. This renders us very sensitive to colours and their particular language, the effects of complementary colours, of their contrast and harmony'. As early as 1874 the Goncourts had written about Degas that he was 'sickly, neurotic, and so ophthalmic that he is afraid of losing his sight; but for this reason an eminently receptive creature and sensitive to the character of things'. The gleaming part of Germany wanted no part in such unhealthiness; the intelligent part wasn't so sure.

The final explosion of anti-Impressionist feeling in Germany took the form of the Vinnen Protest in 1911. Carl Vinnen himself

was a third-rate German painter, but his diatribe against foreign infiltration touched a chord. 'A great, powerfully upward-striving culture and people like ours cannot forever tolerate spiritual usurpation by an alien force', he declared. 'German and French art dealers work hand in glove, and under the guise of supporting art, flood Germany with great masses of French pictures.' Furthermore, art critics had been recruited to join the conspiracy: 'Our able writers are in the hands of the Berlin-Paris speculators!'

But there is a change of emphasis in Vinnen's invective, a shift in direction of attack. The Impressionists are no longer being criticised so much for their artistic inadequacy. It is more that the examples of their work that the deplorable French are allowing the Germans to get their hands on are of inferior quality. 'On the whole we are granted only left-overs, only those paintings not bought by the French themselves or by the great American princes of finance.' And of course prices for these 'old studio remnants by Monet, Sisley, Pissarro, etc.' are 'far too high and sure to decline'.

'The French despise us to such an extent that their arrogance is turning into insolence', Vinnen continues. 'The most pathological paintings of van Gogh's insane period, the rejected experiments and barely prepared canvases from Cézanne's estate, have been acquired with pleasure by the good German Simpletons.' As for those Germans who had actually bought Matisse and Picasso, here was a lamentable surrender not just to Parisian sensuality but – even worse – to the values of Africa. By comparison, there is now a grudging acceptance that the French Impressionists may not be entirely without merit.

This is part of a broader movement across the western world. By about 1910 the first shock of Impressionist newness had worn off. In France, in America, even in Britain, a new wave of modernism was now exciting conservative revulsion, and people turned back to the Impressionists as a safer, more familiar alternative. After all, the

colours were nice and the subjects were pleasing. The conditions were now in place for the next phase of Impressionism's development: its reinvention as a luxury commodity, its enshrining as a great age in the history of art, and the popularisation of its vision so that even a German soldier in the trenches could take pleasure in the early autumn landscape because it reminded him of a Renoir.

In the years either side of 1900, French Impressionism came to various other western European countries. The same sequence of events as in Germany tended to be repeated: a dynamic group of younger artists would secede from the conservative academy, and its members would look for their inspiration to Paris as the perceived home of advanced contemporary art. Sympathetic collectors would follow their lead, and start buying French modern art. Belgium and Holland were responsive to Impressionism early on: the avant-garde group of artists known as Les XX was showing works by Monet and Degas in Brussels in the 1880s, and Durand-Ruel had already lent Impressionist paintings to an exhibition in Rotterdam in 1883. Scandinavia was not far behind: a Manet was acquired by the National Museum in Stockholm in 1896, and in the following decade notable Impressionist collections were being formed by men like Wilhelm Hansen in Denmark. But the country where French Impressionism had most impact on collectors was Switzerland.

Over the past hundred years there have been more good Impressionist paintings owned per head of population in Switzerland than in any other country. And it is significant that the first collectors did not come from the French-speaking community but were based in Basel, Winterthur and Zurich. In other words Impressionism was received through Germany, mediated by German critics and museum directors. The profile of the typical early collector mirrored Germany's, too. It was in the north-eastern, German-speaking part of Switzerland that the most rapid economic growth took place

37 The Swiss tradition: Robert von Hirsch's discreet and
scholarly collection in Basel.

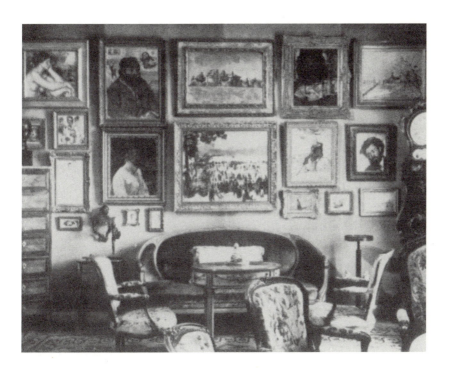

in the late nineteenth century. Large fortunes were made in steel,
chemicals and textiles. And once again it was the new rich who
proved most open to innovation in art. These were the sort of peo-
ple who first collected French modernism: the Reinhart family of
Winterthur, who owned a trading company; Sidney Brown in Baden
who was a successful electrical engineer; Hans Mettler, a St Gallen
textile magnate; the Staechelin family of Basel who were industrial
entrepreneurs.

 That ascetic strand which characterised the German recep-
tion of Impressionism was if anything even more conspicuous in
Switzerland. A commitment to French modernism was a cultural
deed, a testimony to progress. The Swiss are a serious and scrupulous
people, jealous of their privacy and independence, and collecting

Impressionist painting was usually a discreet, understated, intellectual activity. It still is. Not long ago I was asked by a TV company to help in the making of a documentary about collecting art. Could I find a collector prepared to talk to camera about his Impressionist pictures? We'll travel, the producer said gamely. We'll go to Switzerland. Every call I made was politely but firmly refused. It wasn't a surprise. You don't collect for show in Switzerland. You don't do it to impress your neighbours. In the end I had to break it to the producer: his budget was going to have to extend to America. The first three people I called there all accepted with the enthusiasm of natural performers.

In the wake of defeat in World War I, the main bulwark of opposition to modernism in Germany was swept away with the Imperial monarchy. As a measure of the change in attitude, the former Palace of the Crown Prince reopened in Berlin – with a pleasing irony – as a museum of French Impressionist, Post-Impressionist and German Expressionist Art. Germany's economic rebuilding in the 1920s and 1930s meant that new fortunes were made, and new money was spent on Impressionist pictures. A number of exceptionally discriminating collectors emerged, men like Otto Gerstenberg, Max Silberberg, Robert von Hirsch, Otto Krebs and Franz Koenigs. But the way Impressionist art was perceived, accumulated and presented was changing. Here is an extract from Harry Kessler's diary, on Sunday 8 December 1929, in Berlin:

> *Dinner at Baby Goldschmidt-Rothschild's in the Pariser Platz. Eight to ten people, intimate party, extreme luxury. Four priceless masterpieces by Manet, Cézanne, van Gogh and Monet respectively on the walls. After the meal thirty van Gogh letters, in an excessively ornate, ugly binding, were handed round with cigarettes and coffee. Poor van Gogh! I saw red and would gladly have instituted*

*a pogrom. Not out of jealousy, but disgust at the falsification and
degradation of intellectual and artistic values to mere baubles,
'luxurious' possessions.*

Luxurious possessions. How many rich houses have I been into,
75 years on, where the Impressionist painting is presented as pre-
cisely that. The phenomenon is the same across the world, in plush
residences in London or New York, in Munich or Palm Beach, in
Singapore, Moscow or Istanbul. New wealth likes to display itself;
and what better way of doing so than by hanging a Renoir or a Monet
on your wall. It makes a statement simultaneously of aesthetic sen-
sibility and huge financial muscle, a compelling combination. Per-
haps that is why each generation of new money is drawn like a mag-
net to the Impressionists. Theirs is an enduring myth. It is also the
myth of progress: we are wiser than our forefathers, Impressionist
collectors have been able to reassure themselves. During their life-
times, people didn't understand artists like van Gogh. We do.

Nazism's effect on the development of modern art and art collect-
ing in the Third Reich – and, indeed, in the other countries invaded
by Germany – was generally disastrous. The regime's opposition to
modernism went far further than anything managed by the Kaiser
and his supporters. All examples of Post-Impressionism, Expres-
sionism, Cubism, Dadaism and Surrealism were declared degener-
ate, and as far as possible confiscated from private collections and
eradicated from museums. The regime was more ambivalent about
Impressionism. It wasn't exactly approved of – Hitler's regularly ex-
pressed aversion from 'unfinished' pictures precluded that – but its
financial value was appreciated. Works were confiscated and re-sold
on the international market, or exchanged for paintings by more ac-
ceptable artists: Old Masters, or German paintings of the right sort.
Goering, on the other hand, who fancied himself as a considerable

connoisseur, had a secret liking for some Impressionist painters and owned a Renoir or two in his collection.

But one aspect of the artistic tragedy of the Nazi period was the way the great Impressionist collections in Germany were broken up, either by confiscation from Jewish owners, or by allied looting at the end of the war. The Silberberg collection could stand for many as an example of the former, and the Gerstenberg collection of the latter. Expropriations from each of them had, for differing reasons, troubling repercussions extending into the twenty-first century.

Max Silberberg was a Breslau machine-tool magnate who accumlated a fortune in the early part of the twentieth century and spent some of it on major French Impressionist and Post-Impressionist paintings. He owned important works by, among others, van Gogh, Pissarro, Monet and Cézanne. When the Nazis came to power in 1933, he found himself as a Jew the victim of an escalating persecution: first his rights were threatened, then his property, then his life itself. Some Jews managed to get out of Germany in time. Silberberg didn't. He sold much of his art collection at auction in Berlin in 1935. He died in Theresienstadt concentration camp in May 1942.

There the story might have ended, yet one more miserable result of the Holocaust. But 50 years on in the mid-1990s a Berlin lawyer, Dr Jost von Trott, became interested in the fate of the Silberberg collection. He dug around in newly accessible archives from East Germany and discovered that Silberberg hadn't received the proceeds of the paintings he'd sold at auction in Berlin in 1935. The money had gone to the Nazi authorities. It had been a forced sale, and therefore illegal. The buyers did not have good title to their purchases. Therefore ownership remained with Silberberg, or at least his estate. Who had been his heirs? Von Trott dug around further. There was evidence that Silberberg had had a son. It was suggested that the son had escaped to England in 1938/39, but no one knew what had happened to him after that.

38 Hermann Goering, the art connoisseur.

39 Van Gogh, *Olive Trees*, 1889: restituted from the
National Gallery, Berlin to the Silberberg family in 2000.

Being a diligent man, von Trott ordered up as many current British telephone directories as he could lay hands on. He went through each looking for the name Silberberg. Finally he found a possible match: a Mrs Gerta Silberberg, a widow in her mid-eighties living modestly in a village near Leicester. It turned out that she was indeed Silberberg's daughter-in-law. She and her late husband had got out of Germany just before the war. Von Trott told her that she was the sole heir to the Silberberg pictures.

A particularly beautiful van Gogh drawing included in the 1935 Silberberg auction had been acquired by the National Gallery in Berlin. When von Trott pointed out to them that legally this was still the property of the Silberberg family, they handed it back with commendable speed. Mrs Silberberg decided to sell it at Sotheby's, where it came up in June 2000. It made £5 million. The press got hold of the story and cast Mrs Silberberg in the role of a lottery winner. But of course it wasn't actually like that.

Before the sale in London Mrs Silberberg told me she had no desire to see the van Gogh again. It evoked too many painful memories. But the day after the auction, when it transpired that the new buyer was Ronald Lauder and he planned to donate it to the Museum of Modern Art in New York, she called me on the telephone. She felt that, after all, she needed to see it one more time before it went to America.

I met her at the front counter in Sotheby's. She made a strong impression: an elderly white-haired woman who was still remarkably clear-minded, with a brisk and forceful intelligence that belied her frail appearance. I reflected that just to have survived the experiences she had undergone in her life demanded an exceptional determination. I took her up to a private viewing room overlooking the well-heeled shoppers milling about Bond Street. We stood together, waiting for the porter to bring the van Gogh. Finally it came in and was unveiled on the easel, a field of olive trees, swirling in marvellously calligraphic strokes of the reed-pen. But at the same time it was a disquieting image, uncomfortably expressive of mental suffering. Whose? The artist's? Silberberg's? Or that of the old lady at my side? She swayed. I got her a chair. She closed her eyes. It was a moment of extraordinary poignancy. She told me that the last time she had seen the drawing had been 66 years before, on the drawing-room wall of her father-in-law's house in Breslau. The £5 million was irrelevant. This was no lottery winner.

Otto Gerstenberg was a successful insurance mogul who was already buying French Impressionist pictures before World War I. In 1912 he acquired what was the *chef-d'oeuvre* of his collection, the magnificent 1875 Degas of *La Place de la Concorde*, paying 120,000 marks for it from Cassirer. The picture was housed alongside his great Renoirs and Daumiers in his palatial villa in Berlin. He died in 1935, at which point his collection was inherited by his daughter Margarethe Scharf. Then came the war.

40 Presumed destroyed in World War II: a typical
post-war reference to Degas's *Place de la Concorde*.

DEGAS: *Place de la Concorde,
Paris* (Viscount Lepic and his
daughters), c. 1875. 31¾ ×
47¼". Apparently destroyed
during World War II.

As Berlin found itself increasingly under aerial attack, art collections had to be moved to places of greater safety. Most of the Gerstenberg/Scharf collection was found refuge, together with various treasures from the Berlin museums including the Trojan gold from the Schliemann collection, in a fortress-like anti-aircraft tower at the Berlin zoo. Its walls, constructed of reinforced concrete two metres thick, were understood to be bomb-proof. It was a measure of how far Impressionism had come: 75 years earlier Prussian soldiers had been cleaning their boots with Pissarro landscapes. Now room was eagerly being found in the ultimate repository of German national art treasures at a time of acute emergency for works by Renoir and Degas.

The walls of the zoo tower may have been bomb-proof, but they were not immune to the physical invasion of Soviet troops when Berlin fell in April 1945. What the Russians found in the tower was enthusiastically packed up and transported back to Moscow and Leningrad. This operation was carefully overseen by the Red Army Trophy Brigades. These were units of art historians in uniform specially deployed in order to lay hands on as much German-owned art as possible and claim it for the Soviet Union. It was not a looting operation

41 The fortress in the Berlin zoo, which withstood
Allied bombing but not the Soviet Trophy Brigades.

in Soviet eyes, but a German contribution to war reparations. After all, the Nazis had been the aggressors in the Great Patriotic War just ended, and their invasion had devastated the western part of Russia inflicting vast losses. It was an understandable reaction. What is interesting is the term 'Trophy Brigades'. The Scharf/Gerstenberg Degas and Renoirs were borne off by the Soviets as 'trophies' in much the same spirit of acquisition as Russian oligarchs bear Impressionist paintings off today as 'trophies' (although this time having paid the market price for them at Sotheby's or Christie's).

The war ended, and the Cold War began. In the atmosphere of hostility and mistrust, it became Soviet policy to deny the existence of the works of art they had removed from Germany in 1945. The Scharf pictures were held in a secret store room in the bowels of the Hermitage Museum in Leningrad and forgotten about, victims of political necessity. The idea that they had actually perished at the end of the war took root. In fact if you consult books – as I did – published on Degas between 1945 and the early 1990s, you will sometimes find the magnificent *Place de la Concorde* reproduced from an old photograph, regretfully registered as 'destroyed during World War II'.

Then came peristroika, glasnost and the fall of communism. In the new atmosphere of openness, the Russian authorities admitted that they were indeed still 'safe-guarding' certain works taken from Germany in 1945. The Scharf family asked Sotheby's to investigate the situation. So it was that I found myself, one bitter winter afternoon, leaving the frozen Neva behind me and being ushered down into the secret basements of the Hermitage Museum. We were confronted with a large cupboard. A very ancient porter with a very large key stepped forward. The door swung open; and there, stacked unframed against each other, were the pictures. A minute or two later I was actually holding in my hands the Degas *Place de la Concorde*. It was a sublime moment of resurrection.

42 and 43 Shchukin and Morozov, pioneer Russian
collectors of Impressionist and modern art.

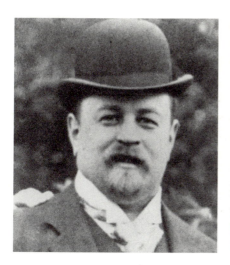 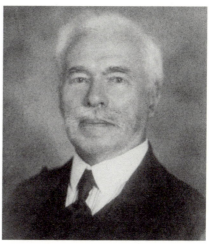

Memories are long in Russia, and the Scharfs still have not
got their pictures back. It is doubtful that they ever will: Moscow
argues that war reparations are not restitutable. But the paintings
are at least on view again in the Hermitage. In a way they reconnect
Russia to its own great heritage of French modernist art collecting,
which began when Sergei Shchukin and Ivan Morozov started buy-
ing the Impressionists in the late 1890s. Unlike the Swiss, whose
discovery of the movement was filtered through Germany, these
two great Russian pre-Revolution collectors went direct to France.
Morozov inherited a fortune made in cotton. Shchukin's family,
too, was in the cloth business. The Americans call them *garmenti*,
the people who have made their money in some area of the cloth-
ing industry – textile magnates, cloth merchants, fashion designers.
It's interesting the way that, from the very beginning, they tended
to be drawn to Impressionist pictures. Why? Presumably because
they were merchants rather than aristocrats, and therefore less
ensnared in old taste and more drawn to new art; and also because
of an aesthetic correlation between couture and modernism. In

the case of Shchukin and Morozov, there was the added element of the legendary business acumen and love of risk common to certain Moscow industrialists, which found an echo in the experimentation and innovation characterising contemporary French art of the time.

Sergei Shchukin's first encounter with French Impressionism made a deep impact on him. It was an exhibition devoted to French art which came to both Saint Petersburg and Moscow in 1896. Included were works (contributed by the far-sighted Durand-Ruel) by Monet, Degas, Renoir and Sisley. This was the momentous exhibition at which Kandinsky saw the Monet *Haystacks* which opened his eyes to the potential of abstract art. Shchukin was bowled over by another Monet, *Cliffs at Etretat*. Three years later he managed to buy it from Durand-Ruel. He amassed 13 of the artist's works, and dedicated an entire gallery in his Moscow palace to them.

Their family business interests meant that both Shchukin and Morozov had reason to visit Paris, as the home of couture, at the end of the nineteenth century. They liked the new art that they found there, and by 1904 their sympathies had expanded to include the works of the Post-Impressionists, Cézanne, Gauguin and van Gogh. By 1910, they had moved on to Picasso and Matisse. The two collectors differed in temperament, Shchukin being more passionate and headstrong while Morozov was calmer and more contemplative. But each brought back astounding examples of avant-garde art to their Moscow palaces, to which they allowed the public occasional access, with the result that there were two separate collections of up-to-the-minute French modernism available to Russian art-lovers before World War I. 'Russia and snowy Moscow can be proud that they have given loving shelter to these flowers of eternal summer which their official mother-stepmother France, failed to pick up', exulted the Russian critic Yacov Tugendhold. Wider acceptance of the new art, however, was inevitably a slow process. As late as 1908 one gallery visitor was still rendered indignant enough by the sight of a

44 The Monet Room in Shchukin's Palace, Moscow.

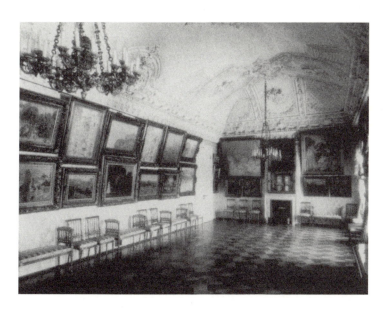

Monet landscape to attack it with a pencil. But the Shchukin and the Morozov collections survived not just early assaults by pencil but also later nationalisation – and attempts at marginalisation – by the Soviets. Today they form the superb holdings visible in the Hermitage and the Pushkin Museums.

Nowhere was French Impressionism weighted with such political significance as in Germany in the first half of the twentieth century. Collecting it became emblematic of an internationalist outlook: progressive to some, unpatriotic to others. It was variously vilified as unpatriotic, or eulogised as progressive. It was identified as a Jewish taste, which provided a focus for anti-semitism. It teetered on the edge of being declared degenerate. The sad consequence of this politicisation was that by the time the ashes of defeat settled on Germany in 1945, most of the great Impressionist collections had been destroyed. The cultural deed had been undone.

MORMONS IN ST PAUL'S

The British Response to Impressionism

———

If **America's positive** response to Impressionism reflected an un-critical idolisation of France, the much more negative British reaction was conditioned by a deeply embedded tradition of hostility to their nearest continental neighbour. From Hastings to Waterloo via Agincourt, the main threat to Britain's security – as every Briton knew – had come from French militarism. You couldn't trust them. Benjamin Haydon, a mediocre English history painter but inspired diarist, voiced the prevailing mid nineteenth-century view of cross-channel relations:

> A Sincere Friendship between England & France is utterly impossi-ble – France, gay, blasphemous, volatile, bloody, bawdy, amiable, & unprincipled, instinctively military, can never unite with a Nation, solid, virtuous, commercial, religious, philosophical, un-military, & money getting.

When Prussia invaded France in 1870, most Britons cheered from the sidelines for the Germans. Even Queen Victoria confided to her diary her wish to see the French defeated. 'Vapouring, vainglorious, gesticulating, quarrelsome, restless and over-sensitive France', was Thomas Carlyle's verdict. It echoed his wife's view of the country as 'this land of fops and pastry cooks, where Vanity and Sensuality have set up their chosen shrine'.

English suspicion of France centred on two things. France was a nation of such political instability that at any moment the people might rise up in revolt against those in power. This was a dangerously close-at-hand example for the British lower orders, a threat to the established order of things, and a source of unease for the British ruling class. Then there was the immorality. Paris was recognised to be the modern Babylon. As such, it exerted a simultaneous horror and guilty fascination. It was the city where Englishmen went to sin furtively; and, in the last resort, the city where they went into exile if they had been too damagingly found out.

Whereas in America and Germany there was no shortage of commentators prepared to declare their cultural subservience to France, it was not an admission that the British found easy to make. George Moore was swimming against the current when he declared in 1888: 'Everyone must go to France. France is the source of all the arts'. His testimony was tainted in British eyes because he'd lived in Paris for some time; he was Irish, anyway, and therefore eccentric. A more typical British attitude was the reaction to an international art exhibition held in Leeds in 1868. Reporting the event, the *London Art Journal* rejoiced that no French landscapes had found buyers. It was a corrective to 'the inordinate conceit of the French, who make boast of themselves as the first landscape painters in the world'.

Against this background it is not surprising that the English did not assimilate a revolutionary new vision of landscape painting emanating from the other side of the channel, when they first

became aware of it a few years later. One of the earliest mentions of a Parisian Impressionist exhibition appeared in *The Times* in April 1874. 'One seems to see in such work evidence of as wild a spirit of anarchy at work in French painting as in French politics', said the head-shaking reviewer, for whom the phenomenon was a sad recurrence of the excesses of the Paris Commune. Two years later, Henry James identified a more specifically artistic reason why Impressionism was unsympathetic to the British. Impressionist truth to nature was alien to the British version of Realism as manifested in the Pre-Raphaelites:

> When the English realists 'went in', as the phrase is, for hard truth and stern fact, an irresistible instinct of righteousness caused them to try and purchase forgiveness for their infidelity to the old more or less moral proprieties and conventionalities, by an exquisite, patient, virtuous manipulation – by being above all things laborious. But the Impressionists, who, I think, are more consistent, abjure virtue altogether, and declare that a subject which has been crudely chosen shall be loosely treated. They send detail to the dogs and concentrate themselves on general expression....The Englishmen, in a word, were pedants, and the Frenchmen are cynics.

If the English were pedants, they were also hypocrites. Paris as the modern Babylon was condemned as a scandalous outrage. But ancient Babylon itself, as a subject for a painting by a Royal Academician, was perfectly acceptable. When Edwin Long's *Babylonian Marriage Market* fetched 6,300 guineas at auction at Christie's in 1882, it was the highest price paid to date for a work by a living artist. It was the Victorian equivalent of one of those TV documentaries that purport to be serious investigations into pornography, and end up being a bit of soft porn themselves. A selection of nubile women in a state of undress are shown being offered for sale to an enthusiastic

45 Academicism as titillation: Long, *The Babylonian Marriage Market*, 1875.

group of male buyers. But various factors made it acceptable. First, it was comfortably anecdotal, and told an intriguing story. Second, it was set in a far-off time in a distant land. It was regrettable that women in those days shed their clothes and were offered for sale, but it was a historical fact vouched for by Herodotus, and look what moral progress we've made since. And third, the figures depicted conformed to an ideal of classical beauty. They weren't ugly, like those dreadful washerwomen and ballet dancers, those drunken hags in Parisian cafés that Degas and Manet delighted in depicting.

An art like Impressionism which so mercilessly ruptured the connection between literature and painting, opposed so firmly the fond Victorian belief that every picture should tell a story, and a moral story at that, was not going to meet with instant popularity. There was no shortage of distinguished English artists ready to do battle with the new painting. 'The new French school is simple putrescence and decomposition', wrote Rossetti to his brother. His fellow Pre-Raphaelite, Holman Hunt, went on record in 1883 to 'warn the

world that the threat to modern art, meaning nothing less than its extinction, is Impressionism'. But in 1888 William Frith, the painter of such supremely anecdotal pictures as *Derby Day* and *Ramsgate Sands*, calmed the anxieties of the British public by assuring them that 'the craze (for Impressionism) will assuredly pass away, as everything foolish and false does sooner or later'. This may have been wishful thinking on Frith's part, but it was a view widely held in British art circles at the time. French Impressionism is a passing fad, and we don't need to bother with it.

It is ironic that the city where three of the young Impressionists – Monet, Pissarro and Sisley – sought refuge from the Franco-Prussian War was London. That same winter of 1870/71, Durand-Ruel opened a gallery there at 168 New Bond Street. It lasted five years, showing a mixture of Barbizon School paintings, genre scenes and the occasional more advanced work by the Impressionists. But little impact was made. Sisley was shunned by his English relations who found him 'queer'. Monet sold nothing to English buyers. Pissarro went back to France at the earliest possible opportunity in the summer of 1871, thoroughly disheartened by his English experience. He wrote from London to Théodore Duret:

> It's only when you're abroad that you realise how beautiful, grand and hospitable France is. What a difference here! One gets only ill-will and indifference, even rudeness, and from other artists jealousy and the most selfish hostility. My painting doesn't take.

'My painting does not take.' As news seeped through to London of successive Impressionist exhibitions in Paris in the 1870s, hostile British critics objected to the pictures that were produced on three grounds: the colours were too bright; the pictures looked unfinished; and there was a perverse disregard of beauty in favour of the gutter in the choice of subject matter. Even Whistler, who was

46 Christie's in 1887, when the saleroom was less
catholic in its appreciation of avant-garde art.

one of the most influential bridges between avant-garde Paris and
London, had his reservations about the lack of discrimination which
the Impressionists showed as innocent retinas in the face of nature.
He observed scornfully: '"Nature is to be taken as she is" is to say to
the player that he may sit on the piano'.

Collectors in Britain who chose actually to buy French Impression-
ist pictures in the nineteenth century needed to be extremely inde-
pendent-minded, and were therefore very few and far between. One
of the first was a retired soldier in Brighton called Captain Henry
Hill, who was buying from Durand-Ruel's Bond Street Gallery until
it closed in 1875. It is tantalising not to know more about Hill; what
first drew him into the gallery, and to the Impressionists in particu-
lar? Was he just wandering down Bond Street after a good lunch with
a spare half hour to fill? Was his first encounter with these strange

47 Hissed when auctioned at Christie's in 1892: Degas,
L'Absinthe, 1876. (See pl. 5.)

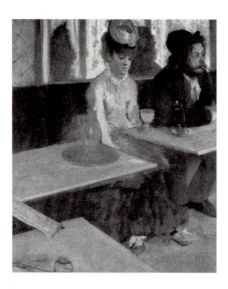

new painters an apocalyptic experience? It seems to have been Degas
who caught his eye. He bought seven examples by the artist, includ-
ing the major work *L'Absinthe* now in the Musée d'Orsay.

In 1876 Hill lent *L'Absinthe* to an exhibition of modern pictures
in Brighton. The critic of the *Brighton Gazette* remarked upon 'the
very disgusting novelty of the subject'. The British public was not yet
ready for a painting showing a down-at-heel man and woman drink-
ing spirits in a Parisian café. Nor had things changed much sixteen
years later when, after Hill's death, his pictures came under the ham-
mer at Christie's. When *L'Absinthe* (lot 209 on 19 February 1892) was
presented to the room, the assembled bidders hissed it. Why? Part-
ly because of its controversial subject matter; and partly, one sus-
pects, simply because of its Frenchness. Arrogant little garlic-eat-
ers, infecting our good British sale rooms with their foreign muck.
And what sort of a drink is absinthe, anyway? What's wrong with a
whisky and soda? More than a century on, can anyone imagine buy-
ers greeting so critically a work of contemporary art about to be of-

fered to the ravening market at Sotheby's or Christie's? It is almost unthinkable; and a measure of the extent to which artistic innovation is now prized, simply for its newness – an equally unthinkable idea to people in Christie's in 1892. Or indeed as recently as the 1970s: I remember when I worked at Christie's and sales exclusively devoted to contemporary art were first instituted, I leant over the banisters with most of the directors of the firm, sniggering at the outlandish art on display and even more outlandish collectors trooping up the main stairs to bid on it. That is a measure of how much Christie's changed in the last quarter of the twentieth century. But that is another story.

L'Absinthe fetched 180 guineas in 1892. It was bought by Alexander Reid and sold on to a Scottish collector, Arthur Kay. It reappeared in London in 1893, lent to Durand-Ruel's Grafton Gallery. This gave the critics another opportunity to mull over its shortcomings. One writer who attempted a spirited defence of it was George Moore, once again. He knew the Impressionists personally having lived among them in Paris in the 1880s. But the muddle he got himself into is indicative of how confused even sympathetic London commentators were by the new French art. His analysis of the picture's formal qualities is a sensitive one: 'The beautiful, dissonant rhythm of that composition', he writes, 'is like a page of Wagner – the figures crushed into the right of the canvas, the left filled up with a fragment of marble table running in sharp perspective into the foreground'. But, describing the woman depicted, Moore gets carried away:

> ...[She] was at the Elysée Montmartre until two in the morning, then she went to the Ratmort and had a soupe aux choux; she lives in the rue Fontaine, or perhaps the rue Breda; she did not get up till half past eleven; then she tied a few soiled petticoats round her, slipped on that peignoir, thrust her feet into those loose morning shoes, and came down to the café to have an absinthe before breakfast.

Heavens! What a slut! A life of idleness and low vice is upon her face; we read there her whole life. The tale is not a pleasant one, but it is a lesson.

The tale is not a pleasant one, but it is a lesson. Oh, dear. Moore has fallen back into the bad old ways of English art criticism, with its insatiable need to see a story in a picture, and a moral one at that. Too late he realised his mistake, so damaging to his credentials of enlightenment. What agonies of remorse he must have suffered before he could retract it. The following week he rushed back into print, clambering maladroitly back on to the avant-garde bandwagon:

I plead guilty to the grave offence of having suggested that a work of art is more than a work of art. The picture is only a work of art and therefore void of all ethical signification. In writing the abominable phrase 'but it is a lesson', I admitted as a truth the ridiculous contention that a work of art may influence a man's moral conduct.

L'Absinthe returned to France the following year, sold by Arthur Kay to Count Camondo. It was probably the best place for it. In the last years of the nineteenth century the British developed two strategies for dealing with Impressionism: either to disregard it totally, and hope it would go away, or to sanitise it, to interpret it in ways that made it more acceptable, to bend it to English predilections. At the New English Art Club, an English version of Impressionism was manufactured, which managed to combine certain superficial elements of the Impressionist technique with a residual sentimentality of subject matter. Then there was Sargent. Sargent was an effective integrator of Impressionism into the taste of the English Establishment. He deployed an undeniably Impressionist brush stroke, but on portraits of the 'great and good' which the sitters rather liked as they found themselves endowed with a certain flashy style. And gradu-

ally people came round to Monet. Seized upon as a happy antidote to the ugliness of Degas, in English hands he was repackaged as a minor Lakeland poet, or as some sort of imitation Robert Browning. Here is the magazine *The Artist* waxing lyrical about Monet's landscapes in 1883:

> *How remarkable in them all is the expression of nature! We seem in one to feel the breeze which bends the long grass on the cliff and ruffles the surface of the sea below; in another we almost perceive the quiver of the leaves which cast a flickering shadow on the sunscorched ground.*

And by 1904, Wynford Dewhurst had gone totally over the top:

> *Monet is a lyrical poet, singing the joy of life and nature.... In every picture he paints we seem to hear Pippa singing:*
> *'The year's at the Spring,*
> *The day's at the morn;*
> *Morning's at seven;*
> *The hill-side's dew-pearled;*
> *The lark's on the wing,*
> *The snail's on the thorn:*
> *God's in his heaven*
> *All's right with the world.'*

It was left to Oscar Wilde, in *The Decay of Lying* (1891), to inject a more satirical note into the analysis of French modernism, and in so doing subtly to underline how insidiously the Impressionist vision was taking hold even in Britain:

> *Where, if not from the Impressionists, do we get those wonderful brown fogs that come creeping down our streets?... The lovely*

silver mists that brood over our river, and turn to faint forms of fading grace curved bridge and swaying barge? The extraordinary change that has taken place in the climate of London during the last ten years is entirely due to a particular school of Art.... Things are because we see them, and what we see, and how we see it, depends on the Arts that have influenced us.

Wilde is right, of course. Once you have looked at enough Impressionist landscapes, it is amazing how much nature starts resembling one. Ask Sergeant Zschuppe. But Wilde couldn't resist a final sally on the connection between meteorology and art:

Now, it must be admitted, fogs are carried to excess. They have become the mere mannerism of a clique, and the exaggerated realism of their method gives dull people bronchitis. Where the cultured catch an effect, the uncultured catch cold.

Up to 1905, Douglas Cooper calculates, English collectors owned or had owned 25 works by Degas, 6 or so by Manet, 4 by Monet, and between 10 and 20 others by Pissarro, Renoir, Sisley and van Gogh. It was not a particularly extensive 'bag' after 35 years' exposure, when you consider what had happened by this time in America and Germany. Worse, the only painting by any Impressionist that had entered a public collection in Britain had done so only as a footnote, a single barely registered Degas accepted by the Victoria and Albert Museum as part of the much larger Ionides Collection in 1901. There was a lack of any native British dealers prepared to take on the Cassirer role in launching Impressionism in a concerted way. The closest to a British Cassirer was the Scotsman Alexander Reid, who had worked for Theo van Gogh's dealership Boussod Valadon in Paris in the 1880s, and had even befriended Vincent. When he came back to Britain, Reid operated between Glasgow and London, but he

rarely put his own money into French modernist artists, preferring to take works on commission from Durand-Ruel. He tended to deal in the safer Barbizon School, and his commitment to Impressionism remained half-hearted until about 1910. But then again, how far can a dealer actually direct taste, as opposed to forecasting its direction and going with it? Even Durand-Ruel, you could argue, did not himself create Impressionism; he was merely in the right place at the right time to exploit a happy coincidence of events in the second half of the nineteenth century: huge new wealth being made in the new, young country of America; that country's idolisation of Paris; and the emergence of a young group of Parisian painters with a new and distinctive brand of painting to market.

But in the middle of the first decade of the twentieth century, things began to change in Britain, too. Up till that point, if you had asked the average Englishman in the street who would be the enemy in the next war, he would still have answered France. But in 1904 the Entente Cordiale was signed, heralding a new era of more friendly relations between the two countries; and suddenly the English realised that their more likely opponents in the future would be Germany. Is it more than coincidence that the following year the biggest exhibition of French modern art ever mounted in London was put on by Durand-Ruel? Twelve thousand people attended the show in the Grafton Gallery. Three hundred works by Degas, Manet, Monet, Renoir, Pissarro and Sisley were on view. It didn't lead to a large surge in sales. But Impressionism had finally arrived, and was there to stay. It could no longer be disregarded.

It could no longer be disregarded, that is, unless you were a museum trustee. Still no works were acquired by either the recently founded Tate or the National Gallery. The Trustees of the latter even refused a Degas offered them as a gift in 1905. That same year, at Durand-Ruel's London exhibition, even the National Gallery of Melbourne bought a Pissarro. Frank Rutter, the art critic of *The*

48 The Entente Cordiale: the major French Impression-
ist exhibition in London in 1905.

Sunday Times, tried to drag the English museums into the twentieth century by starting a public fund for the purchase of a suitable Impressionist painting from the Durand-Ruel exhibition to donate to the Nation. 'Five thousand pounds spent now', he wrote presciently, 'will purchase works which in a hundred years time £50,000 will not buy'. One hundred and sixty pounds was raised, enough to buy Monet's *Vétheuil: Sunshine and Snow*. You could almost hear Pippa singing in the distance.

But that was to reckon without the intransigeance of the British art establishment. The National Gallery told Rutter that, regretfully, they were unable by their constitution to accept the work of a living artist. The Tate declared, equally regretfully, that while they were able to accept the work of living artists, those artists had to be British. Right, said Rutter. We'll get something by Manet, Pissarro or

49 Orpen, *Homage to Manet*, 1909, showing Hugh Lane
(seated far right).

Sisley for the National Gallery. They're all safely dead. Much sucking of teeth by the National Gallery Trustees, who were finally smoked out. 'Actually, old chap, they're a bit advanced for us.' In the end, a compromise was agreed. An anodyne seascape by Boudin was purchased and presented to the nation. Boudin was, by general consent, less controversial than a fully fledged Impressionist. And he was, incontrovertibly, dead.

One pioneer British collector of Impressionist art, however, did make his first purchase through Durand-Ruel in 1905. That was the Irishman, Hugh Lane, who put together the first significant collection in the British Isles. He was a successful dealer, a man with a highly discriminating eye, who had become rich through trading in Old Masters. He now turned his attention to modern art. By the end of the year he had acquired important works by Manet, Monet (the view of Vétheuil that Rutter had earmarked), Pissarro and Renoir; in 1912, he bought the magnificent *Sur la plage* by Degas. Sir William Orpen's painting *Homage to Manet* depicts Hugh Lane at the centre of a group of early twentieth-century British artists who were prepared to acknowledge their debt to French Impressionism.

Lane's Impressionist collection was a labour of love. He put it together not for trading purposes, but for the cultural benefit of the Irish people: it was Lane's intention to give the collection to his native Dublin. A contemporary cartoonist came out with a rather cruel caricature of Lane attempting to edify a throng of brutish Irishmen with a load of Manets. Perhaps the cartoonist was right about Dublin's readiness for the donation: by 1913 Lane had become impatient with the way the city was dragging its feet about building a municipal gallery to house his 39 modern French pictures, and he offered them on loan to the National Gallery in London instead.

Would the English show any more gratitude for such cultural largesse? The decision as to whether to accept the loan was extensively debated by the National Gallery Trustees in 1914. It aroused

50 Prepared to fight Mormons in St Paul's Cathedral:
Lord Redesdale.

passionate feelings. The most violent opponent of the idea was Lord
Redesdale, grandfather of the Mitford sisters. In a memorable out-
burst, he declared:

> *I should as soon expect to hear of a mormon service being conducted
> in St Paul's Cathedral as to see an exhibition of the modern French
> art-rebels in the sacred precincts of Trafalgar Square.*

Redesdale went on to elaborate on the evils of Impressionism. The
only Impressionist artist he could bring himself to analyse was
Sargent, (who at least had the saving grace of being British by
adoption):

> *With almost demonic cleverness he [Sargent] makes a splash or two
> of paint do duty for a hand, an ear, a fan or what not, sparing him-
> self the tedium of detail.*

Redesdale feels he's the victim of a deception, some sort of sleight of hand, and he doesn't like it. But what really upsets him is the laziness of the Impressionist artist. A splash or two of paint and the cunning devil thinks he's done enough to merit inclusion in the National Gallery. How dare he spare himself the tedium of detail? It's not British to avoid hard work. Good art should be laborious and pain-staking. Redesdale comes to much the same conclusion about French Impressionism as Henry James had forty years earlier: it was the work of cynics.

In the end the Trustees' decision on the Lane pictures was an uneasy fudge, a bit like the French Museums' compromise over the Caillebotte Bequest twenty years earlier. They decided that only 15 of Lane's 39 pictures were to be put on view. Lane objected: it was all or nothing. The Trustees wouldn't yield. So the whole collection went into the cellars for storage and no one saw any of it for a few years. Lane, tragically, went down with the *Lusitania* in 1915. And it was only in 1917 that his pictures came out again and were exhibited in a special show. An inadequately witnessed codicil to Lane's will, bequeathing the pictures to Dublin after all, has been the cause of Anglo-Irish acrimony ever since. The pictures remain in London.

If the first significant collector of French Impressionism in Britain was a retired soldier in Brighton, and the second was an Irish-man looking to put Dublin on the map, then it is entirely appropriate that the third and fourth should turn out to be two Welsh Methodist spinster sisters. By 1907 Miss Gwendoline and Miss Margaret Davies, still in their twenties, had inherited massive fortunes accumulated by their grandfather and father in the Welsh coal boom of the late nineteenth century. They had been brought up strictly: their grand-father was such a firm Sabbatarian that he refused even to open a letter on a Sunday, while the only drink available in his household, even for guests, was lemonade. But the sisters expanded their own horizons. How they did this is a fascinating illustration of the way

51 Taste and audacity in the wilds of Wales: Margaret
 Davies, c. 1910.
52 Picking her way through the debris of civilisation:
 Gwendoline Davies in Arras Cathedral, 1919.

the killjoy fog of Puritanism in bourgeois Welsh life was gradually dispersed at the turn of the century by injections of aestheticism and social conscience.

Gwendoline and Margaret travelled on the continent to Italy, Germany and France and educated themselves in art history. In 1908 they started buying pictures and sculpture, spending heavily on Turner landscapes. They were advised by the English dealer Hugh Blaker – whom they met because he was the brother of their governess – but there is no doubt that they had their own views and tastes in art. A visit to the Paris Salon in 1909 prompted Margaret to report: 'One sees some very striking portraits, some pretty landscapes, some good groups and also many I do not care for, they are too Impressionist to suit one'. This was not a promising reaction, but something must have happened in the ensuing three years to open the sisters' eyes to modern French art. In August 1912, Monet was on their minds and Hugh Blaker was writing to them:

> I am delighted that you think of getting some examples of the Impressionists of 1870. Very few English collectors, except Hugh Lane, have bought them at all, although much of their best work is in America already. I expect you also know the work of Sisley, Pissarro and Renoir. These can still be got quite cheaply.

In October they took the plunge, buying three Monet views of Venice. The next year more Monet followed, including three waterlilies paintings, plus a Manet snow scene and a fine Renoir, *La Parisienne*. By the end of the decade they had accumulated a Gauguin, 3 Cézannes, and a van Gogh, as well as sculpture by Degas and Rodin. They bought mostly in Paris from Durand-Ruel and Bernheim-Jeune, shipping their trophies back to their house in the wilds of Montgomeryshire.

But in the meantime the Great War intervened. With admirable courage and determination, the two sisters went out to France and set up a canteen on Troyes station ministering comforts to British troops on their way to the front. But the experience recast their vision of the world, and their art collecting diminished. Gwendoline wrote in 1921: 'I have not bought any (pictures) for 18 months, we simply cannot, in the face of the appalling need everywhere, Russian children, Earl Haig's ex-soldiers, all so terribly human'. Thereafter their energies were given over to cultural and social philanthropy, and most of their splendid collection ended up in the National Gallery of Wales.

It is frustrating to have no testimony from the sisters as to the development of their taste for French modernism between 1909 and 1912. But perhaps a pattern of outsiderhood is emerging: Hill the Brighton provincial, Lane the Irishman, the Davies sisters who are not only mere women but also from Wales. None of them belongs to the London-centric mainstream of English society. What also comes in with the Davies sisters is a feeling that art – and particularly avant-garde art, with its cleansing new vision – can improve people: the collectors themselves, who can grow spiritually through their acquisitions, and society at large by being given access to it. My American client Mrs Markovich, growing as a human being through her collection, was paying an unconscious tribute to the example set by Gwendoline and Margaret.

Conspicuously missing from British collecting of French Impressionism up till 1920 is what facilitated progress in America and other European countries, namely the participation of captains of industry. The men who were making large amounts of money in Britain either side of 1900 – and there were many of them: financiers, manufacturing magnates, mining, railway and press moguls – were not attracted to French modern art in the way that their counterparts

were in Germany, France, Switzerland and even Russia. New rich taste was drawn in other directions, generally to safer, more traditional options. There was a vogue for English eighteenth-century painting: by hanging such works on your wall you were creating a spurious provenance for yourself, enshrouding yourself in aristocratic taste, giving yourself the camouflage that would enable you to pass for the real thing. It was an early form of money-laundering, the process whereby investment in old art turned new money into old. If on the other hand you collected French Impressionists you were not linking your name to a great tradition. You were in effect advertising your parvenu status, confessing to not quite being a gentleman.

The first industrial magnate in Britain to make a significant and unequivocal commitment to French Impressionism was Samuel Courtauld. Born in 1876, he took on the family silk business and, in the Great War and the years after, presided over its transformation into a hugely successful international concern. He is another collector to add to the list of *garmenti*. There may be even more significance in the fact that, like the Davies sisters, he had a Non-Conformist (in this case Unitarian) upbringing. The pattern of outsiderhood is repeated, in the sense that Courtauld with his Unitarian background was not a member of that privileged and entrenched section of the British establishment represented by someone like Lord Redesdale. Accepting innovation therefore came easier to him. And, as with the Davies sisters, Impressionism may even have made an extra impact of joyousness on a spirit earlier on in his life repressed by Puritanism. But that same Puritanism inherent in his upbringing may also have predisposed him to public service, and amplified a sense of mission in his collecting. Trips to Paris and Italy awakened in him an initial interest in Old Masters, and his first purchases were in that field. What later redefined his taste was – rather neatly – contact with works from both the Hugh Lane and Gwendoline Davies collections. He tells the story himself:

53 Samuel Courtauld, the man who lived by his eye.

My second real 'eye-opener' was the Hugh Lane Collection which was exhibited in London at the Tate Gallery in 1917. There I remember especially Renoir's Parapluies, *Manet's* Musique des Tuileries *and Degas'* Plage à Trouville.... *I knew nothing of Cézanne, but I was initiated in a curious way: A young friend who was a painter of conventional portraits and had been serving in the Royal Flying Corps, led me to Cézanne's* Provençale Landscape, *belonging to Miss Davies, at an exhibition of the Burlington Fine Arts Club. Though genuinely moved, he was not very lucid, and he finished by saying, in typical airman's language, 'It makes you go this way, and that way, and then off the deep end altogether!' At that moment I felt the magic....*

Going off the deep end. It is a good summing up of the early British attitude to the appreciation of French modernist art. You were out of your depth. But a few hardy souls jumped in. If you were lucky you found you could swim; and in time the experience even became rather invigorating.

So Samuel Courtauld launched himself into the business of collecting French Impressionism. In the 1920s he bought an extraordinarily high proportion of masterpieces, as any visitor to the Courtauld Institute can see today. Manet's *Bar at the Folies-Bergère*, Renoir's *La Loge*, Seurat's *Une Baignade*, Gauguin's *Te Rerioa*, and Cézanne's *La Montagne Sainte-Victoire* are such familiar images as almost to have become visual clichés. But their supreme quality is a tribute to the discrimination of the man who bought them all within a 5-year period between 1924 and 1929. He was a collector who lived by his eye: he described himself as 'fascinated by observing visual phenomena in nature' and 'spending much time on walks noticing novel and unexpected effects.' Even more important for the British appreciation and understanding of Impressionism, he donated £50,000 to the Tate Gallery for the acquisition of French modernist art. £50,000:

perhaps Rutter's maths echoed in his ear? Prices were indeed signifi-
cantly higher now, a reflection of Impressionism's world-wide status
and desirability by the 1920s, and Courtauld had to pay £20,000, for
instance, to buy the *Bar at the Folies-Bergère* in 1926. Anyway, the re-
sult was a transformation in what was available for the British public
to see in its national collection.

From now on Impressionism, like some unexploded bomb deacti-
vated by intrepid British experts, was rendered safe for the public at
large. Later artistic developments such as Cubism, Surrealism and
abstract art took its place to threaten and horrify the middle class-
es. Impressionism, following the pattern seen in other countries,
grew reassuring by comparison. It was collected in wider and wider
circles. Hugh Walpole, the successful popular novelist, came out of
his dentist in 1927 depressed by the news that he was going to have
to lose all his teeth. To cheer himself up, he walked to the Leicester
Galleries and bought a Renoir still life. (Had he been consulting Dr
Georges Viau, he could have killed two birds with one stone by buy-
ing an Impressionist painting from his dentist.)

The sale must have been a pleasant surprise to the Leicester
Galleries, who pioneered the introduction of French modernism to
London. They had held a Renoir exhibition the previous year where
demand had been patchy. The gallery director, Oliver Brown, was
inclined to the conclusion that 'there was some quality in Renoir's
painting that did not appeal to English taste'. What was that qual-
ity, one wonders? Too saccharine a palette? An excessive prettiness?
A vapidity in the choice of female model? In 1882 Huysmans, con-
templating Renoir's *Déjeuner des Canotiers*, had come up with a more
Gallic explanation for the chocolate-box prettiness of the girls de-
picted: '...The women are charming, but the picture doesn't have a
strong enough smell. The girls are fresh-looking and gay, but they do
not exude the odour of a Parisian; they are spring-like trollops fresh

off the boat from London'. Oh, dear. Will the French and the English never understand each other?

In 1939, Michael Innes's detective story *Stop Press* features the theft of a Renoir from an English country house. As ever with this genre of fiction, the social nuances are carefully calibrated and worth studying. It is revealing that such a picture was now plausibly to be owned by an English gentleman, who in the book is rich but not plutocratic. Perhaps his occupation – like Hugh Walpole, he is a successful writer – is tinged with sufficient bohemianism to explain his relatively advanced taste. The picture is a substantial one, described as follows:

> It was a bathing woman, an exuberance of the flesh untouched by its enemy, thought, its over-opulent curves irradiated and redeemed in light, brightness falling from the air to a still, dark pool below; absolute evanescence made eternal.

It's an effective evocation of a late Renoir, impregnated with English reservations about thoughtless sensuality but providing a good summing up of what Impressionism was all about: 'absolute evanescence made eternal'. In the later 1930s, a taste for such things even penetrated the British aristocracy: the Earl of Jersey, for example, was a collector who forsook Old Masters, and began buying Renoir, Monet and Pissarro. This was a relatively isolated instance, however, influenced by his marriage in 1936 to a glamorous new wife from Hollywood, Virginia Cherrill. Significantly, besides having previously had Cary Grant as a husband, she was also a good friend of Edward G. Robinson and shared his enthusiasm for Impressionism. Thus, for Lord Jersey, buying Impressionist paintings was as much a declaration of American as French sympathy.

As the twentieth century progressed, those at the sharp end of avant-garde art were beginning to find Impressionism tame,

54 According to Huysmans, the girls 'do not exude the odour of a Parisian: they are spring-like trollops fresh off the boat from London'. Renoir, *Le Déjeuner des Canotiers*, 1880–81. (See pl. 6.)

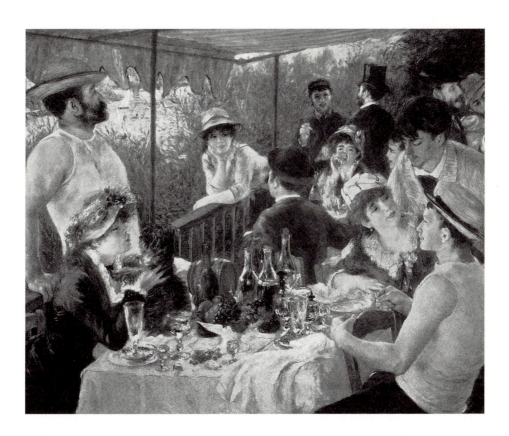

even in Britain. Roger Fry decided that more was required than Impressionism could offer. It was too obsessed with appearance, and lacked 'emotion' and 'imaginative stimulus'. In 1914 Clive Bell was already dismissing Monet's late water-lily series as 'polychromatic charts of desolating dullness'. At the other end of the scale, the die-hard conservative Sir Alfred Munnings, President of the London Royal Academy, was still ranting on in 1949 about the evils of modern French art, rising unsteadily to his feet at the Annual Dinner to praise the guest of honour Winston Churchill on the grounds that

> Once he said to me, 'Alfred, if you met Picasso coming down the street, would you join with me in kicking his something something something...?' I said, 'Yes, sir, I would'.

But the Impressionists were a different matter. Munnings himself painted in a way that would have been impossible without their precedent, and indeed he acknowledged the debt to them implicit in his open brush stroke and liquid technique. They may have been the first chapter in the story of modernism, but with hindsight they could also be interpreted more comfortably as the final act in the development of traditional art. And, now that distance lent enchantment, weren't the colours lovely and the subjects charming?

Up till World War II, the differences in the way nations reacted to French Impressionism are discernible enough to make it worthwhile considering them separately. In France itself, there was the initial hostility, followed by a gradual process of absorption into an accepted canon of rich, establishment taste; in America, a combination of innate Francophilia and the lack of artistic prejudice characteristic of a young country meant that Impressionism took strong, early root; and a rapid increase in national wealth saw large amounts of

American money thrown at the Impressionists from the last years of the nineteenth century onwards. Germany's enthusiasm for French Impressionism on the other hand had political, even racial connotations. In the years leading up to World War I, it was a focus for radical, anti-Imperial sentiment, while the large number of Jewish collectors gave conservative Germany a chance to play the anti-semitic card. The tragedy of Nazism and the upheavals of World War II meant an exodus from the country of many of the great Impressionist pictures so patiently and discriminatingly assembled earlier in the century. In Francophobe Britain, as we have seen, acceptance of Impressionism took longer than anywhere else. But it came, finally, between the two world wars.

From 1945 onwards, we are looking at a changed world, one in which there is an international uniformity of artistic taste. This globalisation is partly the result of more rapid communications, and partly, perhaps, of the world-wide cultural hegemony of America. All vestiges of controversy had been swept away from Impressionism. There was general acceptance that the Impressionists were a good thing and that owning them was an even better thing. What that meant for the Impressionist painting in the second half of the twentieth century is examined in the rest of this book.

CHATWIN'S HAIR

The Impressionist Painting, 1945–70

————

From certain vantage points, the second half of the twentieth century can be interpreted as one long curve of pleasure. As the world became a relatively more peaceful and prosperous place, indulgence reasserted itself: the rich grew richer, and a corresponding upsurge galvanised the market for luxury goods, at the apex of which hung the Impressionist picture. Out of the grey austerity of rationing there emerged through the 1950s and early 1960s a more liberal, vivid and vibrant way of life. Consumerism blossomed; Harold Macmillan told the British public they had never had it so good; around 1963, according to Philip Larkin, sexual intercourse was invented; and part of this general rediscovery of joy was the burst of colour unleashed anew by the Impressionist painting.

That there was a dramatic increase in prices for the work of the Impressionists through the 1950s is indisputable. It was driven, as ever, by the new money of the time. Who were the people making this new money? One conspicuously successful group were the

55 Stavros Niarchos, the Greek ship owner who
 amassed one of the great Impressionist collections.

Greek ship owners. The enormous shipping requirements of post-
war reconstruction poured wealth into their pockets, as huge quan-
tities of raw material and new products needed transportation
round the world. A myth sprang up, an image of wealth informed
by the lifestyles of Hollywood stars and Greek ship owners. The pub-
lic has always been interested in the private lives of the very rich. A
whole section of the magazine industry is driven by that interest to-
day. One strand in the image of wealth formulated in the 1950s was
the collecting of Impressionist pictures. It wasn't just that the very
rich were hanging Renoirs and Monets on their walls: it was also that
the admiring world perceived them as doing so. It was at this time
that the Impressionist picture became securely – and apparently
eternally – lodged in the vocabulary of aspiration.

The upward gear-change in glamour and price for Impression-
ist pictures coincided with the emergence of the auction as the pre-
ferred means of sale for top examples. From the 1950s onwards, the

auction gave a public dimension to the acquisition of art, a process which had previously been a discreet and private one when handled by dealers. This was exciting to both sellers and buyers alike, the former because they often saw prices rising beyond what they had been led to expect, and the latter because of the element of machismo in the inherent competition – the gladiatorial factor. You could show off in an auction room. In fact it was a double pleasure – you got to show off by outbidding all the other rich in the auction room, and you acquired something that you could then show off to your friends on the wall of your drawing room. Works by Monet, Renoir and Degas took on the significance of captured battle standards, literally trophies won on the killing fields of the auction-room floor. From the 1950s onwards, the story of the rise of the Impressionist picture is inseparable from the story of the rise of the auction house.

If one man could be identified as central to the process of the glamorisation of the Impressionist painting, it was Peter Wilson, who became chairman of Sotheby's in 1957. Peter Wilson, as a member of a landed Yorkshire family, sprang from the best social background. He was an Etonian. And yet he showed absolutely no interest in the establishment milieux where, say, Christie's directors would trawl for business. He didn't take pleasure in shooting; he wasn't a member of White's. He didn't seek out dukes and bask in the penumbra of their greatness. In fact he said that he would rather do business with a Jew than a duke, which was certainly an intelligent way forward if you wanted to dominate the Impressionist market because very few dukes had any Impressionist pictures but an awful lot of Jews did. He was an insider who had deliberately reinvented himself as an outsider. His sharpness was legendary; he was a businessman rather than a gentleman. And he was prodigiously successful.

Some traditional Christie's directors found Peter Wilson's priorities very shocking indeed. And something else about Wilson

56 Peter Wilson, the master operator.

worried them too. When I first joined Christie's in 1973, Peter Wilson was in his Sotheby's pomp, his aggressive business methods a constant source of unease and dismay to the Christie's board. I was taken aside by one of the crustiest of the Christie's directors, who decided to give me a word of advice (an early example of what is now encouraged as 'mentoring'). He was mellowed by the consumption of a fairly typical boardroom lunch, which in those days at Christie's involved two stiff gin and tonics beforehand, hock followed by claret once the food was served, and well-circulated port or brandy to finish up with. 'Do you know the difference between us and those barrow boys up in Bond Street?' he demanded a trifle unsteadily. I said I didn't. 'I'll tell you the difference. The difference is that we are all heterosexual.'

It's true that Wilson was not immune to the appeal of a good-looking young man. But Sotheby's recruitment policy during the 1950s and 1960s succeeded in producing a dynamic new generation

of experts because Wilson also understood that in order to attract the best works of art to the auction houses rather than to dealers for sale, expertise must be established and maintained at the highest level. The day-to-day running of the Impressionist department at Sotheby's devolved in the 1960s into the hands of two young men who were to remain at the helm (on opposite sides of the Atlantic) for a quarter of a century. Michel Strauss had an impeccable provenance. His grandfather, Jules Strauss, had been a distinguished Impressionist collector in Paris, and his stepfather was Isaiah Berlin. David Nash's potential, on the other hand, must have been more difficult to spot. He came to Sotheby's having been employed as a gravedigger in a Wimbledon cemetery and an electrical engineer at the Horton Lunatic Asylum. But in his interview he spoke of having spent a day at a recent Monet exhibition at the Tate, and Wilson, acting on the instinct that generally served him so well, took him on. It worked. A few years later Nash was in charge of Impressionist sales at Sotheby's in New York.

An insufficiently appreciated factor in the development of the art market is the timing of the deaths of great collectors. It is only when a major Impressionist picture is released on to the market that a new level in price is attained, that a gear-change upwards in demand is registered to have taken place, and a surge in popularity is perceived by the wider public. But in most cases major Impressionist pictures are only released on to the market when major collectors die. That's why the art trade, only half jokingly, bemoan a mild winter: it means that elderly collectors hang on for another year. In the early to mid-1950s several important collectors died, their demise perhaps hastened by the series of bitter winters in the immediate post-war years. The result was a series of high-profile Impressionist sales at auction which focused the world's attention on the new demand for Impressionist art.

The first was the Cognacq sale in Paris in 1952. Gabriel Cognacq was the nephew of the founder of the Samaritaine department store in Paris, and thus fits the mercantile profile of the typical Impressionist collector of the first half of the twentieth century. His collection was a particularly fine one, and had been bequeathed to the Louvre. But he had had one of those difficult wars that were literally an occupational hazard to Frenchmen of that generation. Afterwards there were official allegations of collaboration against him. Piqued, he changed his will just before he died, and his pictures came to auction in Paris. Prices reached unprecedented levels. New records were set for Manet and Cézanne, and Renoir was also highly sought after.

In May 1957, part of the collection of Mrs Margaret Thompson Biddle, an American, was consigned for auction to Paris. Greek ship owners had in the meantime become even richer because the Suez Crisis, which had closed the canal, meant longer sea journeys for cargo ships and healthier profits for their owners. Gauguin's *Still Life with Apples* was the star of the sale, making three times its estimate at $297,142. *The New Yorker* reported 'a sudden desire to acquire the canvas which ignited simultaneously in the bosom of Mr Goulandris and Mr Stavros Niarchos, causing an explosion of human nature that blew the roof off the international art market'.

Two months later came Peter Wilson's first great success in the field of Impressionist sales when the William Weinberg collection, from New York, was offered at Sotheby's in London. Judged by the highest standards, it wasn't actually a very great collection but it included 10 van Goghs, and Wilson – whose antennae responded as positively to marketability as quality in art – sensed its possibilities. Having managed to persuade the executors to sell in London, he set about promoting the auction. He persuaded Sotheby's board to engage J. Walter Thompson to handle pre-sale publicity. It was the sort of opportunity that PR men dream about, because the 10 van Goghs were the self-same pictures that had been used in the 1956 film *Lust*

57 Kirk Douglas as van Gogh, in the role that outraged
the sensibilities of John Wayne.

for Life starring Kirk Douglas as van Gogh. Here was a chance to buy
pictures by the heroically doomed artist that Hollywood was now
making movies about; here was a chance to buy the pictures that
had actually been featured in that movie; here was a chance to buy
the sort of pictures that the Hollywood star who played van Gogh
might hang on the walls of his own luxurious residence in real life.
This blurring of the boundaries between Hollywood and Impres-
sionism was calculated to drive demand to fever pitch. Auction hype
was raised to a new level. JWT pushed their luck by sending an invi-
tation to view the sale to the Queen; Sotheby's directors were amazed
when Her Majesty turned up: when they saw the name on the guest
list they had assumed it was the magazine. It was not a mistake that
would have been made by the more patrician Christie's board. But
sadly they weren't the ones getting the royal visit. JWT milked the
event for all it was worth, putting about an unattributable story that

the Queen had been particularly taken by Degas's pastel *The Injured Jockey*, and might be contemplating a bid herself. It was totally untrue, but ratcheted up interest in the sale. The glamorisation of Impressionism had taken on a royal dimension.

Finally there was the sale of George Lurcy's collection, which took place in November at Parke Bernet in New York. Lurcy was a Frenchman who had settled in America before the war. He wrote with a Gallic lyricism about the Impressionist pictures that he collected:

> *The priceless temptation of art gives me everything, delectable stings, a hint of pepper and sun, the effortless crunch of the teeth into a morsel of cantaloupe.... If you have ever seen Monet's wall of water-lilies, then you know what I mean. What you see is gorgeous eternity....*

You can almost hear his words set to music, and sung by Maurice Chevalier.

If the Queen had viewed the Weinberg sale at Sotheby's in London, then New York's equivalent of royalty – not to be outdone – turned up in all their glory for the Lurcy sale. The Rockefellers, Fords, Vanderbilts, Goulandrises, Dillons, Chester Dales and Lehmans were all conspicuously present as the hammer came down on the first lot. The room was so crowded that Mrs Niarchos had to be given a chair in the wings of the stage. An eye-witness recorded that Eleanor Roosevelt sat beside Helena Rubinstein: 'Miss Rubinstein dressed as a rich gipsy, Mrs Roosevelt as the most stolid librarian'. Art auctions were taking their place with society weddings and first nights at the ballet as places to be seen. Through 1957, record price followed record price for Impressionist paintings. The American press took to referring, a little disingenuously, to these spiralling prices as 'economic tributes' to art. Here was the sacralisation of the

auction process: the huge sums bid were devotional alms, offered at the shrines for the worship of Impressionism which the international auction rooms were becoming.

Three major sales of Impressionist art had taken place within the space of six months, in Paris, London and New York. What their success proved was that the Impressionist market had become truly international, that wherever you offered a great Manet or Renoir or Cézanne it would be competed for by the same moneyed jet-setting group. International air travel had shrunk the world and inflated Impressionist prices. Peter Wilson understood this as well as anyone. He also realised something else. When the New York lawyers acting for the Weinberg estate originally sent off letters to Sotheby's, Christie's and Parke Bernet soliciting quotations for sale by auction, they were struck by the varied responses received. Parke Bernet offered to take on the sale, but at a commission rate of 23.5 per cent. Christie's reply was polite and mildly interested, but it didn't arrive for three months (possibly because they only sent their letter by sea-mail). Peter Wilson, on the other hand, was on the telephone to New York the same day that he received the lawyers' inquiry, and soon after was offering the executors a knock-down commission rate of only 8 per cent. Lack of auction tax gave London an enormous advantage over New York and Paris, which Wilson exploited to the full. This was one of the reasons why, when the plum of the Jakob Goldschmidt Impressionist collection became available for sale the next year, Wilson managed to get that for Sotheby's London, too.

Wilson and Sotheby's already had a relationship with the Goldschmidt family. Jakob, a Jewish banker who escaped Nazi Germany to settle in the United States, had died in 1955. His son and heir Erwin set about the task of selling the art collection. The first tranche, largely Old Masters, were brought to London for appraisal. Wilson and his picture specialist, Carmen Gronau, were invited to the Savoy Hotel for the purpose. Negotiations proceeded; in a rather myste-

58 Art and money, an irresistible combination: excited
crowds outside Sotheby's on the night of the
Goldschmidt sale.

rious way Goldschmidt and his lawyer kept shuttling in and out of
the room in which Wilson and Gronau were being interviewed, pre-
sumably in order to confabulate in private. What was going on? As
they came back into the room yet again, Gronau overheard
Goldschmidt mutter to his lawyer 'Die hier gefallen mir viel bess-
er' ['I like this bunch much better']. Understanding German,
Gronau realised that Christie's must be pitching for the same collec-
tion in a room along the corridor. And satisfyingly Sotheby's were
winning. (How much better a deal could Goldschmidt have nego-
tiated out of Sotheby's had he had the guile to mutter in Gronau's
hearing 'Die anderen gefallen mir viel besser' ['I like the other bunch
much better']? But life is full of missed opportunities.) So Sotheby's
got the sale of the first tranche, and did well with it. And thus

Sotheby's in London were first choice for the second tranche, the sale of the Impressionists.

The Impressionists were the real plum. There were 7 of them: 3 Manets, 2 Cézannes, a van Gogh and a Renoir. They were all of outstanding quality, and as a group made an even greater impact than the sum of their parts. The decision to offer them in a stand-alone sale of just seven lots was an inspired one. It simultaneously emphasised the auction as an event of unparalleled glamour and importance, and focused attention on the works themselves, undiluted by anything less than a masterpiece. Auction rooms by tradition were functional wholesalers, clearing houses for goods which happened to be works of art. In London in the 1950s there was still sawdust on their floors. Presentation and marketing to the ultimate consumer was generally left to glamorous dealers with luxury galleries for the purpose. But now the sawdust was swept up and plush new carpeting laid down. With events like the Weinberg and the Lurcy sales, the auction houses had not only invaded dealers' territory but also shown they were even more powerful marketers than their rivals. The Goldschmidt sale took the process several steps further. The decision to hold the auction in the evening and to require those who attended to wear dinner jackets, as if it were some gala theatrical event, was not unprecedented because it had happened before in New York, but it further ratcheted up the hype.

Peter Wilson once again employed an outside firm to handle the promotion of the sale. Press previews were held, and journalists were asked to guess which picture they thought would sell for the most. A month in advance of the auction there had already been articles publicising it in newspapers and magazines in 23 different countries. It was billed as 'The Sale of the Century', an overworked cliché since but a novel and arresting idea then. Particular attention was paid to Erwin Goldschmidt, who projected an image of svelte prosperity, and his beautiful wife Madge. They too were photographed

and written up as stars in the pre-sale press. Their personal glamori-
sation was part of the process of the glamorisation of their pictures.

In one of the earliest auctions at which the Impressionists sold
their work, at Drouot in Paris in March 1875, the gendarmes had been
called to eject the hecklers and calm the mockers. On the evening of
15 October 1958 it was the turn of the London police to be called to a
sale room, but this time to control the adulatory crowds surging up
Bond Street towards Sotheby's trying to gain admittance to see the
sale of the works of the same Impressionists. Those who did get in
included Kirk Douglas (fresh from his cinematic role as Vincent van
Gogh), Anthony Quinn, Dame Margot Fonteyn, Somerset Maugham
and Lady Churchill. Edward G. Robinson was linked in by trans-
atlantic telephone. In the words of *The Daily Express*:

> *At 9.35 tall dinner-jacketed Peter Wilson, Chairman of Sotheby's and*
> *auctioneer of the night, climbed the steps of the pulpit-like rostrum*
> *in the green-walled main saleroom. Chubby-cheeked Wilson blinked*
> *in the glare of the massed TV lamps, ran his eye over the mink and*
> *diamond-dappled audience, rather like a nervous preacher facing*
> *his first congregation, and rapped firmly with his ivory gavel.*

The *Express*'s choice of ecclesiastical imagery for the occasion under-
lines the quasi-devotional character of a major auction. But there is a
strong element of theatre, too, and the public are as much audience as
congregation, the auctioneer as much performer as preacher. From
now on the auction house partakes of both worlds. The dappled light
of Impressionism is caught in the glitter of the jewellery worn by
its new worshippers. Everyone goes home elevated by contact with
the mysteries of great art, but they are also energised by their proxi-
mity to huge financial transactions. The drama of those transactions
is heightened by the climactic moment of the fall of the hammer.
The experience of acquiring the paintings becomes as important

as the paintings themselves; the packaging and presentation as important as the art. 'It isn't so much the worms who get everything in the end as the auctioneers', complained George Lyttelton to Rupert Hart-Davis in the wake of the Goldschmidt sale. 'They're all immensely pleased with themselves, as though they were creating the masterpieces they sell.' But in a sense that's exactly what Sotheby's were doing by their marketing and hype: creating the masterpieces. One cannot pay Wilson a greater accolade than that.

The Manet self-portrait fetched £65,000, and then the Manet portrait of Madame Gamby reached £89,000. There was the electricity of success in the air, increasing in voltage with each bid. With the third lot the £100,000 barrier was broken when Manet's *Rue Mosnier with Flags* sold for £113,000, a new world-record auction price for a modern picture. 'The grey head of Somerset Maugham shook slowly in amazement', reported *The Daily Express*. 'Dame Margot Fonteyn, in an off-the-shoulder, eau-de-nil dress, stood on her famous toes craning with excitement.'

The very next lot, the van Gogh, broke the world record set by its predecessor, when it made £132,000. The Cézanne still life, lot 5, sold for £90,000. Then it was lot 6, Cézanne's *Garçon au gilet rouge*. For the third time in the space of four lots, the world-record price was beaten as the bidding surged to £140,000. It continued further, to the gasps of the room, as a duel developed between George Keller, of New York's Carstair's Gallery, and Roland Balay of Knoedler's. Keller finally won out, with a staggering bid of £220,000. 'Two hundred and twenty thousand pounds?' Peter Wilson queried with mock surprise from the rostrum. 'What, will no one offer any more?' It's a sure-fire winner, that remark, just before the hammer comes down on a world-record price, as many lesser auctioneers have found since. But Peter Wilson, with inimitable sang-froid, was the first to deploy it. The final lot was *La Pensée* by Renoir, the work whose re-titling had so upset the artist. It fetched £72,000, the only picture bought by a

Plate 1 Jean-Léon Gérôme, *The Baths at Bursa*, 1885.

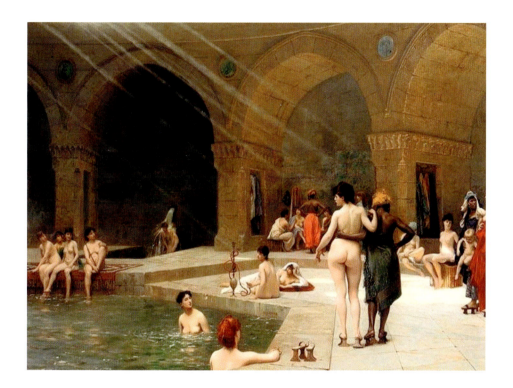

Plate 2 Claude Monet, *The Grand Canal, Venice*, 1908.

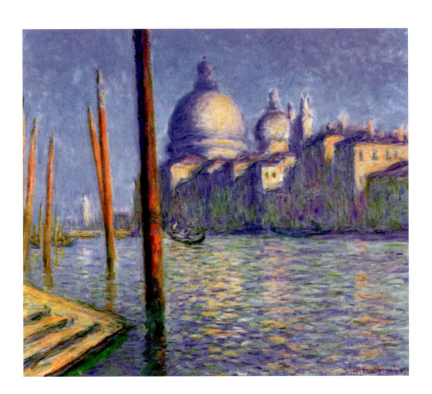

Plate 3 Claude Monet, *Poplars on the River Epte*, 1891.

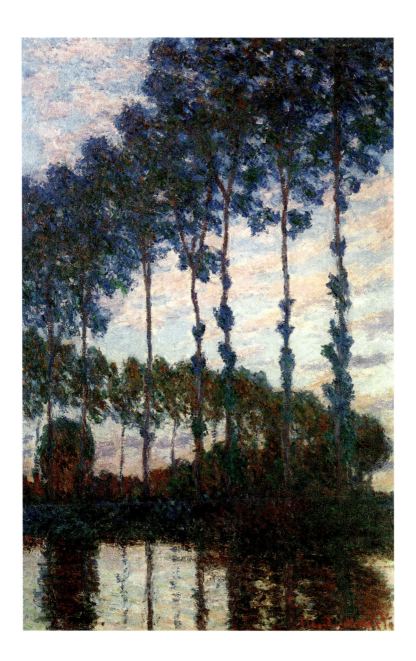

Plate 5 Edgar Degas, *L'Absinthe*, 1876.

Plate 6 Pierre-Auguste Renoir, *Le Déjeuner des Canotiers*, 1880–81.

Plate 7 Claude Monet, *La Terrasse à Sainte-Adresse*, 1867.

Plate 8 Pierre-Auguste Renoir, *La Loge*, 1874–75.

59 A night of great theatre: the Goldschmidt Cézanne
 under the hammer.

British buyer (the Birmingham property magnate Jack Cotton). Then
it was all over bar the shouting. And there was a lot of shouting. Peo-
ple stood on their chairs and cheered and clapped. What were they
applauding? World records, one supposes. The highest total ever
realised (£781,000) for a single sale. But something more than that,
something that they would have found more difficult to define at
the time. Perhaps it was a combination of two things: a reassurance
of the power of capitalism in the face of the communist threat to
the world; and the apotheosis of an appealing and accessible art

movement, an art movement, moreover, that had been mocked and misunderstood in its time and was now at last receiving its full measure of acclaim. People love a happy ending.

A week later the identity of the client for whom George Keller had bought the Cézanne *Garçon au gilet rouge* was revealed. It was the great American collector Paul Mellon. To the question of whether he had paid too much his answer was emphatic: 'You stand in front of a picture like that, and what is money?' What, indeed. The Impressionist painting was being acknowledged as, literally, beyond price. It is an extension of the devotional metaphor. Art, for late twentieth-century society, is the new religion. Buying art is like religious belief: it involves an act of faith. Trying to rationalise that process by a clinical analysis of the sum paid for a great work of art is as futile as the application of scientific reason to transcendent religious experience. It is, as Paul Mellon declares, irrelevant. That irrelevance, vouched for by a major and respected player in the top league of world wealth, was glorious justification for the market to go on rising. 'You stand in front of a picture like that, and what is money?': it was yet one more quotation that Sotheby's and Christie's could have printed on the first page of every Impressionist catalogue, perhaps in lieu of a pre-sale estimate.

The art market was powering upwards. Why was this surge driven by French Impressionism rather than Old Masters, what was it that attracted new rich collectors to Renoirs and Cézannes? The answer lies partly in their accessibility, in the appeal of their colouring and subject matter. But there was another factor: the security of the expertise which established them as unassailably genuine. There was always room for critical uncertainty over Old Masters, even major ones. But thanks to the foresight of early dealers like Durand-Ruel and Bernheim-Jeune, who insisted on keeping comprehensive photographic records of work of the artists they handled, it was relatively easy to establish unchallengeable *catalogues raisonnés* of the

60 Somerset Maugham (right), showing off his Gauguin.

entire *oeuvres* of the major Impressionist painters. So if you were a
Greek ship owner, a Hollywood film star, or a London property mag-
nate, and you didn't necessarily know very much about art but you
wanted to buy it, you could be sure that the Manet or the Monet or
the Renoir, the Sisley or the Pissarro or the Degas you had your eye
on was the real thing. It was recorded. There was no possibility you
would wake up one morning and find your Impressionist painting
had been downgraded to the work of a follower by some bunch of
loony academics, as sometimes happened to the unfortunate own-
ers of Rembrandts.

Beneath the almost irresistible charm of Peter Wilson lurked some-
thing ice-cool and calculating. Once, after a particularly persuasive
performance on the telephone to an elderly lady client, he paused

61 Bruce Chatwin, disenchanted by the personal
demands of the Impressionist market.

before replacing the receiver and was observed to lick it. In the end,
it was said of him, he was more interested in things than in people.
Despite (or perhaps because of) that priority he was adept at manip-
ulating other human beings into doing what he wanted. He almost
met his match in Somerset Maugham, whose capacity to be diffi-
cult was legendary. Maugham had amassed over the years a collec-
tion that included works by Renoir, Degas, Monet and Gauguin. In
1962, approaching 80, he decided the time had come to sell them all
at Sotheby's.

Unhappy at his public school, converted to atheism by the
clergyman uncle who brought him up, guiltily homosexual,
Maugham himself was an outsider, a traveller constantly on the
move, at odds with the British Establishment and resentful of its
smugness. One element in his attraction to the Impressionists may

have been their own original status as outsiders. He was particularly interested in artists' personalities, and in 1919 had written an imaginative novel (*The Moon and Sixpence*) based on Gauguin's life, a novel that Irving Stone could profitably have consulted before doing battle with van Gogh. Now that Impressionist pictures had become Greek ship-owners' status symbols, Maugham felt inclined to cash in.

A few days before the sale of his collection was due to take place, Maugham arrived in London to stay at the Dorchester. At this point another visit to a dentist intervenes. Maugham had toothache; he went for treatment and came out severely disgruntled. Hugh Walpole, after his treatment, had consoled himself by buying a Renoir. Maugham called Peter Wilson to announce that he'd changed his mind about the sale and was keeping his Impressionist pictures after all. Wilson's reaction is another illustration of his Machiavellian genius, his readiness to exploit human frailty to achieve what he wanted.

It was already early evening. He sent for the clever young cataloguer he had recently employed in the Impressionist department. His name was Bruce Chatwin.

'Bruce', he said. 'I wonder if you would mind doing something for me. Are you free for an hour or two?'

'I could be, I suppose.'

'I think it would be a good idea if you went to see Mr Maugham at the Dorchester. He needs a little reassurance.'

'What kind of reassurance?'

'Oh, just calming down. He's got some wild idea about cancelling the sale. Tell him how well his paintings are going to do, and what a privilege it is for Sotheby's to sell them, and how much it will mean to you personally as you catalogued them. He's got toothache, poor man.'

'But, why don't you....'

'No, Bruce. You're the one he'll respond to.'

'OK, if that's what you want.'

'I do. And Bruce, one more thing. Before you go, if you wouldn't mind just washing your hair?'

'He was amazing to look at', said Susan Sontag of Bruce Chatwin. 'There are few people in this world who have the kind of looks which enchant and enthral. Your stomach just drops to your knees, your heart skips a beat, you're not prepared for it.... Bruce had it. It isn't just beauty, it's a glow, something in the eyes. And it works on both sexes.' It worked on Somerset Maugham.

'He wants you to go and sit next to him', said Alan Searle, Maugham's companion, when Chatwin got there.

'His awful old fingers going through my hair!' complained Chatwin looking back on the incident later. It was an encounter that would have made an excellent short story by Maugham himself, or indeed by Chatwin when he got into his literary stride a decade later. What did they talk about in the suite in the Dorchester? Whether things are more important than people? If artistic creation, as Maugham often maintained, is a manifestation of the sexual instinct? If the equation of Impressionist paintings with very large sums of money ultimately tarnished them? Who knows? The outcome, anyway, was that the pictures stayed in the sale. And the sale did very well, confirming the new status of the Impressionist painting as the icon of rich taste. Peter Wilson's willingness to exploit human weakness, in both his staff and his clients, helped establish that new status through the auction rooms. It was now a market where the stakes had become very high indeed.

Bruce Chatwin liked to claim that his experience with Maugham was one of the reasons why he decided to move on from Sotheby's not long after, to distance himself from the 'corruption' of the art market. The story highlights the plight of the auction-house expert, whose success is measured by the number of rich owners he (or she) persuades to consign their Impressionist pictures for sale. How far

62 The globalisation of the art market: Peter Wilson
(right) outside Parke Bernet, New York.

should one go to win business? Allowing 'awful old fingers' to go through the hair might indeed be a step too far for some; my friend Jasper, on the other hand, is more flexible. He reminisces of a particularly grim period in the art market when he 'had to offer physical favours to a pensioner to sell a Russell Flint'. Now the market is stronger, he makes it clear, he wouldn't sink so low. At stake would have to be at least a Sisley.

The Maugham sale was one of several major auctions of French Impressionist art that followed in the wake of Goldschmidt. Peter Wilson had set a template of success in London; but given that a high

proportion of both sellers and buyers were still American, it was perhaps inevitable that he would look to expand on the other side of the Atlantic. After a protracted battle, Sotheby's took over their main rival in the United States, Parke Bernet, and – now that they were equipped to hold sales in New York as well – looked set for a period of world domination. Six months after the take-over, in April 1965, the newly constituted Sotheby Parke Bernet mounted a carefully chosen and extravagantly staged evening sale of Impressionist art at their Madison Avenue headquarters. It was a great success. The magnificent choreography of the evening continued when dinner was afterwards served in a superb recreation of the Montmartre café where Manet and Degas had drunk together, that same café where Degas had painted *L'Absinthe*. In the words of one commentator, it was 'the broadest of hints that Sotheby Parke Bernet was in eternal communion with the Impressionists'.

Was Peter Wilson himself in eternal communion with the Impressionists? How important to the story that this book is telling was he by comparison with Paul Durand-Ruel? Durand-Ruel's sense of mission about Impressionism did not find the same echo in Wilson, for whom the Renoirs and Monets that Sotheby's marketed so effectively were a means to an end. Wilson was a creature of instinct. That instinct told him that as people grew richer in the postwar world, the art market was going to expand out of all recognition, and that this expansion was going to be led by Impressionist painting. He was right. In order to achieve great things you have to be lucky in your timing. Both Durand-Ruel and Wilson were in their prime in post-war periods of growth ripe for commercial exploitation. The aftermath of the Franco-Prussian and, equally significant, the American Civil wars presented Durand-Ruel with his opportunities. Those that opened up for Wilson in the 1950s and 1960s were equally as great.

If you had run a poll on the most popular artists in the French Impressionist pantheon round about 1960, Renoir would have been pretty close to the top. The three Post-Impressionists, Cézanne, Gauguin and van Gogh, were also well up on the list. But a name surprisingly missing from these highest peaks was Monet. Gerald Reitlinger in his *Economics of Taste* (published in 1960) suggested that 'in a popular market, Renoir appeals more (than Monet) because his charm is more obvious'. That judgement has since been reversed, as confirmed by the queues of people that now run several times round the block for any big museum exhibition featuring the word Monet in its title.

Various things happened in the 1960s to change the image of Monet. One was the artist's somewhat unexpected reinvention as an Abstract Expressionist. An exhibition held at New York's Museum of Modern Art in 1960, *Claude Monet: Seasons and Moments*, was an early sign that a new interpretation was in the air. Critical focus was increasingly directed on his large, abstract water-lilies of the twentieth century. Emily Grenauer, writing in the *New York Herald Tribune*, was in no doubt that it was Jackson Pollock and the Abstract Expressionists who had rediscovered late Monet and 'communicated their enthusiasm to museum officials, dealers, and collectors'. She went on:

> The exhibition does make immediately clear why today's avant-garde is so fascinated by this gentle rebel, whose experiments back in the '70s using broken strokes of pure colour to convey the vibrancy of light and air were beginning to be counted old-hat a quarter century ago. It's because in his last years he carried the device to the point where brushstrokes became so breathtakingly free in his attempt to attain maximum freshness and spontaneity of surface that observed reality appeared to have been choked out of his canvas by an abstract tangle of colour.

If you were at the cutting edge of contemporary art, it was OK to like Monet again. Late Monet, anyway. But the general public was probably drawn to the Museum of Modern Art for another reason (and drawn there they were: by 3 April a record 60,000 people had visited the exhibition). It was the first time in modern memory that so many lovely Monet landscapes had been gathered together at the same show. People relished the feast of colour that a mass of Monets generates. A template of box-office success had been established, one which museums world-wide have not been reluctant to exploit in the years since. You can't go wrong with a Monet exhibition. For sale-room validation of the new enthusiasm for the artist, the market had to wait a little longer. Once again it was a question of which collectors die – or choose to sell – when. Few great Monets had come on the market in the late 1950s and early 1960s, so there were no opportunities for big jumps in price appreciation. That had to wait till 1967, the year of the Pitcairn sale in London.

The painting concerned was a magnificent early Monet, *La Terrasse à Sainte-Adresse,* painted exactly a century before in 1867. It encapsulated what people wanted from an Impressionist picture at that time: blue summer skies, sparkling sea, a garden full of flowers with rich red blooms, a couple of flags (one of them the tricolour) unfurled in the breeze, and elegant women – even better, elegant women with parasols. The owner of the picture, the Reverend Theodore Pitcairn, had an unusual background for a collector. He had been ordained minister of the mystical General Church of New Jerusalem in Bryn Athyn, Pennsylvania in 1918 and then worked as a missionary in Basutoland. He ended up back in Bryn Athyn as pastor, and retired in 1962. He married in 1926 and had nine children. Because he was extremely comfortably off – his father founded the Pittsburgh Glass Company, one of the largest firms in the United States – Pitcairn was also able to indulge a passion for buying pictures. 'I remember it was a beautiful day and my wife and I were walking down 57th Street,

63 Monet, *La Terrasse à Sainte-Adresse*, 1867: sold in 1967
 for a then world-record price of £ 588,000. (See pl. 7.)

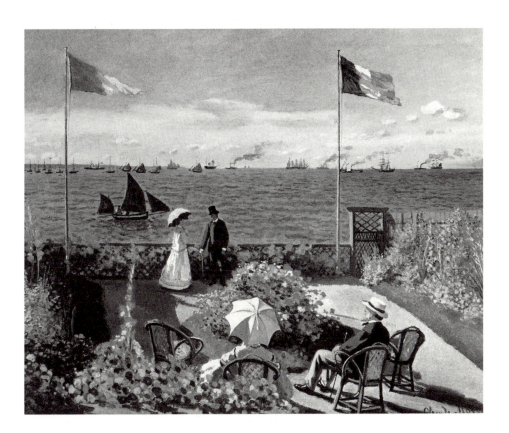

New York when we saw the painting in a dealer's window,' he recalled
of the Monet purchase, made in the year he married. 'We bought it
in ten minutes for $11,000. I wasn't thinking of investment. We were
both struck by its cheerful quality and thought this type of picture
would give us a lift.'

The price realised for it, £588,000, set a new record for a mod-
ern picture. And one of the remarkable features of the sale was that
it was conducted by Christie's, not Sotheby's. Peter Wilson was
no longer having things totally his own way. What Wilson didn't
know was the lengths to which David Bathurst, the young head of

64 The consequences of a late-night ride on a
snowmobile: the Rev. Theodore Pitcairn at Christie's
with his Monet.

Christie's Impressionist Department, had had to go in order to win
the picture. Early in 1967 Bathurst stayed the weekend with the
Pitcairns at Bryn Athyn, hoping to persuade his hosts of the merits of
Christie's as auctioneers for the collection. It was winter. At supper
one evening Feodor, Theodore Pitcairn's son, suggested to Bathurst
that they went for a spin on his snowmobile. It was bitterly cold, but
David, among whose many attractive qualities was an almost insane
bravado, agreed at once. They sped off into the forest. Crouched
behind his client, clinging on for dear life, Bathurst became a
metaphor for the new commercial tenacity of the auction houses

in pursuit of the Impressionist painting. Unfortunately he failed to notice when Feodor ducked his head to avoid an overhanging branch, and took the full force of it on the bridge of his nose. He found himself sitting dazed in the snow bleeding profusely.

The consignment of the collection to Christie's was conceivably an act of embarrassed contrition by the Pitcairns for the injury inflicted on their guest that weekend. David wouldn't have minded, so long as he won the business. Chatwin's hair and Bathurst's nose thus become potent symbols of the new power of the Impressionist picture, and how far people in the art trade were now being asked to go, as the last quarter of the twentieth century approached, to get it for sale.

BEYOND PRICE

The Impressionist Painting, 1970–90

————

By the late 1960s the identification of Impressionist pictures with large sums of money had become firmly and pleasurably embedded in the popular imagination. A media-created legend of what constituted the taste of the rich had come into being, a legend to which the rich themselves seemed as happy as anyone to conform. This is not as strange as it might seem: the unexpected collision with huge amounts of wealth can disorientate people. They are grateful then to consult a road map which directs them along reassuringly well-worn highways. Faced with the unfamiliar, human beings tend to seek refuge in the cliché, and in this respect the newly rich are no different from anyone else. So, if you made a lot of money, buying an Impressionist painting was one of the things you did to establish your credentials as being rich, along with acquiring a yacht, and a jet, and a safe full of jewellery, and maybe also a trophy wife to adorn with your diamonds. But the distinctive joy of collecting Impressionist pictures was that they made you seem cultured as well as glamorous.

65 Monet, *Le Val de Falaise*, 1885: bought by Liz Taylor at
Sotheby's in 1968, the heyday of her fame.

The process of glamorisation was accelerated by people like
Richard Burton and Elizabeth Taylor – at that point the most fa-
mous couple in Hollywood, and possibly the world – attending sales
at Sotheby's and buying Monets, as they did in London in the sum-
mer of 1968. According to *The New York Times*, Miss Taylor 'sat in the
middle of the crowded saleroom and bid with a nod of her head and
a smile.... While she was bidding, her husband was on the other side
of the room shooting a scene for a film, *Laughter in the Dark*'. She
bought *Le Val de Falaise*, an oddly dark and lugubrious example of a
Monet landscape, for £50,000. It went with the famous Cartier dia-
mond Burton bought her for $1.5 million, all 69.42 carats of it. This

66 Aristotle Onassis, who bought his bride Jacqueline
Kennedy a Renoir as a wedding present.

was a phase of extravagant consumption for the Burtons, who are
calculated to have made $81 million in the decade of the 1960s and
spent $65 million of it. Elizabeth Taylor had entered an unreal world
in which she no longer had to have great starring film roles: she had
only to live like a star. In the words of her biographer, 'her offscreen
life was far more glamorous and fascinating to admirers and detrac-
tors than any script submitted.' A significant element in that glam-
orous and fascinating life was the acquisition of Impressionist art.

The same year, in New York, Aristotle Onassis was involved in
a bidding battle to buy a Renoir, *Le Pont des Arts*. He paid a record
$1,541,550 because he wanted it as a wedding present for his new
bride Jacqueline Kennedy. It was a moot point whether diamonds or
Impressionists were now a girl's best friend. In 1984 Cindy Spelling,

the wife of Aaron (producer of *Dynasty*), recounted how she veered in favour of the latter: 'I said to Aaron, let's cool it on the jewels for a while and get into art.' A few days later she and her husband bought a Monet, their first painting.

Not everyone in Hollywood was enamoured with Impressionism. Kirk Douglas recounts how he was accosted at a party by John Wayne soon after the premier of the film *Lust for Life*, in which Douglas took the role of van Gogh. 'Christ, Kirk!' exclaimed Wayne angrily, 'How can you play a part like that? There's so goddamn few of us left. We got to play strong, tough characters. Not those weak queers'. Nor was everyone in the museum world happy. There was resentment at the crassness of the equation of Impressionism with money. In the wake of the Metropolitan Museum's purchase and display of Monet's *Terrasse à Sainte-Adresse*, one commentator complained of the way

> crowds pass by and gape, being properly awed by the price of almost one and a half million dollars paid at public auction…. In the same room, a wonderful study in luminous whites of the Cathedral at Rouen, a glorious bouquet of sunflowers, some landscapes, all proclaim Monet's true greatness. But bearing no price tag, they receive but scant attention.

It raises an interesting question. Rather than wringing their hands at rising prices, wouldn't museums be better off exploiting the public's fascination with the financial value of art. Why hold back? Why not display next to every museum exhibit the figure at which it's insured? I am sure this titillating information would swell museum attendance. It would certainly add an extra circuit of the block to the queues for Impressionist exhibitions.

The decades of the 1970s and 1980s saw the consolidation of the Impressionist painting as the favoured emblem of financial and

cultural status amongst the super-rich. In the race to purvey this highly desirable merchandise to their elite clientele, the competition between the auction houses intensified; and gradually Christie's began to mount a serious challenge to the post-war supremacy of Sotheby's. The decision to open in New York was taken by Christie's in 1977; Sotheby's had grown stale, jaded by their unchallenged success in the United States, and were wrong-footed by the young and enthusiastic team that Christie's unleashed on America, led by David Bathurst.

The first break-through for Christie's in New York came in 1980 when they secured the Henry Ford Impressionist collection for sale. It was the sort of collection that would normally have gone automatically to Sotheby's, with their long tradition of servicing distinguished American collectors. But here again David Bathurst played a role of heroic self-sacrifice and tenacity. He went on another of his weekends to stay with the prospective sellers, hoping to persuade them of the desirability of consigning to Christie's. This one was difficult for different reasons from his Pitcairn experience. 'It was a most remarkable weekend', recounted David, 'because nearly everybody including our host was sloshed the entire time'. Here is another angle on how far one should go to get business. Imperilling the liver is a widely accepted occupational hazard. The only problem is how much better indifferent pictures can look, and how marvellous good pictures seem, after three gin and tonics. Clearly the way Bathurst simultaneously held his drink and retained his commercial judgement impressed Ford, and Christie's got the business – ten pictures, including works by Boudin, Manet, Degas, Renoir, van Gogh, Gauguin and Cézanne. They made $18 million against an estimate of $10 million. It was another personal triumph for David. True to form, when he rang Ford to give him the good news of the result, Ford was drunk; so drunk, in fact, that he couldn't remember Bathurst's telephone call at all next morning and had to be given the

67 Bravado and charm: David Bathurst of Christie's.

good news all over again. But that's the rare sort of conversation one is happy to have with clients as many times as they want.

David Bathurst's career has an international symmetry: an aristocratic Englishman whose success in America was driven by French Impressionist art. In the aftermath of the Henry Ford sale, his winning blend of insouciant charm, energetic optimism, and specialist knowledge of Impressionist painting seemed on the verge of conquering the world. Sotheby's was on the retreat, with the now ageing Peter Wilson trying vainly to run the business from semi-retirement in France, and creating only resentment and division amongst his underlings. But at this point Bathurst's story takes on an element of Greek tragedy. It's an illustration of the pressure on the individual built up by the remorseless rise in the value of art in general, and

French Impressionist art in particular. The heroes of Greek tragedy are brought low by one flaw in their otherwise impeccable armoury of virtues. In David's case it was that same bravado which had impelled him on to the back of Feodor Pitcairn's snowmobile. It now drove him into an error of judgement that had disastrous consequences.

It was a sign of the times that the next person Bathurst found himself negotiating with for a major consignment of Impressionist pictures was not a traditional collector of long standing like Theodore Pitcairn or Henry Ford, but Dimitri Jodidio, the chief agent of a Lausanne-based art investment group, Cristallina SA. An agreement was reached for Christie's to sell 8 paintings (works by Renoir, Monet, Degas, Morisot, van Gogh, Gauguin and Cézanne) as the centre-piece of their New York auction in May 1981. They were expected to fetch in the region of $10 million. But on the night of the sale, bidding was feeble. Interest rates had recently hit 20 per cent, and people sat on their hands. Only one of the 8 – the Degas – actually found a buyer and all the rest were bought in. David, who was the auctioneer, climbed out of the rostrum at the end of a very sticky evening to be confronted by a mass of ravening pressmen wanting to interview him, all impatient to write a story about the collapse of the art market. David was an instinctive risk-taker, and now he jumped on the back of another snowmobile. He decided in the heat of the moment to exaggerate the truth, and announced that the Gauguin and the van Gogh had also found buyers; in other words, three paintings had sold rather than one. His motive was nothing more sinister than to limit damage to the art market. And perhaps to provide a little balm to his own wounded pride: auctioneering, as Bathurst himself was fond of maintaining, is an expression of virility, and there is nothing more insulting to a man's self-esteem than to preside over an unsuccessful sale.

The next day Jo Floyd, Chairman of Christie's International, was informed by David of what he had done. Floyd, an essentially

tolerant man, took a relaxed view. It was common practice at that
time for auctioneers to obscure an unsold lot by knocking it down
to an imaginary name, as if it had actually sold. In some of the less
successful sales that I myself auctioned at Christie's at that time,
swathes of indifferent paintings by minor nineteenth-century art-
ists apparently entered the collections of members of the Chelsea
football team. All David felt he had done that evening was extend the
deception a little further, beyond the parameters of the actual auc-
tion. People soon forgot about the incident. Other, more successful
Impressionist sales followed, and a couple of years later Floyd ap-
pointed Bathurst chairman of Christie's in London, where he proved
a popular and charismatic leader. But in 1985, Jodidio, who had been
brooding on the lack of success of the Cristallina pictures at auction,
brought a claim against Christie's in the US Supreme Court for neg-
ligence over their conduct of the 1981 sale. It was thrown out, but in
the process of the hearing David's deception emerged and was widely
reported in the newspapers. It elicited the sort of high-minded out-
rage which the press reserves for cases where it finds itself to have
been misled. The ensuing uproar was catastrophic. Floyd regretfully
asked Bathurst to resign, which David did, promptly and honour-
ably. It has to be admitted that in many areas of his life David took
huge risks, and most of the time luck was miraculously on his side.
But on the rare occasions, as now, when things went badly wrong, it
was an appealing extension of his bravado that he accepted its con-
sequences without a trace of bitterness. As far as Christie's and Jo
Floyd were concerned, however, you couldn't escape the conclusion
that it had been fine to lie to the press, but it was a punishable error
to be found out.

Cristallina was an art investment fund heavily into the works of the
Impressionists. This use of Impressionism as an investment vehicle
was a natural consequence of the paintings' spiralling values. Not

68 A bonus for the railwaymen. Renoir, *La Promenade*,
1870.

all such ventures were successful; but one which showed very good
returns, certainly as far as its Impressionist paintings were con-
cerned, was the British Rail Pension Fund. At a time of poorly per-
forming equity markets and high inflation in the late 1970s, the dar-
ing step was taken of investing in the art market 4 per cent of the
Pension Fund's assets. By the time the decision was taken to sell, the

Impressionist market was hitting its late 1980s peak. In the auction of the Impressionist collection on 4 April 1989, paintings whose total cost price had been £3,400,000 now realised £35,200,000 for the railwaymen. The operation turned out to be a triumph for Michel Strauss, the head of Sotheby's Impressionist Department, who had advised on their purchase. A Monet of Venice bought for £253,000 in 1979 fetched £6.71 million; and a Renoir which cost £621,000 fetched £10.3 million. Such results, had they been carried through the entire portfolio, could have sent a whole generation of station porters into plutocratic retirement in the South of France. Sadly for them, it was only in what was now emerging as the blue chip field of Impressionism that such spectacular returns were achieved. And that was largely because of the dramatic intervention of the Japanese.

The Japanese connection with French Impressionism goes back to the very beginning of the movement. The European discovery of Japanese prints in the middle of the nineteenth century was an important influence on the way the Impressionists actually painted, setting a precedent for the use of flat areas of pure colour and inspiring many innovative compositional ideas. Perhaps that was why there were Japanese who responded as positively as anyone to the new French art. Tadama Hayashi was at the forefront of this interchange. He first came to Paris from Tokyo in connection with the 1878 Exposition Universelle, and stayed on to deal in Japanese works of art. By 1890 he had showrooms in a fine first-floor flat in the Rue de Victoire. He had also met Monet, Degas and Pissarro, and begun collecting their work. In the early days Hayashi would acquire an Impressionist painting in exchange for a group of Japanese prints, because neither he nor the painters had much available cash, but each admired what the other had to offer. Later, he kept his collection of European art in specially furnished private rooms above his flat. In the words of his friend the artist Raymond Koechlin:

There it was that he piled up his treasures of French painting. And perhaps 'piled up' are the right words, because on the walls there was hardly anything. They were bare walls, and when he wished to show a painting to a friend for whom he had a particular regard, he had to draw it out from some hiding place, the mystery of which no one had ever fathomed. He acted with his pictures as Japanese art lovers with their paintings, not showing them all at a time but contriving agreeable surprises each time they were brought out of their prisons.

It could have been a visit to Hayashi which prompted van Gogh to write admiringly to Theo in 1888: 'The real Japanese hang nothing on their walls, drawings and curiosities all being hidden in drawers'.

Hayashi set a fashion followed by later generations of his countrymen. When Arnold Bennett visited the premises of Durand-Ruel in Paris in January 1911, he noted the nationalities of the clients he heard conversing around him. 'The chief languages spoken', he recorded, 'were American and Japanese'. Immediately after World War I the rich Japanese shipbuilder and collector Kojiro Matsukata, in the words of René Gimpel, 'burst upon Europe and cleared the dealers out of modern pictures to set up a museum in Tokyo.' Among other things he bought 30 Monets, and his museum deserves immortality at least for its name: The Sheer Pleasure Arts Pavilion.

But the wave of Japanese buying French Impressionist paintings that broke over the art world in the 1980s was unlike anything that had gone before. The original interest in Impressionism was given huge new momentum by the gathering strength of the Japanese economy. In 1985 the yen was revalued and by 1987 it had risen nearly 100 per cent against the dollar. A year later, 53 per cent of all auction sales of Impressionist and modern paintings were being made to Japan. The Japanese are great consumers of brands, and 'Monet' or 'Renoir' were brand names that had a particular financial and

69 The special relationship between Japan and
 Impressionism: Matsukata's niece Madame Kuroki
 with Monet at Giverny, 1921.

cultural resonance. Looked at in one way, this is the final step in the
marketing process originally set in motion by Durand-Ruel when
he invented single-artist exhibitions. The emphasis on an individ-
ual painting identity, the marketing of a temperament, was already
creating powerful brand-awareness at the end of the nineteenth
century.

 If you wanted to impress your colleagues as an art dealer in
the late 1980s, you boasted about the number of Japanese clients
you had, and your intimate understanding of their tastes and foi-
bles. Unfortunately there was nothing coherent about the multitude
of theories put forward by the Western art trade as infallible princi-
ples for conducting negotiations in Tokyo. 'For God's sake don't offer

them paintings of cliffs', I was told by one dealer. 'The Japanese are frightened of them.' 'Stand up straight', another one advised. 'The Japanese revere tall men. They think they're nearer to God.' 'Don't try and sell them pictures with crows in them'; 'never let them lose face'; 'always let them beat your price down'; 'never allow them to haggle'.

The first time I was actually invited to the apartment of a Japanese collector, I was thus unsure exactly how to behave. As it turned out, Mr A, who was known to be a major buyer of the Impressionists, could not have been kinder or more polite. The only problem was that I could see no paintings at all on his walls. All that hung there was a dull cluster of small framed documents. Ah, I thought: I was dealing with a latter-day Tadama Hayashi. Of course there would be no paintings actually displayed on the walls. That would be considered vulgar. Shortly Mr A would be contriving some agreeable surprise for me, bringing some treasure out of its hiding place for my delectation. After twenty minutes' polite conversation, nothing had emerged. I finally asked where his paintings were.

'Paintings?'

'Yes. I'd love to see them.'

He looked dismayed, as if I had suggested something faintly improper. 'Paintings not here.'

'Oh. Where are they?'

'Paintings much too valuable to hang in apartment', he explained, with the mixture of patience and embarrassment that my questions often seemed to elicit from Japanese clients. 'Paintings all in bank vault.'

He gestured instead to the cluster of framed documents and encouraged me over to look at them. They proved to be the certificates of each painting's authenticity, each one lovingly presented in a velvet slip. Here was the final reduction of art collecting to stock ownership, of paintings into negotiable assets.

70 The sale of van Gogh's *Sunflowers* in 1987. James
Roundell (bidding on telephone, far left) unleashes
the climactic phase of Japanese Impressionist
collecting.

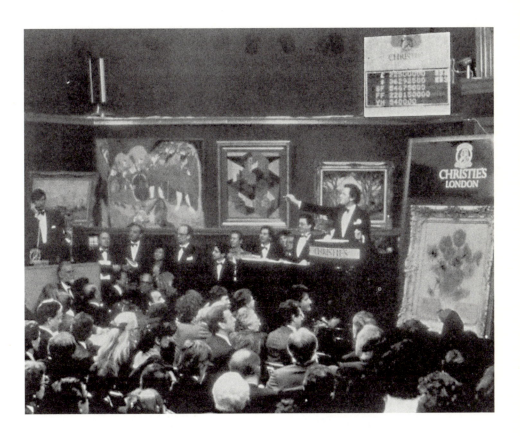

The climactic phase of the Japanese mania for Impressionism
started when Christie's were asked to sell an outstanding van Gogh
Sunflowers in March 1987. Christie's initial estimate on the picture
was something between £4 million and £6 million. In the weeks lead-
ing up to the sale, the feverish level of interest in it led to a gradual
revision of those figures, so that by the day of the auction the expect-
ed selling price was being quoted at 'in excess of £10 million'. It end-
ed up making £24,750,000, three times the previous world record for
any work of art. The buyer was James Roundell, head of Christie's
Impressionist department, on the telephone. And two days later it

was revealed that he had been bidding with the Japanese corporation Yasuda Fire and Marine Insurance.

This was the era when Japanese companies were building corporate art collections, or even what they rather grandly called museums. These had two overt purposes: one was for the cultural refreshment of their staff, and the other was to improve the company's public image. The Yasuda museum was already in existence and owned two Renoirs. They acquired the van Gogh to be the centrepiece of the collection. It was a triumphant success for Yasuda. Their museum was on the 42nd floor of their Tokyo headquarters, and a special amphitheatre was built to exhibit the *Sunflowers*. Local Japanese interest was intense, and between October and December 1987, in excess of 100,000 people paid to see the picture. The massive media publicity that was generated for Yasuda, which in turn led to the sale of a lot more insurance, meant that the van Gogh to all intents and purposes paid for itself.

In the feverish excitement of the late 1980s, the European and American art trade was too busy making money to ask questions about what underlay the Japanese enthusiasm for French Impressionist painting. There were apparently all sorts of people buying: private collectors, corporate museums, financial institutions, even department stores. And if the precise nature of some of the purchasing entities was a little opaque, it was not the business of the auctioneers and dealers to inquire too closely into them. All they needed to know was that there was money forthcoming, large quantities of it; the entire Impressionist *oeuvre* was suddenly blanketed in Far Eastern demand. At last even those voluminous late Renoir nudes were being competed for. My friend Jasper had a theory that they met a latent Eastern fantasy about large Western women, but this theory may have said more about Jasper than about the Japanese. Whatever the explanation, cut-throat saleroom duels were fought over sketches that were no more than the debris of Renoir's studio. 'It is only

71 Renoir, *Au Moulin de la Galette*, 1876: bought by
 Ryoei Saito for $78 million in May 1990.
72 Van Gogh, *Portrait of Dr Gachet*, 1890: bought by
 Mr Saito for $82.5 million the same week.

an auctioneer,' said Oscar Wilde, 'who can equally and impartially admire all schools of art.' Sotheby's and Christie's catalogues were masterpieces of salesmanship dressed up in the language of art history, as they contorted themselves to see merit in these abandoned scraps. Works that Renoir's executors might more humanely have put a match to were entering Japanese collections at unprecedented prices.

In this tumultuous atmosphere, the sale of something genuinely outstanding sent the market into a frenzy. In one climactic week in New York in May 1990, two masterpieces were offered, one in each auction house. Renoir's *Au Moulin de la Galette* (the picture that John Hay Whitney had paid $165,000 for in 1929) came up at Sotheby's. And a portrait of the Impressionists' early patron, Dr Gachet, painted by van Gogh, was the star lot at Christie's. This was one of those legendary episodes of art-market history, as much of a watershed as the Goldschmidt sale in 1958. It created a new highpoint in the adulation of the Impressionist painting. The Renoir fetched $77 million; and the *Portrait of Dr Gachet* made $82 million. Almost as extraordinary was the fact that the same Japanese collector bought both pictures. Overnight the name Ryoei Saito, of whom few in the west had heard before, was on everyone's lips. Who was he? Might he be interested in more Impressionist paintings? How could you get to him?

He was the Chairman of Daishowa Paper Manufacturing, a firm with an annual turn-over of $2.5 billion. 'The value of these paintings will be understood in 50 or 100 years,' he opined to the *The Washington Post* a few weeks later. 'If I don't buy now this art will never come to Japan.' His language unconsciously echoes Cassirer's 'cultural deed' in bringing French Impressionism to Germany, and Frank Rutter's prescient warnings in 1905 about future appreciation of the movement. Both ideas – first, that being exposed to Renoirs and van Goghs is good for people, and second, that as more people

73 Ryoei Saito, whose coffin could have held some
surprises.

come to an understanding of them, there is continuing potential for
their value to go up further – are central and enduring elements in
the Impressionist legend.

Less than a year later, facing an unwelcome income-tax inves-
tigation, Saito was making rather different noises: 'I'm telling the
people round me to put (the paintings) into my coffin and burn them
with me when I die.' Burn them? The western art world, like some
maiden aunt who discovers that the family house she has so prof-
itably rented out is being used as a brothel, had to be revived with
smelling salts. What had happened in the meantime was a collapse
in the Japanese economy, and therefore a collapse not just in Japa-
nese but in world-wide demand for Impressionist art. Cracks had
already been appearing in the summer of 1990, papered over by the
excitement of Saito's purchases. But by the autumn of that year, after
Saddam Hussain's invasion of Kuwait and with the Japanese stock
market in free fall from a peak of 38,000 to an ultimate low of 14,000,

no one was buying any more. Famine had succeeded feast almost overnight. The loss of confidence spread to all areas of the art market. As an art dealer, I noticed the change immediately after the summer holidays. No matter how many telephone calls you made, how many pictures you offered to your clients at suicidally reduced prices, there was simply no business to be done any more. Jasper talked fondly about the insurance claim he was contemplating on his stock. Apparently there was a Chinese man he knew who for a consideration would come round at night and burn down your gallery. Days at work certainly became very empty. My colleague Henry Wyndham and I were reduced to going to the cinema in the afternoons. That winter we saw every matinee in London's West End.

And gradually revelations emerged about the corruption that underlay the recent Japanese enthusiasm for Impressionism. A lot of the buying had been motivated not by love of the art but by the need for a vehicle in which to move money around, often illicitly. For instance, in an effort to cool an over-heating property market the Japanese authorities had capped the price of real estate. You got round that as a purchaser by throwing a bunch of Monets into the deal, selling them to the vendor for 10 million and then buying them back a month later for 20 million. The technical term here was *zaiteku*, which translates euphemistically as 'financial engineering'. French Impressionist pictures, in what was already a dramatically rising market, were perfect for the purpose, because they had no fixed and provable value. They were worth what you wanted them to be worth. So you could use a Renoir or a Monet or a Degas to weight a property deal or bribe a politician or fast-track your name up the waiting list of a particularly desirable golf club. What would Degas, the man who observed that there is a certain success which is indistinguishable from panic, have made of it all?

Once what had been going on became clear, the Japanese authorities cracked down heavily on anyone who had been buying art,

which meant that the innocent as well as the guilty fell under suspicion. Even as a serious collector in Japan, you didn't go on buying Impressionist paintings now that it was tantamount to a confession of financial malpractice. Mr Saito turned out to be one of the guilty ones. In October 1995 Tokyo District Court sentenced him to a three-year prison term for tax offences, suspended for five years. In March 1996, he died. But his van Gogh and his Renoir, to everyone's relief, did not accompany him to the funeral pyre. They have since found new homes in more congenial surroundings.

OPTICAL COLLUSION

The Impressionist Painting after 1990

————

The Japanese debacle devastated the market for Impressionist pictures like an earthquake. When the dust settled, a new and unfamiliar landscape was revealed. It wasn't that Impressionism had lost any of its glamour and appeal: museum exhibitions featuring the major names of the movement were as popular as ever, and lavishly illustrated books about them were bought by the public with undiminished enthusiasm. It was just that no one was now sure what the paintings themselves were actually worth, once you subtracted the Japanese from the financial equation. In the atmosphere of uncertainty, very few sellers were tempted to put their Impressionist pictures on the market; the quality of what did come up was generally mediocre, so prices remained heavily depressed by comparison with 1989/90 levels, in some cases down by as much as 50 per cent.

For the auction houses, times were very difficult. The overall art market took its tone from the blue-chip Impressionists, and sunk into a consequent slough of despond. Survival was the best you

74 The last word on the Monet/money pun: *Daily Mail*
headline, June 1994.

Daily Mail, Wednesday, June 29, 1994

Manet, Monet, Money

IT'S A RICH MAN'S WORLD

THE sale of two Impressionist paintings for well over £4million each last night signalled to the art market — and some optimists outside it — that the good times have arrived again.

could hope for: 'Stay alive till '95', intoned the dealers grimly. There was a lot of optimistic talk about green shoots of recovery, but they were hard to detect in the early 1990s. By the middle of the decade, however, a few signs of life were returning. One or two collectors with good Impressionists to sell had the decency to die. In London in June 1994, a Monet and a Manet in the same sale exceeded their top estimates when each made over £4 million, an exciting enough event for *The Daily Mail* to announce it with a memorable tribute to Abba: 'Manet, Monet, Money: It's a Rich Man's World'. But volume was still thin, and competition between the auction houses to attract the star Impressionist works that might kick-start another boom grew more and more intense. Particularly in demand were paintings that were 'fresh to the market', in other words Impressionist pictures that had not been offered over the previous generation and therefore held out hope of a fresh start, not being besmirched by association with the Japanese bubble.

That was why, one spring morning in the 1990s, Michel Strauss and I found ourselves in a railway carriage heading north from Milan, climbing a steady ascent through the mist into the foothills of the Alps. After an hour the train slowed, negotiating the points that led through a web of sidings and customs sheds, until it drew to a halt at Chiasso. We had crossed into neutral Switzerland. Chiasso, like many border towns, is a repository of secrets. We disembarked and were met by a driver who took us straight to the place where most of them are hidden: the free port.

Free ports are a fascinating idea. They answer a basic human fantasy: the existence of an area that is not in any country, a place beyond normal regulation and controls. Free ports are a refuge, but for things not people. They are a sanctuary for precious objects persecuted by tax and customs regulations. You pay no dues on what you store there. The great free port novel has not yet been written, but it offers a tremendous emotional metaphor to a writer. More pertinently to an art expert, the concentration of high-security warehouses that is the physical reality of a free port contains a lot of paintings. There are many different reasons why works of art find their way there. You don't need to agree with Balzac that behind every great fortune lies a great crime in order to find those reasons fascinating. No one knows for sure the sum total of the great art stored at any given time in the world's free ports (most of which are in Switzerland). But you could be fairly certain that an exhibition of its highlights would outshine most of the great museums of the world.

The car pulled up at the entrance to the free port. We had to show our passports. Just for security, but it felt as though we were crossing another border. 'This is it', I said to Michel as we drove in.

'This is it', repeated Michel.

We had travelled here because we had been approached by a middle-man back in London. Mr Benedetti was a svelte and smooth Italian who had a deal for us, he said. An incredible deal. The sort of

deal that comes along once in a lifetime. What was demanded first was total discretion. Could he rely on us?

Of course, we said.

He acted for people with a collection of great Impressionist pictures that had to be sold. He was going to tell us, in strictest confidence, whom he was representing. But it must go no further. Opus Dei.

'Opus Dei?'

'Precisely.'

'Do they own Impressionist pictures?'

'Monet, Degas, Pissarro, Renoir.' He counted them off on well-manicured fingers. 'Outstanding examples.'

'But where do they come from?'

'Gifts of the faithful, stretching back over many years. You will not have seen these paintings before.'

We tried to hide our excitement under a mask of professional interest. 'Why are they selling now?'

'There is a need to turn them into money. The fathers have a number of projects – schools in Africa, underprivileged children, things like that.'

'Where are the pictures?'

'In Switzerland.'

'Have they been exported from Italy legally?' I asked.

'Listen, my friend. These pictures, they have not come out of Italy. They have come out of the Vatican, a separate sovereign state. There is no need of export licences from the Vatican.'

I supposed there wasn't.

When we arrived in the viewing room at the free port, a number of canvases were waiting for us, face in to the wall. Benedetti was waiting for us, too: as smooth and svelte as ever, but his manner was more urgent, less relaxed than when we had seen him in London.

'Before I show you the paintings, I have to explain something. Obviously it is not possible for Opus Dei itself to be consigning

directly to Sotheby's for a public auction. It would be – how can I say it – compromising to the dignity of the Holy Church. Therefore I have agreed to help them.'

We nodded in appreciation of Mr Benedetti's piety and self-sacrifice.

'I am going to buy the paintings from them. So when they are sold at auction, it will be in the name of one of my companies. But it will involve a considerable financial outlay on my part. I will therefore need from you a generous guarantee before I can proceed.'

I was about to say something. But then, in a distant part of the room, I noticed the movement of a figure. He was wearing a black cassock and a biretta. He paused, raised a hand half in greeting and half in benediction, then disappeared. 'You see, they are anxious,' explained Benedetti. 'They need reassurance. I have told them that you are trustworthy.'

'Of course.'

'Shall we look at the pictures?' suggested Michel.

'And as we go', added Benedetti, 'I will tell you the money I am giving for each of them to the Opus Dei. Those will be the guaranteed prices from Sotheby's, please'.

After we had looked at the fifth painting, Michel said under his breath: 'Do you recognise these?'

I whispered that there was something disturbingly familiar about at least two of them.

'What is that you say?' demanded Benedetti.

'Michel was saying that this Monet is a particularly good one', I lied.

We got out, thank God, intact. No financial undertakings had been given, though we had promised to call Benedetti in couple of days' time with our considered offer. What we had been looking at was a selection of Parisian dealers' stock, artfully repackaged as the totally bogus Opus Dei collection. Benedetti had probably borrowed

them from their various trade owners, on the pretext of showing them to some rich private buyer, and assembled them at Chiasso.

'But what about the priest?' wondered Michel in the train back to Milan.

I'm almost sure he was an out-of-work actor, hired for the afternoon. You had to admire Benedetti's invention. In his way he was an artist, too.

The shortage of top-quality works coming on to the market in the 1990s continued to create revenue problems for the auction houses, made worse by the intense commercial rivalry between them. This meant that even when you finally got something good to sell, you made very little money because you'd had to reduce your commission rate so drastically to win the business. There was much head shaking: 'We can't go on like this', people in the auction houses muttered. 'Something's got to be done.' And done it was. In secret, with ultimately disastrous results.

The episode of collusion between Sotheby's and Christie's in the late 1990s is relevant to this book insofar as it illustrates the continuing power of the Impressionist picture. It was a fall in the hugely important Impressionist market which led to a loss of corporate earnings, which in turn aroused the tempting spectre of price-fixing as an answer to the problem. Many company chief executives have dreamed of a perfect, competition-free world in which margins remain intact and healthy profits are generated. But for the vast majority, such dreams remain fantasy. For a start, they just aren't practicable. The difference with Sotheby's and Christie's was that they operated in a totally duopolistic world: it is that much easier to institute a cartel when only two very similar entities are involved.

Who knows what actually went on in the series of private breakfast meetings that took place in the mid-1990s between the two company chairmen, Alfred Taubman and Anthony Tennant?

75 Alfred Taubman in 1992: the then owner of Sotheby's, in happier times.

76 Dede Brooks: the cushion in her office was embroidered 'No good deed goes unpunished'.

77 A step too far: Christopher Davidge, Chief Executive of Christie's in the 1990s.

A certain amount of hand-wringing, maybe, about the way the two auction houses were cutting each other's throats. The expression of a generalised desire to do something about it. A decision to pass the ball over to the respective company chief executives to see what they could come up with. And then a lot of relieved chat about shooting, a subject dear to both men's hearts.

What neither Taubman nor Tennant can have expected was the enthusiasm with which their chief executives – Dede Brooks at Sotheby's and Christopher Davidge at Christie's – grasped and ran with the ball they'd been passed. Their eagerness was the result of an unfortunate coincidence: both Brooks and Davidge had reached dangerous moments in their careers. Both had started to believe their own myths. Both, in their different ways, were ground-breakers who had already achieved considerable success. Davidge was the first person to run Christie's who hadn't come from the traditionally privileged background of most of his colleagues. Brooks was the first woman to run an auction house. Both had a point to prove: Davidge, that he was more able than the toffs about him, with their infuriating sense of superiority; and Brooks that she was better than any man. Their ambition seems to have blinded them both simultaneously to the legal implications of what they jointly resolved to do. Presented with the challenge of increasing company profits in difficult times, they decided that a secret arrangement to peg commission rates and secure margins was the answer; moreover it was the solution that they – as the two maverick innovators bounding free of outmoded tradition – were uniquely equipped to deliver. Like illicit lovers, they took to meeting in the back of limos in unlikely locations. Together, they planned their agreement.

Their remarkable achievement was the way they managed to keep that agreement secret, so that even their closest colleagues were unaware of what had happened. No one within Sotheby's and Christie's suspected that the higher commission rates shortly

thereafter brought into force were the result of anything other than a new regime of rigorous discipline. Davidge and Brooks felt pretty good about themselves, although it was necessarily a self-satisfaction that could not be shared: only the two of them knew how they had at a stroke saved the art market and protected their shareholders' interests. Sometimes heroism is a lonely business. A cushion in Dede's office was embroidered, with an unintended extra dimension of irony: 'No good deed goes unpunished.'

The unravelling of the wrong-doing was nothing if not dramatic. Christie's was bought by an unsuspecting new French owner, François Pinault, who decided to get rid of Davidge. Davidge responded with his bombshell: sack me, and the illegal collusion will come out. What illegal collusion? The commission rates I fixed with Sotheby's. You did what? Horrified, Christie's raced to the Department of Justice to get their confession in first and insure their own immunity from prosecution. Their sale-room currency converter found that 30 pieces of silver equated that week to $7,000,000, which was the personal pay-off Davidge was granted. Sotheby's were fined $45 million. What was not part of Christie's calculations were the subsequent class actions taken by their clients against both auction houses which ended in each of the two having to pay out $256 million more to settle. Sotheby's very nearly went out of business. Monsieur Pinault found that the purchase price of his new acquisition was effectively increased by a quarter of a billion dollars. It is never easy to disentangle moral principle in such cases, but it is doubtful that justice was served in respect of Alfred Taubman, chairman and majority shareholder of Sotheby's. Dede Brooks claimed in court she was only carrying out his orders. Those who knew both him and Dede found this hard to believe, but the jury were persuaded and Alfred – who had already paid a significant part of Sotheby's fines out of his own pocket – was the only one of the alleged malefactors who ended up going to jail. At the age of 78.

The collusion affair, with its appalling financial consequenc-
es for the auction houses, can be viewed as the most spectacular of
the many collisions between art and commerce that modern society
has generated. Impressionist painting, the driving force in the art
market during that time, has frequently been the catalyst to those
collisions. There's a certain symmetry to the sequence by which art
and commerce have grown ever more dangerously intimate since
the nineteenth century. In 1836 Alphonse Barbier utters his prophet-
ic warning that art will shortly be quoted on the commodity mar-
kets, just like sugar. In 1890 Harry Havemeyer, the American whose
fortune has been made in sugar dealing, starts buying Impression-
ist paintings. The same year Havemeyer is taken to court accused of
swelling his fortune by price-fixing: his sugar trust is allegedly a car-
tel. Havemeyer gets off. But in 2002, Alfred Taubman isn't so lucky,
going to prison for price-fixing the mechanism by which people
now buy Impressionist art – the auction. From art to price-fixing, via
sugar: it's a history of the Impressionist painting in a nutshell.

Meanwhile, despite what was happening in the art market and
the law courts, there was no let-up in the Impressionists' box-office
appeal. *Impressionists in Winter*, *Impressions of the Riviera*, *The
Impressionists at Argenteuil*, *Impressionism and the North*, *Impressionism
Abroad*, *Impressionists at the Seaside*: all were hit shows at museums in
places as far-flung as Portland, Washington, San Francisco, Nagoya,
Ottawa and Stockholm in the years either side of the new millenni-
um. One of the most successful exhibitions ever mounted in London
– *Monet in the 20th Century* – played to packed houses in the winter
of 1999. The queues at the Royal Academy were longer than ever. The
show had enjoyed similar success in Boston. Spin-off merchandis-
ing in museum shops reached new heights of ingenuity. A green soft
toy called Philippe the Frog, dreamed up by the marketing depart-
ment as a cuddly inhabitant of the water-lily pond in Monet's

78 Merchandising Monet: Philippe the Frog.

garden at Giverny, was a souvenir that many visitors to the exhibition felt unable to return home without acquiring. What next? A German museum was rumoured to be considering a St Sebastian pin-cushion; but if it reached production, it didn't have the same success.

By the turn of the new millennium, art prices were rising again. Not just for Impressionist art, but even more strongly for modern pictures, for Matisses and Picassos and Modiglianis. There was a huge surge in demand for contemporary art, for Rothko and Warhol and Bacon. The world-record prices set in the same week in 1990 – for a Renoir and a van Gogh – were finally broken in 2004. Significantly the painting that did it, the first one to exceed $100,000,000 at auction, was not an Impressionist but a Picasso. A Jackson Pollock changed hands privately for even more. There was a feeling that the Impressionist picture had grown a little old fashioned.

But Impressionism, by comparison with cutting-edge contemporary art, has been old fashioned for almost a hundred years.

79 Renoir, *La Loge*, 1874–75: the painting whose history encapsulates the story of this book. (See pl. 8.)

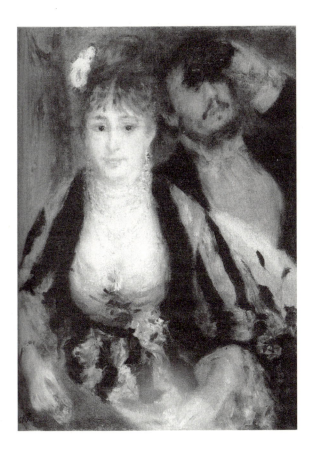

Ever since the early twentieth century people have been turning to Monet, Renoir, Degas and company as the safe, comforting alternative to the strident excesses of the avant-garde. What is remarkable is their perennial appeal. A significant element of every succeeding generation's new wealth is attracted to them like a magnet. As today's emerging markets – Russia, China, India, the Middle East – spawn more and more super-rich, it is fascinating to watch a sizeable proportion of them still being drawn to Impressionism. The allure continues, more globalised than ever.

The history of a specific painting, Renoir's smaller version of
La Loge, probably painted in 1874, provides a fascinating overview of
the growing demand for Impressionism over the past century and a
quarter. In the first Impressionist auction at Drouot in March 1875 it
sold for 220 francs; in 1912, at the sale in Paris of the collection of the
industrialist Jean Dollfus, it fetched 31,200 francs. Coming up once
more at Christie's New York at the height of the Japanese boom in
May 1989, it made $12,100,000. Offered again in the dog-days of 1993,
it was a measure of the extent to which confidence in the market had
been undermined that it failed to attract a bid against an estimate
of $6 to $8 million. Then, in February 2008 it came up at Sotheby's
where it was competed for by a bevy of newly rich bidders from all
quarters of the globe, and finally sold for $14,800,000. The show was
on the road again, underpinned by a much broader-based interest
than in the time of the Japanese bubble, now that Russian, Asian
and Middle-Eastern wealth was competing with that of America and
Europe for the great Impressionist prizes.

The other thing that the story of *La Loge* tells us very clearly is
that Impressionist paintings are investment vehicles, too. The strat-
egy of Maupassant's Monsieur Walter would have paid enormous
dividends by 1900 had the names of the young men whose works he
bought cheap and hoarded in the 1870s turned out to be Monet and
Renoir. Extraordinary accelerations have since been punctuated by
one exceptional dip in the 1990s, but the underlying tendency of pric-
es is an upward one. It must be, given the finite quantity of Impres-
sionist paintings available to the market and their long-established
desirability. If there is an art market equivalent of a blue-chip stock,
it is a major Impressionist painting. History suggests that there
will be a reliable return on it over the years. It is a lesson not lost on
today's buyers: besides being collectors, they are also investors.
Superficially the new generation of Impressionist collectors are all
the same, because they are rich. But beneath the surface there are

glorious instances of unexpected individualism. Take Mr D. I can't
say now whether he lived in Taipei, Palm Beach or the Ruhr Valley; it
could have been any or none of them. But his house had all the famil-
iar accoutrements of vast wealth, conforming to that international
style of rich display that knows no continental boundaries. A fleet
of expensive cars spilled out of the garaging, a scale model of a mas-
sive private yacht dominated a corner of the living room, the sort of
lush velvet grass that never grows a weed extended as far as the eye
could see in the garden. And on the walls hung a group of Monets
and a van Gogh.

I waited in the drawing room. A heavily groomed and scented
chihuahua wandered in, its movements encumbered by the canine
diaper it was wearing. Presumably the grass had to be protected, and
a mishap indoors was unthinkable. A little later Mr D himself ap-
peared. He had that faintly worried look that often clouds the fea-
tures of the very rich, an anxiety that something better might be
happening elsewhere, something that was being denied to him. It
is the sort of anxiety that means, no matter how absorbing your cur-
rent conversation, you always break off and answer your mobile tele-
phone when it rings in case it's offering you a sharper sensation, a
more piquant diversion. It's a manifestation of what Dr Johnson
called 'the insolence of wealth'. But in the case of this man, one thing
at least commanded his unfeigned enthusiasm: his paintings.

'Wait', he said. 'Before you look at them I just have to switch
something on'. I imagined that it was some aspect of the lighting
that he wanted to adjust. He re-emerged satisfied and ushered me
forward to the first Monet. It was a coastal scene of the 1880s, a rich
azure expanse of sea glittering in the sun. When I was exactly a me-
tre and a half away from the canvas, the sound system was activat-
ed. The room was abruptly flooded with Debussy. I stepped back a
pace or two and the music stopped. The next Monet, a water-lilies,
triggered Gershwin's *Rhapsody in Blue*. Finally I was encouraged to

approach the van Gogh, a late and tortured landscape. A metre and a half away Frank Sinatra burst into 'I did it My Way.'

I warmed to Mr D's quest for appropriate musical enhancements to his paintings. It was his attempt to meet the challenge that has confronted Impressionist collectors for more than a century. How do you evolve a suitable vocabulary to express your aesthetic response to the new art? Verbal formulations have come in varying degrees of success. 'The pictures glow, the pictures have warmth, the pictures care,' declared Edward G. Robinson. 'We glow, we have warmth, we care. You see, it's reciprocal.' The Franco-American collector Georges Lurcy, of course, used more extravagant language: 'The priceless temptation of [Impressionist] art gives me everything, delectable stings, a hint of pepper and sun, the effortless crunch of the teeth into a morsel of cantaloupe'. Mrs Havemeyer's response is nothing if not emotional: 'You must hear the voice calling to you, you must respond to the vibrations Manet felt, which made his heart throb and filled his brain, which stirred his emotions and sharpened his vision as he put his brush upon the canvas.' Or then there is Sam Courtauld's airman friend struggling to articulate the pleasure he felt in Cézanne: 'It makes you go this way, and that way, and then off the deep end altogether.' Reciprocal glowing, crunching cantaloupe, calling voices: with this heritage of linguistic contortion, why not try music?

'That's amazing', I said inadequately.

But Mr D didn't hear me. He had turned away to answer his mobile phone.

Impressionist paintings are enduring emblems of great wealth, and in the early twenty-first century have come to create for their owners an image of traditional taste and substance. They are turned to by those new rich who seek a conventional affirmation of status. In contrast, those who collect more difficult contemporary works aspire

to a more daring and edgy image. If Théodore Duret, that pioneer patron of Manet, Monet and Pissarro in the 1870s, were alive today, would he be buying Impressionism or Conceptual art? Probably the latter: with his pleasure in the eccentric and desire for the impossible in art, it seems likely that he would be drawn to the cutting edge in whatever era he lived. The only thing he might be surprised by is the number of people now conditioned to join him in taking a risk on new, unproven art. We live in an era which, more than ever before, equates novelty with quality.

The appeal of the Impressionists today is something different. They have been overlaid with history. People find them attractive for a number of reasons: because of the brightness of their colours, the serenity of their subject matter, the allure of the era that they document; the security of their attributions, the high recognisability of their style; and the lingering romance that attaches to them as the first harbingers of modern art, as painters who weren't understood in their time. Not the least satisfying part of the enduring Impressionist myth is the reassurance it brings of human progress, the opportunities it provides for the smugness of hindsight. This is art that was difficult for the artists' poor, misguided contemporaries to comprehend; but art that is easy to grasp for us, their enlightened descendants. Impressionist paintings not only assert wealth and seduce the eye, but they make people feel good about themselves, too. It is a recipe for continuing success.

SELECTED BIBLIOGRAPHY

CHAPTER ONE

Brettell, R. R. *Impression: Painting Quickly in France 1860-90*. New Haven and London, 2000.
Hauser, A. *The Social History of Art*. London, 1951.
Gay, P. *Pleasure Wars*. New York, 1998.
Goncourt, É. and J. *Manette Salomon*. Paris, 1866.
Nochlin, L. *Realism and Tradition in Art 1848-1900*. New Jersey, 1966.
O'Brien, J. (ed.) *The Journals of André Gide*, vol. I, 1889-1913. London, 1947.
Rewald, J. *The History of Impressionism*. New York, 1973.
Tucker, P.H. *Monet, Life and Art*. New Haven and London, 1995.
Wharton, E. *The Custom of the Country*. New York, 1913.

CHAPTER TWO

Adler, K. and T. Garb. *The Correspondence of Berthe Morisot*. London, 1986.
Assouline, P. *Discovering Impressionism, the Life of Paul Durand-Ruel*. New York, 2004.
Distel, A. *Impressionism: The First Collectors*. New York, 1990.
Dumas A. et al. *The Private Collection of Edgar Degas*. New York, 1997.
Flaubert, G. *L'Éducation Sentimentale*. Paris, 1869.
Gay, P. *Modernism*. New York, 2007.
Gimpel, R. *Diary of an Art Dealer*. London, 1992.
Goncourt, É. and J. *Pages from the Goncourt Journal*. London, 1984.
Lepine, O. et al., *Équivoques* (exh. cat.). Paris: Musée des arts décoratifs, 1973.
Maupassant, G. de. *Bel-Ami*. Paris, 1881.
Moffett, C. *The New Painting, Impressionism 1874-78*. Washington, 1986.
Pissarro, C. *Letters to Lucien*. New York, 1943.
Raibinow, R. A. (ed.) *Ambroise Vollard, Patron of the Avant-Garde*. New York, 2006.
Renoir, J. *Renoir My Father*. London, 1962.
Richardson, J. *A Life of Picasso*, vol. 2. London, 1996.
Stolwijk, C. and R. Thomson. *Theo Van Gogh*. Zwolle, 1999.

Vollard, A. *Recollections of an Art Dealer*. London, 1936.
Zola, É. *L'Oeuvre*. Paris, 1886.

CHAPTER THREE

Brownell, W. C. *French Traits*. New York, 1888.
Davis, R. H. *Round About Paris*. New York, 1895.
Dumas, A. and D. Brenneman. *Degas and America, The Early Collectors*. New York, 2001.
Fussell, E. S. *The French Side of Henry James*. New York, 1990.
Havemeyer, L. *Sixteen to Sixty, Memoirs of a Collector*. New York, 1993.
Hirschler, Erica. *Impressionism Abroad: Boston and French Painting* (exh. cat.). London: Royal Academy of Arts, 2005.
Matthews, N. M. *Cassatt and her Circle, Selected Letters*. New York, 1984.
Matthiessen, F. and K. Murdock. *The Notebooks of Henry James*. New York, 1955.
Meixner, L. L. *French Realist Painting and the Critique of American Society 1865-1900*. Cambridge, 1995.
Méral, J. *Paris in American Literature*. Durham: Duke University Press, 1989.
Morrow, W. C. *Bohemian Paris of Today*. London, 1899.
Poli, B. *Le Roman Américain, 1865-1917: mythes de la frontière et de la ville*. Paris, 1972.
Ross, I. *Silhouette in Diamonds*. New York, 1960.
Saarinen, A. *The Proud Possessors*. London, 1959.
Stone, I. *Lust for Life*. London, 1935.
Vickers H. (ed.) *Beaton in the Sixties*. London, 2004.
Wegelin, C. *The Image of Europe in Henry James*. Dallas, 1958.
Weitzenhoffer, F. *The Havemeyers: Impressionism Comes to America*. New York, 1986.
Bailis, J. et al. *Claude Monet (1840–1926)* (exh. cat.). New York: Wildenstein, 2007.

CHAPTER FOUR

Akinsha, K. and G. Koslov. *Stolen Treasure: The Hunt for the World's Lost Masterpieces*. London, 1995.

Busch, G. and L. von Reinken (eds.) *Paula Modersohn-Becker, The Letters and Journals*. New York, 1983.

Grodzinski, V. *French Impressionism and German Jews*. University of London PhD thesis, 2005.

Jensen, R. *Marketing Modernism in Fin-de-Siècle Europe*. Princeton, 1994.

Kessler, H. *Das Tagebuch, 1880–1937*. Stuttgart, 2004.

Kostenevich, A. et al. *From Russia*. (exh. cat.). London: Royal Academy of Arts, 2008.

Nicholas, L. *The Rape of Europa*. London, 1994.

Nordau, M. *Degeneration*. London, 1895.

Paret, P. *The Berlin Secession: Modernism and Its Enemies in Imperial Germany*. Harvard, 1980.

Paret, P. *German Encounters with Modernism 1840–1945*. Cambridge, 2001.

Saltzman, C. *Portrait of Dr Gachet: The Story of a Van Gogh Masterpiece*. New York, 1998.

Stourton, J. *Great Collectors of Our Time, Art Collecting since 1945*. London, 2007.

Taylor, I. and A. *The Secret Annexe, An Anthology of War Diarists*. Edinburgh, 2004.

Tuchmann, B. *The Proud Tower*. London, 1966.

Vansittart, P. *Voices, 1870–1914*. London, 1984.

Chapter Five

Bell, C. *Art*. London, 1914.

Bodkin, T. *Hugh Lane and his Pictures*. Dublin, 1956.

Brown, O. *Exhibition, The Memoirs of Oliver Brown*. London, 1968.

Cooper, D. *The Courtauld Collection*. London, 1954.

Evans, M. 'The Davies Sisters of Llandinam and Impressionism for Wales 1908–23', *Journal of the History of Collections*, 16, no. 2. Oxford, 2004.

Fairclough, O. et al., *Things of Beauty: What Two Sisters Did for Wales*. Cardiff, 2007.

Flint, K. *Impressionists in England, The Critical Reception*. London, 1984.

Gregory, Isabelle Augusta, Lady. *Sir Hugh Lane, his Life and Legacy*. Gerrards Cross, 1973.

Hart-Davis, R. *Hugh Walpole*. London, 1952.

House, J. *Impressionism for England, Samuel Courtauld as Patron and Collector*. London, 1994.

Innes, M. *Stop Press*. London, 1939.

Joliffe, J. (ed.) *Neglected Genius: The Diaries of B. R. Haydon*. London, 1990.

Moore, G. *Confessions of a Young Man*. London, 1886.

Munnings, A. *An Artist's Life*. London, 1950.

Rothenstein, W. *Men and Memories*. London. 1931.

Wilde, O. 'The Critic as Artist', *Intentions*. London, 1891.

Wilde, O. 'The Decay of Lying', *Intentions*. London, 1891.

Chapter Six

Cooper, J. *Under the Hammer: The Auctions and Auctioneers of London*. London, 1977.

Faith, N. *Sold: The Revolution in the Art Market*. London, 1985.

Herbert, J. *Inside Christie's*. London, 1987.

Herrmann, F. *Sotheby's*. London, 1980.

Lacey, R. *Sotheby's: Bidding for Class*. London, 1998.

Lyttelton, G. and R. Hart-Davis. *Letters*, vol. III. London, 1981.

Reitlinger, G. *The Economics of Taste*. London, 1960.

Robinson, E. G. *All My Yesterdays*. London and New York, 1974.

Shakespeare, N. *Chatwin*. London, 1999.

Watson, P. *From Manet to Manhattan, The Rise of the Modern Art Market*. London, 1992.

Chapter Seven

American Auction Galleries. *Collection of T. Hayashi* (auction cat. 9 January). New York, 1913.

Douglas, K. *The Ragman's Son*. London, 1988.

Flower, N. (ed.) *The Journals of Arnold Bennett, 1911–21*. London, 1932.

Sproto, D. *Elizabeth Taylor*. New York, 1995.

Chapter Eight

Mason, C. *The Art of the Steal*. New York, 2004.

INDEX

The numbers in italics refer
to illustrations

A
Abba 203
Acquavella galleries 70
Alexis, Paul 28
Astor, Brooke 87
Astruc, Zacharie 18
B
Bacon, Francis 212
Balay, Roland 160
Balzac, Honoré de 38, 204
Barbier, Alphonse 43, 211
Barbizon School 10, 44, 66, 68,
 124, 130, 131
Barnes, Dr Albert C. 87, 88
Bathurst, David 179, 180–81,
 186–89, 187
Baudelaire, Charles 13
Beaton, Cecil 87
Bell, Clive 146
Bellio, Georges de 33
Bennett, Arnold 192
Berenson, Bernard 90
Berlin, Isaiah 152
Bernheim-Jeune 49, 99, 138, 170
Bernstein, Carl 95
Biddle, Margaret Thompson 153
Blaker, Hugh 138
Blanche, Jacques-Émile 38
Bond, Alan 43
Bonnard, Pierre 87
Boudin, Eugène 134, 186
Bouguereau, William
 Adolphe 49
Boussod Valadon 49, 68, 70,
 130
British Rail Pension Fund 190
Brooks, Dede 208, 209, 210
Brown, Oliver 143
Brown, Sidney 107
Brownell, W. C. 62
Browning, Robert 129
Burlington Fine Arts Club 142

Burton, Richard 183, 184
Byron, George Gordon, 6th
 Baron 15
C
Caillebotte bequest 136
Caillebotte, Gustave 12, 51, 52
Camondo, Count Isaac de 52, 128
Carlyle, Thomas 121
Carstair's Gallery, New York 160
Cartier 183
Cassatt, Alexander 24, 61, 64
Cassatt, Mary 14, 24, 48–49, 62,
 63, 64, 65, 69, 70, 74, 76, 79, 83,
 84, 86
Cassatt, Robert 61
Cassirer, Paul 97, 98, 99, 113,
 130, 198
Castagnary, Jules Antoine 15,
 18, 37
Cézanne, Paul 30, 39, 40, 56, 87,
 101, 102, 105, 108, 110, 118, 138,
 142, 153, 156, 158, 160, 170, 177,
 186, 188, 216
 Le Garçon au gilet rouge (1890)
 160, 170
 La Montagne Sainte-Victoire
 (1882–85) 142
 Provençale Landscape
 (c. 1885–87) 142
Charry, Paul de 48
Chatwin, Bruce 173, 172, 173,
 174, 181
Cherrill, Virginia 144
Chester Dale family 155
Chevalier, Frédéric 37
Chevalier, Maurice 155
Child, Theodore 16
Chocquet, Victor 34, 39, 40,
 41, 48
Christie's 7, 38, 116, 122, 125, 126,
 150, 151, 154, 156, 157, 170, 179,
 181, 186, 188, 189, 195, 195, 198,
 207, 209, 210, 214
Churchill, Clementine 159
Churchill, Winston 146

Cognacq, Gabriel 153
Cognacq sale 153
Cooper, Douglas 130
Cotton, Jack 169
Courtauld Institute, London 142
Courtauld, Samuel 140, 141, 142,
 143, 216
Cozens, Alexander 15
Cristallina SA 188, 189
D
Daily Mail, The 203, 203
Daishowa Paper Manufacturing
Daumier, Honoré 113
Davidge, Christopher 208, 209,
 210
Davies, Gwendoline 136, 137, 138,
 139, 140
Davies, Margaret 136, 137, 138,
 139, 140
Davis, Erwin 65, 69
Davis, R.H. 60, 61
Debussy, Claude 215
Degas, Edgar 13, 19, 26, 30, 38,
 45, 48, 50, 60, 64, 65, 66, 67,
 70, 71, 79, 87, 97, 104, 106, 114,
 116, 118, 123, 129, 130, 131, 134,
 138, 150, 171, 172, 176, 186, 191,
 200, 205, 213
 L'Absinthe (1876) 126, 127, 128,
 165, 176
 Danseuses à la barre (c. 1880) 77
 Femme s'essuyant après le bain
 (1884) 56
 The Injured Jockey (1896–98)
 155
 Place de la Concorde (1876) 113,
 114, 116
 La Plage à Trouville (1870) 142
 Sur la plage 134
Dewhurst, Wynford 129
Dillon family 155
Divisionists 51
Dollfus, Jean 214
Douglas, Kirk 90, 154, 154, 159,
 185

Drouot 32, 56, 159, 214
Durand-Ruel, Joseph 46, 88
Durand-Ruel, Paul 20, 23, 34, 41,
 42, 43, 44, 45, 46, 47, 48, 49, 51,
 52, 64, 65, 66, 68, 69, 70, 71, 77,
 78, 83, 86, 88, 97, 99, 100, 106,
 118, 124, 125, 127, 130, 131, 132,
 134, 138, 170, 176, 192, 193
Duret, Théodore 33, 39, 65,
 124, 217
Duveen 70
E
École des Beaux-Arts,
 Paris 13
Elder, Louisine (Mrs. H. O.
 Havemeyer) 64, 65, 70, 74, 76,
 77, 82, 216
Elizabeth II, Queen 154–55
Ephrussi, Charles
Ernst, Max 94
Ernst, Philip 94
F
Fantin-Latour, Henri 66
Faure, Jean-Baptiste 34, 35
 Faure collection 48
Fénéon, Félix 69
Fisher, Dorothy Canfield 61
Flaubert, Gustave 18
 A Sentimental Education (1869)
 44
Flint, Russell 175
Floyd, Jo 188–89
Fonteyn, Margot 159, 160
Ford, Henry 188
 Ford family 155
 Henry Ford Impressionist
 collection 186
 Henry Ford sale 187
Freeman-Mitford, Algernon
 Bertram, 1st Baron Redesdale
 135, 135, 136, 140
Frith, William
 Derby Day (1858) 124
 Ramsgate Sands (1854) 124
Fry, Roger 146
G
Gachet, Paul 34, 34
Gagosian, Larry 42
Gallimard, Paul 52
Garbo, Greta 90

Gauguin, Paul 26, 28, 87, 91, 118,
 138, 171, 172, 177, 186, 188
 Still Life with Apples 153
 Te Rerioa (1897) 142
Gérôme, Jean-Léon 9, 10, 12, 13,
 52, 53, 68
 The Baths at Bursa (1885) 11,
 160
Gershwin, George
 Rhapsody in Blue (1924) 216
Gerstenberg, Otto 108, 113
Gerstenberg/Scharf collection
 114, 116
Gide, André 30
Gimpel, René 51, 86, 87, 192
Goering, Hermann 55, 109, 111
Gogh, Theo van 68, 91, 130, 192
Gogh, Vincent van 7, 26, 28, 49,
 68, 84, 90, 91, 97, 99, 104, 105,
 108, 109, 110, 112, 113, 118, 130,
 138, 153, 154, 158, 159, 160, 173,
 177, 185, 186, 188, 192, 196, 210,
 212, 216
 Olive Trees (1889) 112
 Portrait of Dr Gachet (1890) 197,
 198
 Sunflowers (1888–89) 195, 195,
 196
Goldschmidt, Madge 158
Goldschmidt, Erwin 158
Goldschmidt, Jakob 156, 157
 Goldschmidt sale 157, 158,
 169, 175, 198
Goldschmidt-Rothschild,
 Baby 108
Goncourt, brothers 15, 18, 104
 Manette Salomon (1866) 15
Goncourt, Edmond de 30, 50
Goulandris family 155
Goulandris, Basil P. 153
Grafton Gallery 131
Grant, Cary 144
Grenauer, Emily 177
Grodzinski, Vera 102
Gronau, Carmen 156, 157
Gros, Antoine-Jean (baron) 15
H
Haig, Douglas, 1st Earl Haig 139
Hallowell, Sara 74
Hals, Frans 17

Hansen, Wilhelm 106
Hart-Davis, Rupert 160
Havemeyer, H. O. 46, 52, 65, 78,
 79, 83, 211
Hayashi, Tadama 191–92, 194
Haydon, Benjamin 120
Hemingway, Ernest 62
Herodotus 123
Hill, Captain Henry 125, 126,
 139
Hirsch, Robert von 107, 108
Hitler, Adolf 109
Hoschedé, Ernest 33
Hunt, William Holman 123
Hussain, Saddam 199
Huysmans, Joris-Karl 143
I
Innes, Michael 144
Ionides collection 130
J
J. Walter Thompson 153, 154
James, Henry 58, 59, 60, 62, 72,
 74, 122, 136
 The Ambassadors (1903) 58,
 61, 73
 The Art of Fiction (1884) 73
 A Bundle of Letters (1879) 60
 The Coxon Fund (1894) 73
Jodidio, Dimitri 188, 189
Johnson, Samuel 215
Jopling, Jay 42
K
Kandinsky, Wassily 30, 118
Kay, Arthur 127, 128
Keating, Billy 43
Keller, George 160, 170
Kennedy, Jacqueline 184, 184
Kessler, Harry, Graf 100, 101,
 102, 108
Kipling, Rudyard 74
Knoedler's 160
Koechlin, Raymond 191
Koenigs, Franz 108
Korda, Alexander 90
Krebs, Otto 108
Kuroki, Madame 193
L
Laforgue, Jules 95
Lane, Hugh 134, 136, 139
Larkin, Philip 148

Lauder, Ronald 113
Lehman family 155
Leicester Galleries 143
Les XX 106
Liebermann, Max 95, 97, 101
Long, Edwin
 The Babylonian Marriage
 Market (1875) 122, 123
Lurcy, George 155, 216
Lurcy sale 155, 158
Lyttelton, George 160
M
Macchiaioli 51
Macmillan, Harold 148
Mahan, Captain A. T. 59
Mallarmé, Stéphane 9, 15
Manet, Édouard 13, 15, 24, 38, 45,
 48, 50, 54, 63, 97, 101, 102, 103,
 106, 108, 123, 130, 131, 132, 134,
 138, 153, 156, 158, 160, 171, 176,
 186, 203, 216, 217
 Bar at the Folies-Bergère
 (1881–82) 142, 143
 The Execution of Maximilian
 (1868) 65
 Gare Saint-Lazare (1872–73) 77,
 164
 Musique des Tuileries (1862) 142
 Portrait of Madame Gamby
 (1879) 160
 Rue Mosnier with Flags (1878)
 160
Marks, Montague 104
Master of Flémalle 97
Matisse, Henri 87, 105, 118, 212
Matsukata, Kojiro 192
Maugham, William Somerset
 159, 160, 171, 172, 173, 174, 175
 The Moon and Sixpence (1919)
 173
Maupassant, Guy de
 Bel-Ami (1885) 44, 214
Meier-Graefe, Julius 97, 99,
 101, 103
Meissonier, Ernest 68
Mellon, Paul 170
Mendelsohn-Bartholdy, Paul 100
Menzel, Adolph von 95
 Auf der Fahrt durch schöne
 Natur (1892) 96

Metropolitan Museum, New
 York 69, 185
Mettler, Hans 107
Miller, Henry 62
Millet, Jean-François 68
Modersohn-Becker, Paula 104
Modigliani, Amedeo 212
Monet, Claude 7, 8, 9, 13, 16, 17,
 19, 21, 23, 24, 25, 26, 28, 30, 31,
 32, 38, 40, 45, 46, 48, 49, 50,
 52, 54, 56, 57, 64, 66, 67, 68,
 69, 70, 76, 84, 86, 87, 90, 94,
 95, 97, 100, 102, 104, 105, 106,
 108, 109, 110, 118, 119, 124, 129,
 130, 131, 134, 138, 144, 149, 150,
 152, 155, 171, 172, 176, 177, 178,
 183, 185, 188, 191, 192, 193, 200,
 203, 205, 212, 213, 214, 215,
 216, 217
 Cliffs at Etretat (1886) 118
 The Grand Canal, Venice (1908)
 11, 162
 Haystacks (1890–91) 118
 Parc Monceau (1878) 22
 Poplars on the River Epte (1891)
 27, 163
 La Terrasse à Sainte-Adresse
 (1867) 167, 179, 178, 185
 Vétheuil: Sunshine and Snow
 (Lavacourt under Snow) (1881)
 132
 Le Val de Falaise (1885) 183, 183
 Water-lilies (1908) 53
 Winter on the Seine, Lavacourt
 (1880) 29
Moore, George 121, 127, 128
Morisot, Berthe 32, 36, 48, 188
Morozov, Ivan 117, 117, 118, 119
Morrow, W.C. 61
Munnings, Alfred 146
Murer, Eugène 34
Murger, Henri 60
Museum of Modern Art, New
 York 177, 178
N
Nash, David 152
National Gallery of Wales,
 Cardiff 139
National Gallery, London 131,
 132, 134, 136

National Gallery, Melbourne 131
Niarchos, Eugenia (née
 Livanos) 155
Niarchos, Stavros 149, 153
Nietzsche, Friedrich 93, 95
Nordau, Max 104
O
Onassis, Aristotle 184, 184
Opus Dei 205, 206
Orpen, Sir William
 Homage to Manet (1909) 133,
 134
Osthaus, Karl 100
P
Panofsky, Erwin 89
Pellerin, Auguste 52
Petit, Georges 49, 50, 51, 83, 100
Phillips, Duncan 87, 88
Picasso, Pablo 54, 87, 105, 118,
 146, 212
Pinault, François 210
Pissarro, Camille 13, 16, 24, 26,
 30, 38, 39, 45, 50, 51, 52, 66,
 68, 69, 71, 92, 97, 102, 104, 105,
 110, 114, 124, 130, 131, 132, 134,
 144, 171, 191, 205, 217
Pissarro, Lucien 68
Pitcairn, Feodor 180–81, 188
Pitcairn, Theodore, Rev. 178,
 180, 188
 Pitcairn sale 178
Pollock, Jackson 177, 212
Pope, Theodate 84
Pope, Theodore 70–71, 101
Portier (dealer) 69, 70
Potter Palmer, Bertha Honoré
 74, 75, 76
Q
Quinn, Anthony 159
R
Redon, Odilon 26
Reid, Alexander 127, 130
Reinhart family 107
Reitlinger, Gerald 84
 The Economics of Taste
 (1961–70) 177
Renoir, Jean 72, 83
Renoir, Pierre-Auguste 7, 13, 19,
 20, 23, 26, 30, 32, 38, 40, 43,
 45, 50, 52, 54, 64, 66, 68, 71,

72, 72, 83, 84, 87, 100, 101, 102, 104, 106, 109, 110, 113, 114, 116, 118, 130, 131, 134, 143, 144, 149, 150, 153, 156, 158, 170, 171, 172, 176, 177, 186, 188, 191, 192, 196, 198, 200, 201, 205, 212, 213, 214
Au Moulin de la Galette (1876) 88, 197, 198
Le Déjeuner des Canotiers (1880–81) 88, 143, 145, 166
La Loge (1874) 142, 168, 214
La Parisienne (1874) 138
Parapluies (1880–85) 142
La Pensée (1877) 83, 160
Portrait of Madame Clapisson (Dans les roses) (1882) 83, 85
Portrait of Victor Choquet (c. 1875) 41
Le Pont des Arts (c. 1868) 184
La Promenade (1870) 190
Richardson, John 54
Rivière, Georges 40
Robinson, Edward G. 90, 144, 159, 216
Robinson, Theodore 87
Rockefeller family 155
Rodin, Auguste 57, 138
Roosevelt, Eleanor 155
Rossetti, Dante Gabriel 123
Rothko, Mark 212
Roundell, James 195, 195
Rousseau, Théodore
The Edge of the Forest (1886) 12
Royal Academy of Arts, London 146, 211
Rubinstein, Helena 155
Rutter, Frank 82, 131, 132, 134, 143, 198
S
Sainte-Beuve, Charles Augustin 18
Saito, Ryoei 197, 198–99, 199, 201
Salon des Refusés 14
Sargent, John Singer 18, 69, 73, 128, 135
Scharf, Margarethe 113
Schliemann collection 114
Schmitz, Oscar 100
Schuffenecker, Émile 28
Searle, Alan 174

Seurat, Georges 30, 66
Une Baignade (1884) 142
Shaw, Quincy Adams 50
Shchukin, Sergei 117, 117, 118, 119
Signac, Paul 18
Silberberg, Gerta 112, 113
Silberberg, Max 108, 110, 112
Silvestre, Armand 23
Sinatra, Frank 216
Sisley, Alfred 13, 30, 32, 45, 66, 71, 99, 105, 118, 124, 130, 131, 134, 171, 175
Sontag, Susan 174
Sotheby Park Bernet 176
Sotheby's 7, 38, 112, 113, 116, 150, 151, 152, 153, 154, 155, 156, 157, 159, 160, 170, 174, 176, 179, 183, 187, 191, 198, 206, 207, 209, 210
Spelling, Aaron 185
Spelling, Cindy 184–85
Spiegel, Sam 90
Staechelin family 107
Sternheim, Carl 100
Stevens, Alfred 45
Stone, Irving 173
Lust for Life (1934) 90
Stourton, James 102
Strauss, Jules 54, 55, 152
Strauss, Michel 152, 191, 204–07
Sutton, James 66
Swarzenski, Georg 98, 99
T
Tarkington, Booth 61
Tate Gallery, London 131, 132, 142, 152
Taubman, Alfred 207, 208, 209, 210, 211
Taylor, Elizabeth 183, 184
Tennant, Anthony 207, 209
Thode, Henry 103
Thomson, Frank 69, 70
Thoré, Théophile 14
Trott, Jost von 110, 112
Tschudi, Hugo von 97, 101, 102
Tucker, Paul Hayes 26, 28
Tugendhold, Yacov 118
V
Vanderbilt family 155
Velázquez, Diego 17
Viau, Georges 56, 56, 143

Victoria, Queen 121
Villiers, George Francis Child, 9th Earl of Jersey 144
Vinnen, Carl 104, 105
Volker, Dr 103
Vollard (dealer) 49, 83, 99
W
Walpole, Hugh 144, 173
Warhol, Andy 212
Wayne, John 185
Weinberg collection 153, 156
Weinberg sale 155, 158
Wharton, Edith 25
The Custom of the Country (1913) 25, 61
Whistler, James Abbott McNeill 124
White's (club) 150
Whitney, John Hay 88, 198
Whittemore, John Howard 70–71
Wilde, Oscar 66, 198
'The Critic as Artist' (1890) 46
The Decay of Lying (1889) 129–30
A Woman of No Importance (1893) 60–61
Wildenstein 70, 87
Wilder, Billy 90
Wilhelm II, Kaiser 93, 94, 102, 109
Wilson, Peter 150, 151, 151, 152–53, 156, 157, 158, 159, 160, 171, 173, 174, 175, 175, 176, 179, 187
Wolff, Albert 32, 34, 36, 48
Wölfflin, Heinrich 99
Wyndham, Henry 200
Wyzewa, Téodor de 74
Y
Yasuda Fire and Marine Insurance 196
Z
Zola, Émile 10, 25, 26, 39, 41, 42, 70
The Masterpiece (1886) 10
Zschuppe, Helmut 92, 130

Acknowledgements and Picture Credits

Author's Acknowledgements
I am grateful to the many people, both in the art world and beyond, who have helped me in the researching and writing of this book. I would particularly like to acknowledge the following: Nielly Bathurst, Noemie Daniel, Matthew Floris, Amelia Gibbs, Minette Marin, David Nash, Alex Schiffer, Miranda Seymour, James Stourton, Andrew Strauss, Michel Strauss and Lucy Tagg.

Picture Credits
The illustrations in this publication have been taken from the Author's and the Publisher's archives with the exception of the following:

Fig. 1 and pl. 1 Jean-Léon Gérôme, *The Baths at Bursa*, 1885. Private collection. Photo: Sotheby's.
Fig. 2 and pl. 2 Claude Monet, *The Grand Canal, Venice*, 1908. Private collection. Photo: Sotheby's.
Fig. 3 Théodore Rousseau, *The Edge of the Forest*, 1866. Private collection. Photo: Sotheby's.
Fig. 4 Bridgeman Art Library.
Fig. 7 Claude Monet, *Parc Monceau*, 1878. Private collection. Photo: Sotheby's.
Fig. 8 and pl. 3 Claude Monet, *Poplars on the River Epte*, 1891. Private collection. Photo: Sotheby's.
Fig. 9 Claude Monet, *Winter on the Seine, Lavacourt*, 1880. Private collection. Photo: Sotheby's.
Fig. 14 Pierre-Auguste Renoir, *Portrait of Victor Chocquet*, c. 1875. Fogg Art Museum. akg-images.
Fig. 15 Photo courtesy Archives Durand-Ruel.
Fig. 18 Claude Monet, *Water-lilies*, 1908. Private collection. Photo: Sotheby's.
Fig. 30 Pierre-Auguste Renoir, *Portrait of Madame Clapisson*, 1882. Private Collection. Photo: Sotheby's.
Fig. 32 akg-images.
Fig. 33 Adolf von Menzel, *Auf der Fahrt durch schöne Natur*, 1892. Private collection. Photo: Christie's.
Fig. 38 akg-images.
Fig. 39 Vincent van Gogh, *Olive Trees*, 1889. Private collection. Photo: Sotheby's.
Fig. 45 Edwin Long, *The Babylonian Marriage Market*, 1875. © Royal Holloway and Bedford New College, Surrey, UK/ Bridgeman Art Library.
Fig. 49 Sir William Orpen, *Homage to Manet*, 1909. © Manchester Art Gallery, UK/Bridgeman Art Library.
Fig. 50 Mary Evans Picture Library.
Fig. 51 National Museum of Wales/By kind permission of Lord Davies.
Fig. 52 National Museum of Wales/By kind permission of Lord Davies.
Fig. 54 and pl. 6 Pierre-Auguste Renoir, *Le Déjeuner des Canotiers*, 1880–81. Phillips Collection, Washington, USA. Artothek, Weilheim.
Fig. 55 © Bettmann/Corbis.
Fig. 57 © Bettmann/Corbis.
Fig. 59 © 2008 Getty Images.
Fig. 62 © Sophie Bassouls/Sygma/Corbis.
Fig. 63 and pl. 7 Claude Monet, *La Terrasse à Saint-Adresse*, 1867. The Metropolitan Museum of Art, New York. Purchase, special contributions and funds given or bequeathed by friends of the museum, 1967. Artothek, Weilheim.
Fig. 65 Claude Monet, *Le Val de Falaise*, 1885. Private collection. Photo: Sotheby's.
Fig. 66 © Bettmann/Corbis.
Fig. 68 Pierre-Auguste Renoir, *La Promenade*, 1870. Getty Museum. Photo: Sotheby's.
Fig. 71 Pierre-Auguste Renoir, *Au Moulin de la Galette*, 1876. Private collection. Photo: Sotheby's.
Fig. 72 Vincent van Gogh, *Portrait of Dr Gachet*, 1890. Private collection. Photo: Christie's.
Fig. 78 Philippe the Frog, plush toy, Museum of Fine Arts, Boston © 1998. Available at www.mfa.org/shop. Thanks to Mia Breuer.
Fig. 79 and pl. 8 Pierre-Auguste Renoir, *La Loge*, 1874–75. Private collection. Photo: Sotheby's.

Prestel Verlag
Königinstrasse 9, D-80539 Munich
T +49 (89) 242 908 329
F +49 (89) 242 908 335
www.prestel.de

Prestel Publishing Ltd.
4 Bloomsbury Place, London WC1A 2QA
Tel. +44 (020) 7323-5004
Fax +44 (020) 7636-8004

Prestel Publishing
900 Broadway, Suite 603
New York, N.Y. 10003
Tel. +1 (212) 995-2720
Fax +1 (212) 995-2733
www.prestel.com

Library of Congress Control Number: 2008935241

British Library Cataloguing-in-Publication Data: A catalogue record for this book is available from the British Library. The Deutsche Bibliothek holds a record of this publication in the Deutsche Nationalbibliographie; detailed bibliographical data can be found under: http://dnb.dde.de

Prestel books are available worldwide. Please contact your nearest bookseller or one of the above addresses for information concerning your local distributor.

Editorial direction: Philippa Hurd
Design and layout: Liquid Agentur für Gestaltung, Augsburg
Typesetting: Bernd Walser Buchproduktion, Munich
Origination: Reproline mediateam, Munich
Printing and binding: TBB, Banská Bystrica

Printed in Slovakia on acid-free paper

ISBN 978-3-7913-3971-9